south essex college

FURTHER & HIGHER EDUCATION
SOUTHEND CAMPUS

In Focus

In Focus

John Holtz

BLANDFORD PRESS

POOLE DORSET

A Quarto Book

Copyright © 1980 by **Quarto Marketing, Ltd.** All rights reserved including the
right of reproduction in whole or in part in any form.

Edited by John Smallwood
Book design: Mary Tiegreen and Roger Pring
Design assistant: Elizabeth Fox
Text editor: Gene Santoro
Production: Millie Falcaro

Produced and prepared by **Quarto Marketing, Ltd.**

Manufactured in the United States of America
Printed and bound by the Maple-Vail Manufacturing Group

First published in the U.K. 1980
by Blandford Press Ltd.
Link House, West Street
Poole, Dorset BH15 1LL

British Library Cataloguing in Publication Data

Holtz, John

 In focus
 1. Photography—Great Britain—Apparatus and
 supplies
 I. Title
 77140941 TR197
ISBN 0-7137-1105-1 (U.K.)

Introduction

In recent years photography has seen an explosion in its popularity and a proliferation of equipment and gadgetry at both amateur and professional levels. While generally this has meant that the photographic process, from original exposure to final image, has been simplified technically, photographers in all fields are now confronted with a bewildering choice of working tools and materials. Not all of this equipment is essential, or even good, and IN FOCUS intends to discuss its advantages and disadvantages honestly and objectively.

This book therefore has two related aims: first, to provide a critical guide to the types of equipment—cameras, lenses, and so on—currently available; and second, to evaluate and recommend the best brands to buy in each category. First, then, it is designed to answer such commonly asked questions as "What cameras should I buy?" or "Should I buy a motor-drive?". The answers to these questions must, of course, be related to each individual's needs and styles of work as well as the subjects he or she intends to shoot.

The second aim of the book—selecting the very best of each type of equipment— is more demanding. Sometimes choosing the best camera or lens was easy, because certain pieces of equipment have good reputations established by years of reliability and excellence. More often it was difficult and the competition for inclusion intense. As a result, every choice was carefully examined and considered before it was accepted or rejected.

Not everyone in the photography world has seen the expansion in equipment and materials as a good thing. There are those who argue that it has not led to a corresponding improvement in the quality of the work produced, and that too often equipment and gimmickry is substituted for real photographic ability. If, by describing and critically examining equipment and materials, this book is able to clarify their places in the photographic process, then it will have succeeded.

35mm Single-Lens-Reflex Cameras

Today, the ubiquitous 35mm SLR camera is so prevalent that it is almost synonymous with photography, particularly at amateur and semi-professional levels. The wonderful thing about the 35mm SLR is that it is as easy, or as complicated, to use as you like and, above all, it can be sold at a price that is within most people's reach. Indeed, it is almost impossible to separate the enormous growth in popularity of photography since 1960 from the development of the economically-priced SLR and its various "systems."

From time to time, camera and film manufacturers have tried to push the 110 format as a cheaper, smaller competitor, but without much success. Although quite sophisticated equipment like the Pentax 110 (with interchangeable lenses) is available, the basic problem is that the 110 image is just too small (12x16mm compared to 24x36mm on 35mm cameras) to lift it out of the adult-toy category. In addition, there is only a very limited range of 110 films including only one black-and-white film, albeit an excellent one—Verichrome Pan—and the specifications of plastic 110 cartridges are such that it is unlikely that the film is held flat in the film gate.

Today's 35mm films include color-slide films, color-print films, and black-and-white negative materials with up to ASA 400 speed rating. This range means you can take more pictures by natural daylight or indoor illumination, with less dependence on flash and other artificial light sources. Slower films (with lower ASA speed ratings), are incredibly sharp, fine-grained, and capable of producing pictures with that special kind of clarity and smoothness that makes people forget that you used "such a little camera." In 35mm format, the range of films is as versatile as the equipment: sometimes you can use fast ASA 400 films for the excitement of "available darkness" photography; other times you can turn to slower films in the ASA 25 to 100 range in order to produce the best possible 35mm picture quality. Either way, you'll be using materials whose image qualities—resolving power, tonality, etc.—were only dreamt of a few short years ago.

Interchangeable lenses for 35mm SLRs are faster than ever before. Faster (larger maximum-aperture) lenses can produce well-exposed pictures with faster shutter speeds than those needed for slower lenses, which allows 35mm SLRs to function where there is less light and to be used at high enough shutter speeds to avoid blurred and smeared images when shooting fast. High-speed lenses like 50mm f/1.8 and f/1.4 are now standard optics on the typical SLR and have done a lot to build the 35-mm camera market today. And there are zooms that let you change from a sweeping wide-angle view to a tight telephoto composition without taking the camera from your eye. There are wide-angle, ultra-wide-angle and even fisheye lenses; and lenses for "macro" close-up photography and long-range tele-photography.

Before SLRs appeared, 35mm cameras were focused by means of coupled rangefinders, and you looked through optical viewfinders that gave a reduced picture of the world around you. Except in a close-up shot, you could hardly see the expressions on people's faces in the average group picture; and close-up the different optical positions of the lens and the viewfinder meant that you didn't see exactly what you

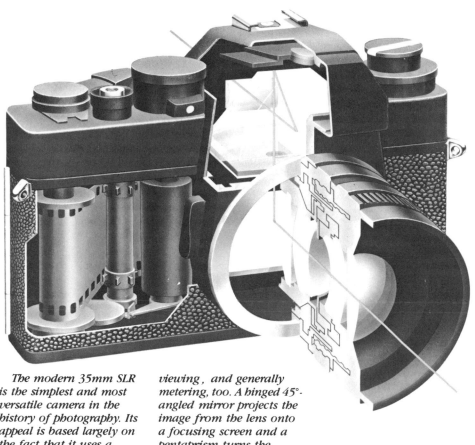

The modern 35mm SLR is the simplest and most versatile camera in the history of photography. Its appeal is based largely on the fact that it uses a single lens for taking, viewing, and generally metering, too. A hinged 45°-angled mirror projects the image from the lens onto a focusing screen and a pentaprism turns the image right-side-up.

were shooting. This was the famous "parallax error" that has been totally eliminated in the SLR by using the same lens to produce the viewfinder image and the image.

Those older rangefinder-focusing 35mm cameras, such as Leica, Contax, and Nikon, did have very accurate distance focusing. The SLR substituted a beautiful viewcamera-style chamber with a groundglass for parallax-free composition and framing, but the early ones gave very poor focusing. Nowadays, SLR screens are fitted with different sorts of optical rangefinders to improve focusing ability, like split-im-

age prisms (which do just that until you get the subject properly sharp), and tiny "microprisms", that make out-of-focus subjects appear to shimmer. The 35mm SLR's viewfinders no longer offer your eye the gray, dingy flat view that they once did. Today's machines also use higher quality mirrors, mirrored pentaprisms, and vastly improved viewfinder optics and screens to give you a bright, contrasty, crystal-clear view of the subject through the widest aperture the mounted lens possesses. Almost every 35mm SLR manufactured today allows you, with the press of a button, actually to preview the depth

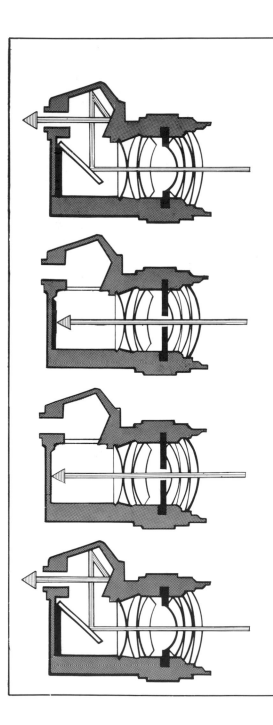

For viewing and metering in most cases, the diaphragm is wide open to allow maximum light to pass through the lens to the viewfinder.

When the shutter release is pressed, the diaphragm stops down, the mirror swings up, and exposing light reaches the film plane.

The two blinds of the focal plane shutter move in sequence across the film, the gap between them determining the exposure time.

After exposure, the mirror falls back and the diaphragm re-opens for viewing and metering.

of field you will get at any lens aperture you select, which is especially valuable in macro work.

The 35mm SLR should really be called the "MLR," or multi-lens-reflex, because of its ability to accept all kinds of short- and long-focus, narrow- and wide-angle lenses. This is another reason why the SLR has replaced those great rangefinder-focusing cameras of yesteryear. The best rangefinder camera—the Leica M-type—could focus lenses from a 21mm wide-angle to a 135mm telephoto. To handle really long-focus lenses, like a 200- or 400mm, you had to convert your handy little rangefinder into a heavy, clumsy, hard-to-operate camera, by adding something called an "accessory reflex housing." Modern 35mm SLRs can accept almost any lens, including specialist optics, and still give a bright clear view of the image formed by the lens.

In the SLR things have been so ingeniously inter-related that when you press the shutter release, a rapid series of mechanical events takes place:
1. Mirror flies upward, to get out of the ray-path of the lens.
2. Lens aperture ("iris diaphragm") shuts down to the user's preselected value for actual exposure. If the camera has automatic aperture settings, this working f-stop is determined by the camera's through-the-lens (TTL) light metering system
3. The focal-plane shutter, which is a set either of curtains or of thin metal blades positioned very close in front of the camera's film plane, begins and ends the exposure. If a synchronized electronic-flash unit is being used, this will be fired at the instant in which the first shutter curtain, or first set of metal blades, has completely uncovered the full 24x36mm image plane. Again, if the camera has automatic-shutter setting, the shutter speed will be determined by the camera's meter.
4. Finally, as the shutter completes its flight across the camera's film gate, the reflex mirror falls back down into focusing position, and the lens-aperture blades snap open again in order to restore a bright viewfinder image.

35mm SLRs and electronic circuitry
Electronics do play two important roles in the modern SLR, whose innards are becomingly increasingly—some think alarmingly—transistorized and battery-dependent. These two jobs are first, to regulate and to control the operation of the camera's focal-plane shutter (FPS), and second, to measure incoming TTL light rays, and to translate this "information" into a combined lens f-stop and shutter-speed exposure. In an old-style mechanical SLR these functions were performed by slow and breakable tiny gears, levers, cams, pins, shafts, and springs.

The first mechanical operation to disappear from mechanical cameras was the slow-speed escapement that used to time the slower shutter speeds, meaning those longer than the speed specified for electronic-flash, or "X" synchronization. For example, if the camera synchs strobe lights at 1/60 sec, all the speeds longer than this, usually one to 1/30sec, would be timed by this escapement (which some of the better camera-makers actually purchased from watch and clock manufacturers). Now, things are a lot different: when you fire the shutter, its first curtain (or first set of horizontal-running blades) starts moving. But the second curtain (or set of blades) is

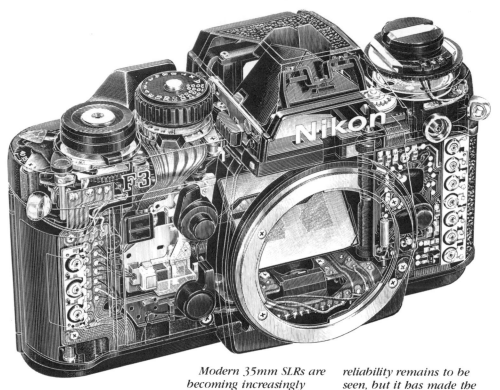

Modern 35mm SLRs are becoming increasingly electronic-based, as this cut-away of the advanced Nikon F3 shows. Whether this will result in greater reliability remains to be seen, but it has made the cameras lighter, more compact, cheaper to manufacture and generally more sensitive.

held back by an electro-magnet which is kept electrically energized until a little computer-like electronic circuit determines that the right amount of time has elapsed. In the second and current stage of electronification, the same circuitry and electromagnets control all of the shutter speeds, even exposures of 1/1,000 or 1/2,000sec.

Photographers in general, are still very sceptical about these changes within the camera—whether the flexible solid-state circuit boards are as durable or as easy to repair as mechanical cameras. The photographic industry argues that electronic circuitry is a form of simplifcation, and that simplification makes for greater ruggedness and reliability. That if you knock a mechanical camera just hard enough to stop it from operating, or from operating with proper accuracy, a similar knock might not affect a solid-state circuit without any moving parts.

No one really knows yet how well electronic cameras are going to hold up against heat, cold, and moisture. Camera batteries are exotic, expensive, and expendable. Their rated service life is usually just about equal to their rated shelf lives—the pre-service time that they can safely be stored. This

means that carrying a spare battery is really little more than a snare and a delusion, unless you're smart enough to start the spare after about half the rated life of the in-service cell or cells. Because most SLR batteries are rated to last about twelve months, this means you should buy the spare after six months. All of this can, and often does, become pure nonsense if your camera dealer sells you a battery that's been aging for as long as your SLR battery.

One sop to battery dependency is the so-called "mechanical back-up speed" on some cameras. In most cases this means only one or two almost useless shutter settings (like 1/60sec and Time on the new Nikon F3) that don't need the battery. Very little to offer on a professional camera to the photographer who is shooting far away from any store selling batteries when the power runs out.

LIGHT METERING

The 35mm SLR is an incredibly efficient machine for making photographs. It is small, light, quick, reliable, and accurate. It actually allows you to look directly through almost any lens you choose to mount on it (the choice is endless) to see almost exactly the image you will record on film (most show about 96% of the picture area in their viewfinder). You can, at the push of a button, even preview the depth of field given by the particular f/stop you've chosen. The most logical approach to 35mm SLR metering was to add it right on to the camera, so that it too is as fast, accurate, and easy-to-

use as the rest of the camera.

Through-the-lens metering (TTL) is now a feature of nearly every major 35mm SLR on the market. The development of very sensitive battery-powered CdS (cadmium sulfide) photocells, in the early 1960s, first made the idea of building really sensitive light meters into the camera bodies feasible. (Zeiss Ikon had this as early as 1936, with selenium-cell meters in their rangefinder-focusing Contax III and Super-Ikonta B cameras, but they really weren't very good when the sun wasn't shining.) Through-the-lens light metering first appeared in 1963, when Topcon unveiled their "measuring mirror" design in which a pattern of CdS cells was actually integrated with the focusing mirror.

TTL metering systems actually look at a sample of the light that will subsequently expose the film: light that has passed through the SLR's entire optical system, including any polarizing or color-correcting filters, prisms, bellows, extenders and other accessories that have to be accounted for in any hand-held meter reading.

Most TTL meters these days are as sensitive and accurate as most hand-held meters. But, as in everything else, you get what you pay for. You can get more sensitivity in a hand-held meter than you can in any TTL system we're aware of (including the EV-6 extreme sensitivity of the Olympus OM-2 on automatic) if you really want it and are willing to pay for it—a Gossen Luna-Pro hand-held meter or a Minolta Autometer II will take you all the way down to EV-8. (But as neither has an illuminated dial you should carry a flashlight because EV-8 is very dark. You had better be sure that your hand-held or TTL meter has fully arrived at

its super-low reading, because even the best of meters takes a long time to settle down to a final reading when operating in poor light.

A TTL meter is a reflected-light meter, and being such has its severe limitations. Generally, it can't be used to measure the light being reflected from a very small, dark subject in front of a very bright source of illumination (examples include product shots being back-lighted for silhouetting on a trans-illumination table or light-box, or some stage-lighting situations). In such cases you can try to move in on the subject until it fills the entire screen (or the sensitive portion of it, if you know where that is) but that can block some front light and give you a poor reading anyway. Alternatively, you can guess and bracket widely (standard procedure) or use a hand-held meter of one or two types. If you can get to your subject you can measure the light falling on it with an incident meter. Better yet, use a hand-held 1-spot-reading, reflected-light meter focused on the subject alone. In either case, the reading will expose your main subject with the same tonal quality of an 18%-

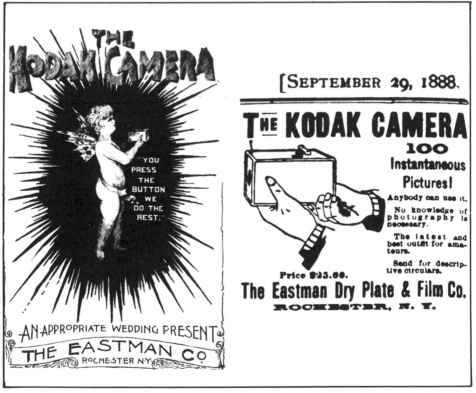

The ultimate in camera design seems to be a daily event in the photographic industry, and the current trend towards automation is not new, as this early Kodak advertisement shows. Actually, Kodak offered an automatic camera in the more modern definition around fifty years ago.

gray card. If this is not what you want, bracket around the reading. Automation or no automation, TTL meter or hand-held meter, bracketing is the photographer's best friend.

TTL meter weightings

Camera meters which are center-weighted have their metering cells and circuits arranged in such a way as to evaluate most of the light falling in the center of the scene, and this weighting diminishes toward the edges of the frame: typically, the corners of the scene are not read at all. This system is quite commonly used; an example of a contemporary 35mm SLR with center-weighted metering would be the Minolta XG-7.

A bottom-center-weighting system is also in wide use. It assumes that you will be taking a lot of pictures that include bright sky in the top of the frame. A fair assumption generally, but an awful one in many particular cases. The meter cells evaluate most of the light in the lower central portion of the scene, and less progressively toward the top of the frame. The Canon AV-1 employs this system as do many cheaper 35mm SLRs.

A side-center-weighing system is little used, and rightly so. It could be justified if most users were constantly aware of which side was being read, because then the user could turn the camera to the vertical, with the most heavily weighted area down, and the system would automatically ignore skylight. Such a system may be right- or left-side-center-weighted; it hardly matters. The meter cells evaluate most of the central portion of one side of the scene, and diminishing amounts away from this area. Olympus OM-10 uses this system.

Center-weighted metering, popularized by Nikon, is probably the most practical and simplest system for general photography.

Side center-weighted metering has little or no virtue; one of the few cameras that employs it is the Olympus OM-10.

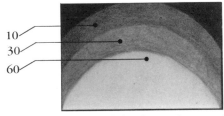

Bottom center-weighted metering, used by Canon AV-1 among others, is practical for shots with lots of bright sky in them, but limited for anything else.

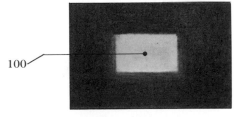

The zone reading of the Canon F-1 requires careful handling, but once mastered is probably the best TTL meter weighting.

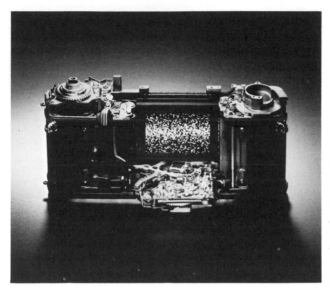

The Olympus OM-2N uses a very sophisticated metering system which automatically governs the shutter by reading off the film plane itself, even during exposure. Two SPDs provide center-weighted readings that shift to an averaging reading as the exposure time increases.

The zone-reading metering system used to be more common than it presently is, and more's the pity. It's an excellent metering scheme that allows you to select the most important part of the scene, place it in the metering zone, meter it, and adjust your camera's controls for an optimum rendering of just that portion of the subject. The problem with this system is that you have to be careful when you use it to measure accurately from your main subject. It is the system employed in the professional Canon F-1. The metering cells look at all the light falling in a central portion of the screen, marked on the F-1 by a dim patch.

Viewfinder readouts

Built-in SLR meters are either manual or automatic. Most manual meters respond to light from the whole scene, but some (like the Canon F-1) measure only a selective section or spot. Manual exposures are set by the match-needle system, or by some sort of electronic readout with light-emitting diodes (LEDs) built into the SLR viewfinder. (At this writing, only one SLR, the Nikon F3, uses a liquid crystal display (LCD) rather than LEDs, in order to save battery power.)

Match-the-needle manual metering systems show you when the exposure is about right, so that you can shoot fast, without adjusting the controls to unnecessary hair-splitting accuracy. Nobody has ever succeeded in accomplishing this sense of adequate accuracy with any kind of electronic dot or digit readout. Nikon have tried twice, in their LED-manual Nikon FM and the F2AS incarnation of the Nikon F2. Here, they use three red dots. Super-accurate exposures are set when you adjust the cross-coupled lens-aperture or shutter-speed controls until only the central LED is burning. If one of the two end LEDs light up above, the exposure is anywhere between plus-or-minus one f-stop and infinitely wrong. If the center LED and one of the side

spots light up—which is fairly normal—the exposure might be somewhere between plus-or-minus $\frac{1}{5}$th of an f-stop, and ± 1 stop off. The trouble with this is that although plus-or-minus $\frac{1}{5}$th of a stop is meaningless (even with Kodachrome), plus-or-minus one stop can be disastrous, even with Tri-X. But meter needles mean galvanometers, and galvanometers are hard to make and hard to adjust, so cheaper electronic readouts are replacing galvanometers in 35mm SLRs. Digital readouts with LEDs and LCDs, however, are slowly replacing confusing, distracting, dancing diodes.

Automatic exposure systems

Before selecting any AE SLR, make sure that it does provide optional manual metering. Some don't, like the Minolta XG models. Going manual is sometimes the only way you can get a picture when, for example, you want good detail in a strongly back-lighted subject, instead of the black silhouette that you'll get from any sort of exposure automation. In addition, as you become more proficient with a camera and familiar with its controls, you will almost certainly want the kind of picture-taking options manual metering gives.

Auto-exposure SLRs are available in two basic types, and one combination. Aperture-priority systems require you to set the f-stop, and it finds the corresponding shutter speed for proper exposure. With a shutter-priority AE system, you pick the shutter speed, and the camera finds the f-stop. Multi-mode cameras work optionally in either aperture- or shutter-priority modes. In addition, two multi-mode cameras also provide an exposure program. This is a set of predetermined shutter-speed and lens-aperture combinations for every brightness within the camera's measuring range.

The Nikon F3 uses a very different metering system from previous Nikon cameras. While it retains the well-regarded center-weighted reading, more sensitivity (about 80%) is given to the central area. The placement of the SPDs inside the camera body eliminates the need for exposure compensation with different screens and finders as they measure light that actually passes through thousands of microscopic holes in the reflex mirror.

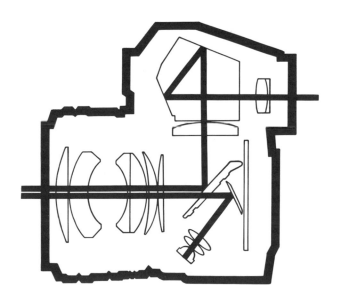

Auto-exposure systems measure light from the whole image field, for the very simple reason that making an automatic exposure means measuring the light and taking the picture with the same camera lens pointed in the same direction. Most such so-called "integrating" systems are at least slightly "center weighted," meaning that they count the center of the picture frame for more than the outer edges and corners. Nikon made a virtue of this by heavily promoting the 60/40 distribution of their TTL models, right through to the present. Apparently they believe in this type of design because their latest model, the Nikon F3, actually uses an 80/20 distribution. For manual metering this has the advantage of permitting more precise aiming to determine a problem exposure. In any auto-exposure mode it means more frequent use of the camera's automation overrides.

The three important overrides to look for in any auto-exposure SLR are (1) full manual metering, with clear viewfinder exposure readout; (2) an exposure compensation dial that lets you increase or decrease the automated exposure level, usually over a plus-or-minus two f-stop range; and (3) a metering "memory-lock" control that will hold a meter reading while the camera is aimed in another direction. Exposure compensation dials are often used for making bracketed series of exposures. The best of these are calibrated in $\frac{1}{3}$-stop increments (Canon A-1), but $\frac{1}{2}$-stop doses are also practical (Nikon, Contax).

Metering memory-locks make exposure automation really work. Suppose you've got a patch of bright blue sky between a canyon of skyscrapers. If you aim and shoot with an AE camera, the meter responds to the sky, and the sky gets perfect exposure, but the gray buildings get underexposed. With a memory-lock you can point the camera at gray buildings, push the lock to hold this exposure, then frame the subject and shoot. (Some cameras have a so-called "back-light button," which increases the AE exposure by $1\frac{1}{2}$ f-stops, in order to introduce automatically a three-times exposure increase. Not so fine as a metering lock, but pretty effective, and maybe even faster to use.)

The choice between aperture- and shutter-priority is largely a personal one, depending on which aspect of your photography you want to retain control over. There are no firm arguments for or against one system. If you use aperture-priority blindly, forgetting whatever indicators or warnings are built into the viewfinder system, you will get at least some perfectly exposed smears. This happens when the f-stop you picked won't give a short enough shutter time to stop subject movement, or to eliminate camera-shake. You are supposed to watch what's going on and dial in bigger f-stops before this can happen.

With a shutter-priority system, you must watch the indicators or you'll lose control of depth of field. This means sometimes too much, sometimes too little picture sharpness. This may be a bit less disastrous than an unexpected blur, but if you mount a long, mirror-type (no diaphragm at all) lens, or a non-automatic bellows or tubes (without any mechanical linkage to connect to the body's diaphragm-actuating mechanism) to do some macro shooting, your shutter-priority automation system will be totally useless, as

there will be no way for it to set a diaphragm that isn't there or isn't connected to the setting mechanism. An aperture-priority camera, however, will work perfectly happily with this kind of gear mounted.

One variety of aperture-priority camera that is currently on the market, however, is well worth avoiding. Represented currently by the Minolta XG-9, the Pentax ME and MV, the Canon AV-1, and the Nikon EM, these are aperture-priority cameras without a shutter speed dial. In most of these lamentable cameras you are at least informed of the selected shutter speed; in some, however, the viewfinder tells you nothing on the wisdom of the automatic setting.

If you use the AE system (or systems) blindly, without watching the inboard indicators, and without taking advantage of the AE overrides when they're needed, you are likely to end up with more incorrectly exposed pictures than you would get with a non-automatic camera.

FOCAL-PLANE SHUTTERS

Focal-plane shutters (FPS) built into the camera bodies, right in front of the film position, or "focal plane," are what make interchangeable lenses possible, practical, and affordable. The only other way to permit multi-lens photography is to build a shutter into some other part of the camera body, or to actually put a shutter inside of each interchangeable lens. The first method has been tried many times, but without any lasting success. At one time, for instance, a number of amateur-oriented SLRs had shutters built into the front of the camera body, just behind the bayonet lensmount. This shutter position produces a lot of serious optical and mechanical problems, and consequently the design has been withdrawn entirely. (If you're a used-camera collector, this shutter position was on the Voigtländer Bessamatic, and their Prominent rangefinder-focusing 35s, among others.)

Putting a shutter inside of each lens is the costly path taken by Leica in 35mm, and by Hasselblad and most medium-format rollfilm cameras. Commercial, advertising, and fashion photographers prefer this style of construction because the kinds of shutters built into individual camera lenses synchronize electronic-flash units at much higher shutter speeds than are possible with an FPS.

In addition to opening the path to interchangeable lenses, the FPS gives the highest shutter speeds. Most run to 1/1,000 sec, and a lot of new models give even 1/2,000 sec. Today, if a shutter can operate accurately at these high speeds, it's a very important advantage. Modern films are faster than ever before, and it is often quite difficult to avoid overexposure on a bright sunny day. More than this, most lenses really perform best at their middle apertures, that is, at f/stops around f/5.6 instead of f/11 or f/16. (At large apertures, they lose contrast, resolution, and brightness in the corners; at small apertures, they suffer from defraction problems.) Only the new breed of faster focal-plane shutters allows these optics to be used to their fullest possible advantage.

Even when used at the same speed as a leaf-type shutter that opens completely, pauses, and then closes to end the exposure, the flying opening of an FPS that rushes across the filmgate to expose the picture strip-by-strip, has much better action-stopping power. This depends upon a lot of technical factors, including both the focal lengths and the lens apertures that are involved, but in general it's possible to say that the FPS in a typical 35mm SLR has twice the action-stopping capability of a leaf-type interlens shutter. For example, $\frac{1}{30}$ sec on an FPS will stop motion equivalent to $\frac{1}{60}$ sec with a between-lens shutter. (This is because the FPS exposes a constantly moving narrow panel of the scene. If the slit moves in the direction of the motion, and this is important, the movement of the slit itself tends to stop the subject motion. The leaf shutter, in contrast, allows all of the scene to be exposed throughout the entire exposure duration. It will show all of the motion that occurred in all of the scene through all of the exposure time. The FPS shutter shows only part of the motion, in part of the scene as the opening travels across the film gate.)

Horizontal and vertical shutters
In terms of their construction, there are several different sorts of focal-plane shutters. You need know little about their inner workings, unless you're interested in following those asinine skeletal "strip-down" pictures of camera parts that adorn the pages of monthly camera magazines, but some basics are still worth reviewing.

Curtain-type FPS have two rolled-up cloth (or thin titanium metal foil) curtains that travel horizontally across the long, 36mm side of the camera's film-gate. The blade-type FPS has two sets of thin metal blades that move vertically, along the short 24mm side of the picture frame. The exposure is made by delaying the second shutter curtain, or second set of shutter blades, after the first shutter curtain or blade set has started to move. This creates a free slit between the two, and it is this travelling slit that literally wipes the lens image onto the film surface. High shutter speeds call for very thin slits, slower speeds are obtained by using much wider slits. In all cases, the speed of travel is the same.

Very long exposures use the whole width of the picture frame, the closing action of the second set of curtains or blades being delayed until the first part of the FPS has completely exposed the whole frame.

The new, vertically-running metal blade shutters operate in a similar fashion to horizontal shutters, but they run across the short side of the frame, having to go only 24—instead of 36mm. This is important, because the fastest FPS speed that completely exposes the whole filmgate area is also the fastest speed that can be used to synchronize an electronic-flash unit. The majority of horizontal-run FPS today synchronize electronic-flash at $\frac{1}{60}$ sec, although a few models do provide this full-frame exposure at $\frac{1}{80}$ or $\frac{1}{90}$ sec. But almost all vertical-running metal-blade shutters synchronize flash at $\frac{1}{125}$ sec. Faster flashing is a big advantage, for example, whenever there's a lot of ambient light or when you want to combine the flash with some other bright light source.

There really isn't any practical difference between metal and cloth curtain-type FPS. Cloth curtains are quieter, and if jabbed while loading

film, cloth will almost always spring back into position. Metal shutters, however, should never, under any circumstance, be touched.

Metal blades have faster X-synch possibilities, and because of mass-production economies they are cheaper. But short-run blade-types don't seem rugged enough to stand the beating of very high motor-drive cycling rates. There isn't a single vertical-blade FPS that can do 3 fps, but a lot of the older horizontal curtain types can go anywhere from 4 to almost 10 fps (in different camera models). There are two reasons for this. First, the two curtains are nearly always just two roll-up parts. The blade-type, however, uses a lot of very light-weight pieces that have to pivot together precisely, and just can't take the same degree of banging and hammering given by a professional high-speed motor drive. Second, the slower shutter action of the curtain-type FPS, and the larger dimensions of its members, makes it a lot easier to incorporate the various kinds of motor-drive interlocks that are needed to prevent the motor from attempting to wind-on before all of the SLR's shutter, mirror, and lens-aperture operations have returned to normal after each exposure. Perhaps this is because blade-style shutters run too fast, and their insides are just too small, and too weak, to provide rugged and reliable safety interlocks.

At present, shutters are a neglected area of development. A lot of electronics are being used to modernize the timing function of the FPS, but its mechanical movements are hardly being changed at all. As a matter of fact, Nikon's newest model, the professionally-oriented Nikon F3, has a three-post horizontal-run FPS that is practically identical to the three-poster used by Oskar Barnack in the original Leica models, which were first marketed in 1925. Even the most highly automated of all SLRs, the multi-mode Canon A-1, uses a horizontal cloth curtain FPS speeded to 1/1,000 sec, and with X-synch at $\frac{1}{60}$ sec. This is a performance standard that was reached very long ago, and it really is time for some shutter improvements.

VIEWFINDERS

Originally the SLR viewfinder was a simple piece of glass roughened on the side facing the lens. This groundglass showed the image surrounded by the blackness of a four-sided rectangular frame, within which it was possible to focus at any point in the picture field—not just in the middle—without any internal distractions to interfere with the photographer's quiet composition.

This was before the optical problems in producing short-focus, wide-angle lenses for the SLR were solved. It was found that these wide-angle lenses were very hard to focus on such screens. For most of the history of SLRs, the mechanical movement of the mirror prevented the use of short-focus lenses, that is, any lenses whose back elements poked into the body more ´deeply than the up-and-down arcing of the mirror would permit. For about the first 20 years of 35mm SLRs this meant no lenses shorter than the 50mm "standard" focal length popularized by rangefinder-focusing 35mm, and most 35mm SLRs actually employed 58mm lenses as their shortest focal length.

A Frenchman named Pierre Angenieux solved this problem by designing a telephoto lens that was shorter than its effective focal length. This reversed-telephoto design gave a longer lens-to-film distance, and a consequently shorter effective focal length. The result was popularized as the "retrofocus" lens. Today, any lens with a focal length less than 50mm that shows an image via the mirror of a 35mm SLR is a retrofocus. Great, we had wide-angled vision at last. But not so great was the poorer focusing caused by smaller viewfinder image sizes.

Because wide-angle lenses produce such smaller images in the viewfinders, something was needed to improve the accuracy of SLR focusing. This addition to the SLR focusing screen was a pair of opposed circular prisms that were carefully recessed into the rough side of the groundglass, so that the centers of the two prisms met at the focal plane of the camera. These are split-image rangefinders without any moving parts. If a straight subject line crossing the prismatic cut-line isn't in focus, its two halves are shifted sideways. This gives an easily recognizable indication of distance focus, providing that there's a straight line in the subject. Broken line means an out-of-focus image; unbroken line means an image sharply in focus.

The trouble is, not every subject has straight lines for focusing, and even when they do, it's very difficult to do straight-line focusing with any moving objects. As a result, microprisms were added to the screen as a focusing aid, as they do not require straight lines to show focus. Three-sided microprisms produce six out-of-focus blurs, and four-sided microprisms, now almost universally used, bring eight out-of-focus blurs. And, because the prisms are so small and so tightly packed, you get an unpleasant shimmering effect when the focus is off, and this turns clear when the image is in focus.

Professionals tend to prefer the straight uncluttered groundglass whenever possible, to accept microprisms as

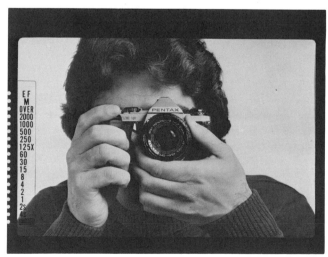

In any 35mm SLR, viewfinder information is vital and should be clear and easily understood. The camera should tell you as much as necessary and no more, and it should keep the information from cluttering up the image area. One drawback to LED displays, such as the one on this Pentax, is that they do not distinguish sufficiently between acceptable and unacceptable over- or under-exposures.

a second choice, and to dislike the sometimes distracting split-image focusing method. Amateurs have just the opposite order of preference, and nearly always choose split-image focusing as their favorite SLR screen. This is clearly shown by the fact that after about ten years of experimentation with different screen configurations, almost every SLR in current production offers a screen with central split-image focusing prisms surrounded by a microprism focusing collar as standard equipment.

Split-image and microprism focusing provides considerably better accuracy than a plain groundglass with short-focus lenses. For focal lengths of about 100mm and longer, the groundglass can be as good, or even better when the lens is reasonably fast. With something like a 100mm f/2.8 or a 200mm f/4, the groundglass can hardly be bettered. If you've had more than passing experience with an SLR you know that when the lens is manually stopped down you reach a point at which half of the prism faces suddenly black out. This is because these prisms have been optically engineered so that only rays from some medium aperture, usually between f/5 and f/7, are actually deflected by all of the prism faces so as to reach the camera eyepiece. You can determine this focusing f-stop for your SLR screen by setting the camera lens to manual and carefully observing the effect of closing down until a blackening of half the prism faces is observed. Now slowly open the diaphragm up again until all of the prisms are bright. This is the focusing aperture, as determined by the optical geometry of the camera screen. If you try the same experiment with a number of different lenses you'll find that the

result is the same for an f/1.4 or an f/2.8, in fact for any lens whose maximum aperture is greater than the focusing aperture. Of course, if the lens doesn't open up to this focusing aperture, the screen prisms will always remain blacked out, which is exactly what happens when using very long-focus lens systems with apertures of f/8 or smaller.

Exchangeable focusing screens

Two systems of user-exchangeable focusing screens are provided by modern SLRs. Fully modular professional cameras like the Nikon F, F2, and F3, and the Canon F-1, have removable pentaprisms, permitting interchangeability through the top of the camera. A small number of SLRs with fixed pentaprisms offer screen interchangeability through the lensmount. Models with this feature include the Contax RTS and 139, the Olympus OM-1 and OM-2, and the Nikon FE. (A number of companies will make screen substitutions through their service departments. Minolta will do this for their XD, XE, and XG models, and Canon for their A-series.)

It is important to note that front-exchangeable screens—via the open lensmount—give the photographer focusing options only. You may want microprisms or split-image focusing, a plain groundglass or one with ruled lines, and so on. Top-exchangeable screens for cameras with interchangeable prism viewfinders are usually combined with glass and/or plastic Fresnel-type field lenses providing optimized illumination for lenses of very short or very long focal length, in addition to all of the lens focusing options. They are usually easier to interchange than the front-exchangeable type.

Focusing screens

In common with other professional cameras, the Nikon F3 offers several types of interchangeable focusing screens in addition to the standard Type K screen. Nikon's range is currently the most extensive, with 20 screens for use with different lenses or for different subjects, and the simplest to change yourself.

Type K

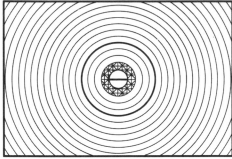

Type K: for general photography.

Type A: matte fresnel field with split-image rangefinder circle and reference spot. For general photography.

Type B: matte fresnel field with reference circle. For general work.

Type C: fine matte field with cross-hair reticle. For high magnification work.

Type D: fine matte field. For long telephoto lenses or close-up work.

Type E: matte fresnel field with etched vertical and horizontal lines. For architectural work with PC lenses.

Type G: clear fresnel field with microprism focusing spot. For work in dim light.

Type H: clear fresnel field with microprism pattern over screen. For focusing in dim light.

Type J: matte fresnel field with microprism focusing spot. For general work.

Type L: similar to A but with split image rangefinder line at 45° angle. For focusing on a subject with horizontal and vertical lines.

Type M: clear surface with double cross-hair reticle and scales. For high magnification photomicrography.

Type P: matte fresnel field with split image rangefinder divided at 45° angle and etched vertical and horizontal lines. For general photography.

Type R: matte fresnel field with split image rangefinder and etched vertical and horizontal lines. For architectural work.

Type T: matte fresnel field with outline for TV format. Used when preparing slides for TV broadcasts.

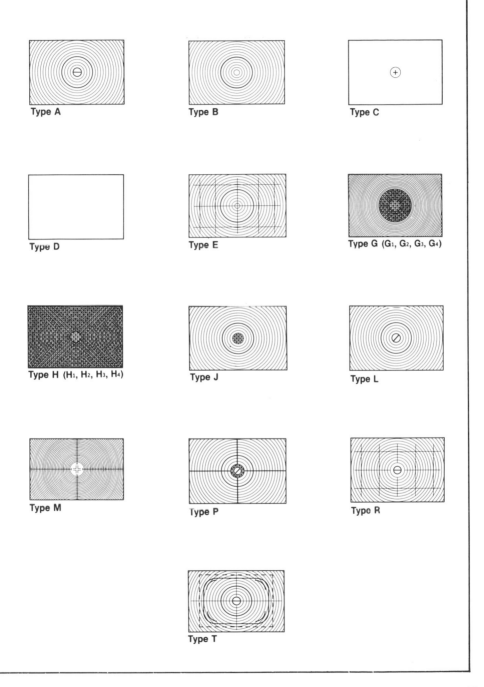

Type A

Type B

Type C

Type D

Type E

Type G (G₁, G₂, G₃, G₄)

Type H (H₁, H₂, H₃, H₄)

Type J

Type L

Type M

Type P

Type R

Type T

Interchangeable finders

Interchangeable finders can offer considerable advantage for certain types of work. The simplest is usually called a plain pentaprism. It replaces the type of pentaprism that contains metering and/or electronic automation provisions. This is the type of viewfinder most prefered by cautious professionals who prefer using a hand-held meter. Another popular viewfinder is the waist-level type. These units have no metering provisions either: their tops open to provide a hood into which you

Magnification and focal length

With an SLR, like all such telescope-like instruments since Galileo, telescopic magnification is given by the focal lengths of the objective (here, the camera lens) and of the eyepiece. This can be calculated using a simple formula:

$$M = F_{cl}/F_{el}$$

Where F_{cl} is the focal length of the camera lens in use, F_{el} is the focal length of the camera's eyepiece lens, and M is the telescopic magnification given when the camera lens is set at infinity (∞) focus.

Because SLR viewfinders are designed to work with properly corrected human eyes—with or without corrective eyeglasses—their eyepiece lenses can't vary more than a few millimeters on either side of a standard eye-lens focal length of 58mm. The very shortest eyelenses might be 55mm, the longest perhaps 62mm, but 58mm is most common. You can test this if your SLR instruction manual lists the telescopic magnification for a 50mm lens. For example, many will state that the magnification with a 50mm lens is 0.86X. This means that $0.86 = 50/F_{el}$, which is the same as $F_{el} = 50/0.86 = 58mm$. (But a word of warning: such calculations are not necessarily completely accurate because the focal lengths of standard lenses are commonly permitted to vary within plus-or-minus 4%, meaning that a piece of glass engraved "F = 50mm" might actually be as long as 52mm or as short as 48mm—quite a difference.)

These maths don't bode well for focusing with such wide-angle lenses as the ubiquitous 28mm lens. In this case: $M = 28/58 = 0.48X$, meaning that in a typical instance, the viewfinder image obtained with a 28mm wide-angle lens is a bit less than one half of life-size. In other words, you can see more than twice as much subject detail with your naked eye as you can with a 28mm wide-angle lens on an SLR.

Of course, things are a lot more favorable if you turn them around. Take the popular 135mm tele-lens focal length:

Here, $M = 135/58 = 2.33X$, meaning that you've got a small telescope with a magnification of just about two-and-a-third times what the unaided eye can see from the same distance. This is also why it is so much easier to focus long- than short-focus SLR lenses. Plain old ground-glass screens might be all that's needed for 135- or 200mm tele-lenses, but not for 28mm or shorter wide-angle optics.

Viewing and eyesight correction

Simple near- and far-sightedness can be compensated by adding dioptric lenses to the camera eyepiece. This is really not the best idea, however, unless you're already wearing recently-prescribed eyeglasses. Remember that even when you're using a camera, most of your seeing is not done through its viewfinder. If too much correction is added to the camera you end up constantly fumbling with your eyeglasses.

Some slight eyesight correction is often needed today because of a widespread design defect in many, if not most, SLRs. Simply stated this flaw causes the finder-screen image to appear at one optical distance (in most cases one meter, or about 40in from the eye), and viewfinder information scales to appear at a different (usually much closer) optical distance. Because of this, many people can benefit from the addition of a weakly negative (if nearsighted) or positive (if farsighted) eyepiece correction lens. Excellent advice is usually obtainable by bringing your SLR along when seeing an optometrist, but you can find out by experimenting with several eyepiece lenses in the camera store.

Astigmatism should always be corrected by eyeglasses, and not by camera eyepiece corrector lenses because no such correction can work for both horizontal and vertical pictures (unless the corrector is supplied in a complicated rotary mount of a type that is no longer generally available). Many individuals have a small amount of astigmatism that isn't enough to interfere with normal vision, and is therefore left uncorrected by the optometrist. This can cause problems, however, because out-of-focus points will appear as small lines.

can look down on to the screen. A small magnifying lens is built into the hood, and can be folded out.

The so-called sports finder usually has no metering but allows you to work without your eye at the eyepiece and still follow the action.

For macro or micro work, or any time that absolutely critical focus must be achieved, a high-magnification finder is very useful. These units, also without metering, usually provide about 6X viewfinder magnification and also often offer variable dioptric eyepiece adjustment for users requiring it but who prefer to work without eyeglasses. Some manufacturers also offer viewfinder options that have simple match-needle metering only, or else more expensive finders that operate servo-motors to convert the camera to automatic-metering operation. Many such viewfinders, and the fixed viewfinders on good quality automatic 35mm SLR, have viewfinder-window shutters. These are critical to the function of an unattended (remotely operated) automatic SLRs because they prevent light from entering the viewfinder window and affecting the metering system.

CANON

against F1

Canon's current 35mm SLR camera line comprises a quartet of medium compacts, the A-series, and one bigger, heavier, professional camera, the Canon F-1. There are two outstanding cameras from Canon today, the Canon AE-1, a shutter-priority auto-exposure SLR with full manual metering and the marvelous Canon A-1, the "hexa-cybernetic" multi-mode camera that combines all auto-exposure methods, plus full manual metering.

Before these two models are described, the F-1 deserves some attention. Canon F-1 was first issued in 1970, and then slightly upgraded in 1976. This is one of the very few so-called "full-system" SLRs that interchange everything, including top-section prisms, viewfinders, and focusing screens. It's also the only contender to have been taken seriously as competition for the Nikon F and F-2. Against Nikon's bigger battalions of lenses and accessories, Canon F-1 offered a manual TTL meter inside the camera body, so that you could switch finders without losing the TTL light meter (as happened with Nikon F and F-2, whose light meters were parts of different exchangeable viewfinders). But against this convenience, the Canon F-1 metering system never caught fire with the professionals, mainly because of its low sensitivity and sluggish meter needle. This was—and still is—a cadmium sulfide (CdS) system. In addition, some photographers did not like the light metering system that crowded the whole reading into a small rectangle marked on each of the F-1's interchangeable screens. This rectangular central reading represented about an eighth of the full picture area. Some highly technical photographers liked it because it permitted separate (but slow) measurements of the light in different parts of the picture.

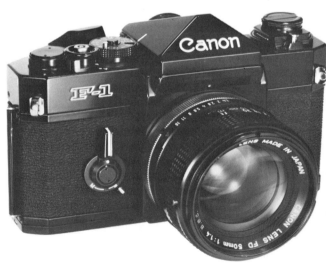

The Canon F-1 was the first 35mm SLR to compete in the professional market with Nikon. Designed as part of a system, it is a rugged machine with many operational advantages and good reliability.

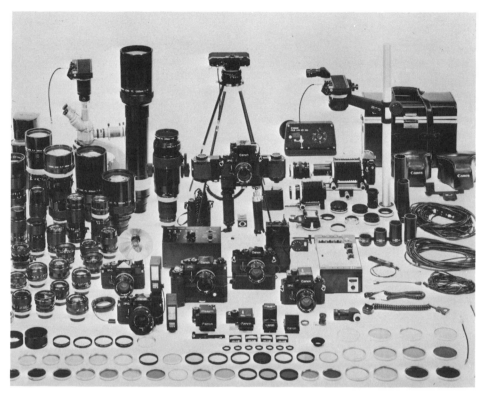

The Canon system is matched in range and variety only by Nikon. Here the Canon F, their professional camera, is shown with accessories, including more than 40 lenses that also fit Canon A series cameras.

This was not so good, however, for press and other photographers who have to work quickly.

Some photographers consider that one of the Canon F-1's interchangeable prism units, misnamed "Speed Finder," alone almost justifies buying the camera. It has a large rotatable eyepiece section that can be pointed straight back or straight up. This lets you position the camera practically anywhere, even right up against a wall, or held over your head, with full vision of the finder screen. Also worthy of praise is their interchangeable F-screen—one of nine—with central microprisms for focusing fast lenses. It's the only screen that gives a real focusing advantage for lenses faster than f/2.8.

Canon A-1

For sheer technological sophistication, the Canon A-1 is hard to beat, and it remains a matter of debate as to whether Nikon's latest F-3 even rivals the A-1 on this level. The A-1 is the ideal

The Canon A-1 is a "do-anything" automatic. It offers three automatic modes: aperture priority, shutter priority, and fully programmed automation, and a fully manual mode.

camera to recommend to anyone who takes photography seriously and takes a variety of subjects—everything from action shots to macro work. The Canon A-1 has its six operating modes that will cover any working situation:

(1) Shutter-priority automatic; you set the speed and A-1 finds the f-stop;

(2) Aperture-priority automatic; you pick the f-stop, and the A-1 sets the shutter speed;

(3) Programmed automation; set the A-1 to "P," and it selects f-stop and shutter-speed combinations to match the subject brightness;

(4) Stop-down automation; older Canon "FL" lenses and adapted non-Canon optics get correctly automated doses of shutter-timing after you stop the lens down to the exposing aperture;

(5) Automated flash; pick the f-stop you want to use on the calculator dial of one of Canon's so-called "dedicated" flash-units and, as soon as the electronic unit is switched on and charged up, it sets the A-1 (or AE-1) shutter to its 1/60sec synch speed, and the FD lens to the f-stop you chose; and

(6) Full manual TTL metering; a small red "M" lights up inside the finder to tell you that you're on manual; metered exposures are shown in A-1 digital display, but you set the exposure.

With a range of settings like this, the A-1 comes with a 100-page instruction manual, which ideally you should master before taking it out into the field. The great success of this multi-mode design (Canon A-1's are being used by a small but growing group of working professionals, especially in newspapers and magazines) make nonsense of the competitive counter-claim that Canon A-1 is "too complicated," or that it's simply too much to be true, and that it doesn't work.

It works, and very well, even when set at p-for-programmed automation. One quibble is that color-film speed indexes seem to need higher settings on the A-1 than on other TTL-metering SLRs. But you should always make your own ratings experiments with any TTL-metering camera.

All of the A-1's "alpha-numerical" readout appears below the black borders of the frame, and if this is still a distraction, Canon has provided an on/off switch. If you do want the readings on, you will have comfortable visibility at all times, because the LED readout display automatically adjusts its brightness in relation to that of the viewfinder screen, to maintain comfortable visual contrast.

Finally, although it is the most highly automated of all SLR's, the Canon A-1 provides the three essential automation overrides demanded by thinking photographers. These are (1) full manual TTL metering, (2) a plus-or-minus exposure compensation scale (which goes ±2 f-stops, in 1/3-stop jumps), and (3) a metering memory lock that works in all modes.

From a professional point of view, one way to look at the question of exposure automation and the long-term usefulness of any auto-exposure camera is to look at how well it works in manual. There is no doubt that the A-1 satisfies this with lots of good, practical features.

Canon AE-1

No other precision camera, maybe no other camera of any sort, has ever sold so many units so rapidly as the AE-1. Eighteen months after its introduction in 1976 Canon had made and sold over 1 million AE-1's. Now the figure is approaching 4 million. Exactly what makes this camera so popular is not difficult to see, and apart from the professional Nikon F-3 and its electronic multi-mode sister, the Canon A-1, the AE-1 is the best 35mm SLR camera and best value for money you can get.

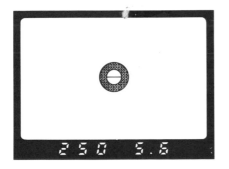

Canon A-1 uses LED digital readouts of aperture and f/stop. If there is a drawback to the design of the Canon A-1, it is the greater battery power that LEDs require over a LCD display. LEDs, however, adjust well to a wide range of ambient light conditions.

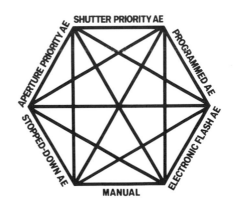

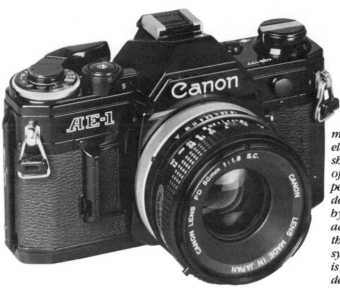

A shutter-priority machine with an electronically governed shutter, the Canon AE-1 offers an irresistible price/performance ratio that deserves serious attention by any camera buyer. In addition, it gives access to the complete Canon system. But one drawback is its almost total dependence on batteries.

For a very modest price, you will get a reliable, no-nonsense shutter-priority SLR with electronic timing and electromagnetic release that opens the door to adding accessories from the vast Canon system, such as dedicated flash units, powerwinders, and so on.

The AE-1 meter uses SPD cells to make center-weighted readings, and has a range of EV 1 (1sec at F/1.4) and EV 18 (1/1,000sec at f/16) for ASA 100. The viewfinder reading uses a galvanometer needle and, to guard against mistakes, red LED over- and underexposure warning lights. On automatic, the setting can be overridden by means of a backlight button, which increases exposure by $1\frac{1}{2}$ f-stops. The AE-1 can transfer to fully manual operation by uncoupling the FD lens from its automatic setting; then you can adjust shutter and aperture manually.

NIKON

Nikon is entering the 1980s with four 35mm SLRs, and the world's largest camera-system backup of lenses and accessories. The Nikon picture is complicated at this moment because the great Nikon F2, last of the old, completely mechanical Nikon SLRs that have dominated professional 35mm photography for nearly two decades, is now being phased out in favor of the Nikon F3.

The Nikon F series

Nikon became the leading professional 35mm machine when the famous Nikon F (introduced in 1959), took the title away from Leica's legendary M2 and M2 rangefinder-focusing champions in the mid-sixties. Nikon F was an extraordinarily rugged camera that permitted total interchangeability of almost everything. As a matter of fact, the only basic parts that you couldn't separate were the shutter and mirror-box. This was the Nikon F camera body, to which you could attach any kind of lens or macro-focusing accessory at the front, optional long-length film magazines and even a Polaroid back at the rear, motor drives at the bottom, and prisms, viewfinders, and focusing screens at the top. A professional could attack this body from all sides, to create exactly the camera needed for a specific job, taking it apart and putting it back again differently whenever changes in optics, viewfinding, film capacity, or firing mode were wanted. It was almost a photographic do-it-yourself kit. And the F stayed in production for twelve years, from 1959 to 1971.

One way that Nippon Kogaku kept the Nikon F in production for so long was to exploit their own modular system of interchangeable units to permit piecemeal modernization. In this way, they were able—to a great extent—to keep pace with technological progress, while keeping to the same camera body. Professional as well as amateur photographers applauded what was an obviously effective answer to the curse of artificially planned obsolescence. The best example of how this worked

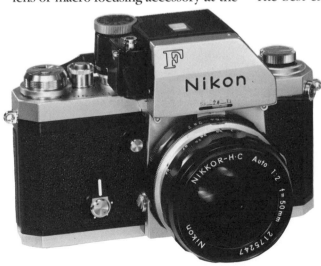

The Nikon F series cameras are classic 35mm SLRs that have yet to be bettered in many people's eyes. The original modular 35mm SLR, the F is an extremely durable brass machine that can be adapted to numerous tasks. It is also an extremely reliable camera, and many battered Fs are still giving good service. A very special advantage of the F is its 100% accurate viewing of the entire image area.

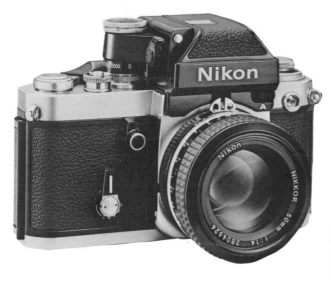

The successor to the F, the F2, lacks its hair-splitting viewing precision but added some electronic sophistication and a better back. While not as legendary, the F2 is quite rugged for professional use, and early problems in its motor-drive have been ironed out.

can be seen in the history of Nikon metering systems.

When the Nikon F began, it was normal to have a camera in the hand and a light meter in the pocket. Then, because of the development of new and very sensitive battery-powered CdS (cadmium sulfide) photocells, the old Zeiss Ikon idea of building light meters into the camera bodies became feasible. To answer any such craving for convenience, Nippon Kogaku offered a special CdS "Photomic" prism head for the Nikon F, with a built-in light meter that read light through its own small illuminator window at the front of the housing. You took off your regular eye-level prism, and the new Photomic substitute transformed your Nikon into

a camera featuring an onboard metering system.

Then came inboard metering, measuring light coming through the camera lens, actual image-exposing light rays. Through-the-lens light metering had been hinted at earlier, but it first appeared in 1963, when Topcon unveiled their "measuring mirror" design, in which a pattern of CdS cells was actually integrated with the focusing mirror. Accordingly, Nippon Kogaku introduced the first of their TTL-metering prism heads, the Photomic FT, in 1962. This was followed by several successively improved models, and a slight lens modification so that they could cross-couple to the lens f-stop as well as to the camera shutter speed.

All of this was fine until, in 1970, another competitive Nikon-style fully modular procamera appeared. This was (and still is!) the Canon F-1, which had one important difference. Its CdS meter wasn't part of the exchangeable prism finder unit, but was built right inside the camera body. Unlike the Nikon, you could change finders and not lose your TTL light meter. Consequently, Nikon introduced the F2. But it was obvious that this new model was an interrupted built-in meter design, for although it had a system of exchangeable viewfinders and meter-prism heads similar to the F's, the battery compartment was conventionally located in the F2 baseplate.

But, with lots of help from Nikkor lenses, and some technical improvements, the F2 succeeded in defending Nikon's dominance of the professional field through the 1970s. For one thing, the F2 offered a top shutter speed of 1/2,000sec, and X-synched electronic flash at 1/90sec. Besides, it was marketed with three different eye-level prism heads, as three different models.

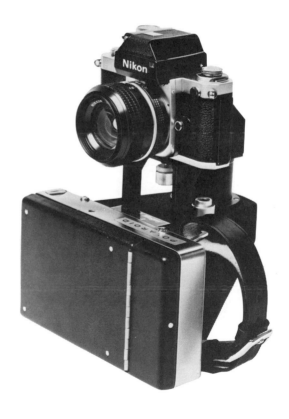

Nikon is the only company currently making a Polaroid back, the Speed Magny, for a 35mm SLR. It greatly reduces the amount of light reaching the film due to its optical system, and a number of professionals have customized Nikon Fs with J33 rollfilm backs for previewing flash lighting and composition on Polaroid film.

If you chose a non-metering standard pentaprism, it was the Nikon F2. Exactly the same camera with a CdS-type Photomic Finder for TTL light readings became a Nikon F2A. And you could fit the same body with an SPD-type TTL meter, to create the Nikon F2AS, with digital-dot LED readout.

Nikon F3

The answer to all this is here and now. The new Nikon F3 is the first genuine procamera with topsection exchangeable prisms, finders, and screens, to feature auto-exposure control (plus a manual metering mode) with all viewfinders. (Please note that Canon F-1 provides only manual metering, and this with all finder units save their open four-sided focusing hood. Nikon F3 operated either automatically or manually, and with all of its finder units including the open hood gizmo.) The F3 is a fully modular professional camera, with heavy emphasis on motor-drive operation, and can probably be

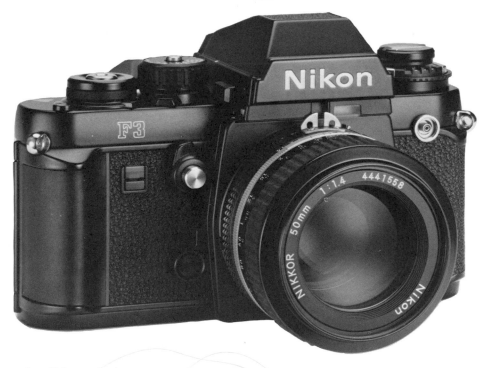

It will be some time before the F3 becomes generally accepted by working professionals. They are leery, and their Fs and F2s aren't easy to wear out. It would not surprise anyone to see Nikon reissue the F2, but it is unrealistic to ignore the metering and motor-drive improvements of the F3.

less good on metering than A1 ?

considered to represent the state-of-the-art in professional 35mm photography today. It introduces at least two fundamental design innovations: it's the first procamera to employ fully electronic shutter-timing and release, and to feature exposure automation (by the aperture-priority method).

The Nikon F3 TTL light-metering method is new and interesting. About 8% of the light striking its reflex focusing mirror passes straight through a central pattern of about 50,000 tiny "holes" in its front-surface aluminized reflective coating. These light rays now encounter a second, piggy-back mirror that rides behind the main mirror, folding flat whenever it moves for an exposure. This secondary mirror (which has a very complex surface design) reflects the incoming light rays down to an SPD mounted in the base of the F3 mirror-housing. (In a way, this represents the older, now-discontinued spot-measuring methods of the Zeiss Contarex and the Leicaflex SL. In F3, however, it gives a full-field center-weighted reading.)

One good spin-off of the F3 scheme is that the bottom-mounted SPD serves to measure light reflected directly from the film surface for the camera's auto-flash exposure mode. This is very much like the system pioneered in the Olympus OM-2 and OM-2N, except that in the Nikon F3 no measurements are made during long ambient-light exposures. Instead, all readings made via the main and secondary mirrors are locked in and used as taken, and the film-surface reflection is measured only for the comparatively brief-duration of electronic-flash exposures.

But this system gives only adequate meter sensitivity, giving an ASA 100 threshold reading of EV 1 (1sec at f/1.4). Other SPD cameras improve on this by about three stops. The Canon A-1, for example, measures down to EV 2, which is 4sec at f/1.4. Converting this data for ASA 100 film, you have the Nikon F3 measuring exposures down to 1/4sec at f/1.4, and Canon A-1 to 1sec at f/1.4.

Two electronic components long known to the watch and clock industries have also entered the circuitry of the Nikon F3, to some advantage. One is a quartz crystal that controls the accuracy of the oscillator that controls the accuracy of shutter-timing in the F3 manual mode, a worthwhile improvement previously used by Yashica in their Contax 139 Quartz model. Nikon F3 is also the first camera of any type to drop LEDs in favor of LCDs for the internal viewfinder shutter speed (and manual-metering $+/-$) displays. LCDs use far less electrical energy than the LEDs used up until now for most SLR camera viewfinders.

LCDs are mirrors, not light sources. They turn bluish or blackish to reveal alpha-numerical signs, but these can only be seen if you have some ambient light. The Nikon F3 provides this light two ways. First, there's an illuminator window in the front of the camera. This works most of the time, but when it doesn't there's a second source, a little electrical "grain of wheat" lamp that you can turn on by simply pressing a button.

Because its shutter is electronically timed, and electromagnetically released, the Nikon F3 joins the new list of battery-dependent SLRs—no current, no camera. Well, almost no camera, because F3 does have very limited mechanical backup. In F3 this takes the

form of a small front-mounted lever, that is a mechanical shutter release providing two backup settings: 1/60 sec, and T-for-time. This is not really adequate support in a so-called professional camera, but the T setting is very useful. Long camera exposures drain the batteries, because the electromagnet (or magnets) have to be kept energized in order to hold the second section of the focal-plane shutter back. But with the T setting, long time exposures are made manually, using no battery power at all.

Another aspect of the Nikon F3's battery dependency is also worth noting. When the professional motor-drive unit MD-4 is used, its heavy-duty integral battery-pack takes over all F3 current supply, so you don't even need the costly little S76 silver-oxide cells. The motor-drive MD-4 gives just under 4 fps with AA alkaline penlight cells, 5 or 5.5 fps with a nicad rechargeable pack, 6 fps if you lock the mirror out of the way, and electrical auto-rewinding at the end of the roll.

F3 departs from Nikon procamera tradition in two significant respects. Although it accepts all current Nikkor lenses and front-mounted camera accessories that fit into the Nikon

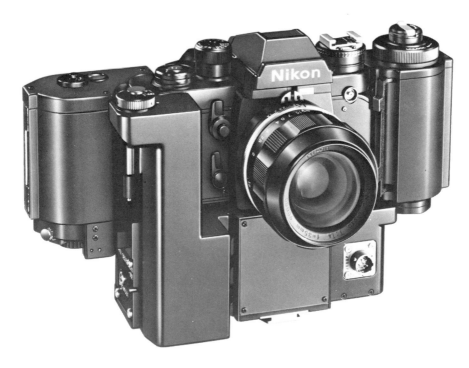

NASA's Nikon F3 is essentially an off-the-shelf machine with some modifications. It is fitted with a 35mm f/1.4 lens, motor-drive and bulk film back; the operating controls are larger to facilitate use with gloves.

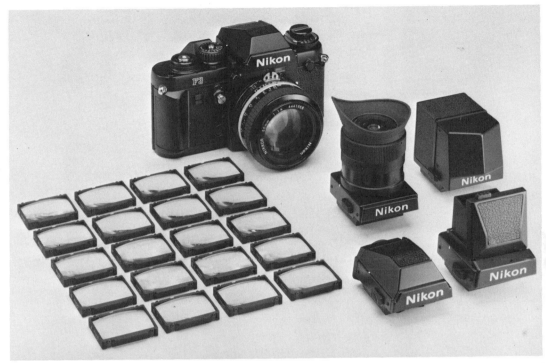

Accurate viewing is perhaps the biggest advantage of the SLR, and it is worth capitalizing on this by adapting your viewing system for each task. Nikon and Canon offer the largest range of viewfinders for shooting where speed or critical viewing is necessary. Also, interchangeable screens help you to maximize focusing accuracy with different lenses. A split-image rangefinder screen, for example, helps focusing with a wide-angle, whereas a plain ground-glass is best for long lens work.

bayonet lensmount, all other inter-changeable units are new for the F3. This means a new F3 metal-frame size for its 20 interchangeable viewing screens, although these are duplicates of the F2 assortment, and a new top-frame saddle for all of the F3 prisms and finders. (Four were revealed at the time of introduction: standard eye-level pentaprism DE-2; long eye-relief Action Finder DA-2; four-sided, folding Waist-Level Finder DW-3; and 6x High Magnification Finder DW-3.) Additionally, the F3 won't accept previous F/F2 mo-

tor drives and accessory film maga-zines—an obvious problem for current Nikon owners.

In effect, this means that the Nikon professional's principal investment—in optics—has been protected, but it also means that getting the F3 will mean buying new mechanical and viewfind-ing accessories.

If all of the above isn't enough to convince you that the F3 is the most advanced professional camera avail-able, then you only have to look at Ni-kon's unequalled back-up range of

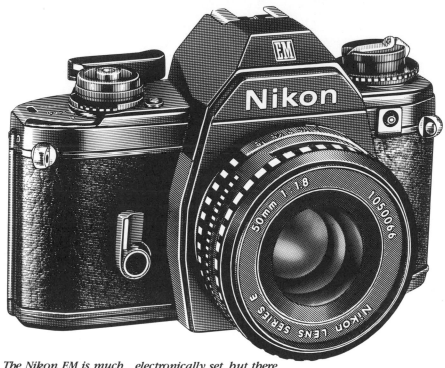

The Nikon EM is much smaller and lighter in weight than most 35mm SLRs. Shutter speed is automatically and electronically set, but there is a limited manual override for two speeds: B and 1/90sec. Both are battery dependent.

lenses and accessories. Nikon has long established itself as an innovator in this area, and the likelihood is that if a piece of equipment isn't in the Nikon range, you won't find it in any 35mm SLR system. Currently, Nikon has over 60 Nikkor lenses with outstanding specialist optics in every category. For macro photography, for example, they offer an excellent 105mm f/4 lens; but if price is no object, then the 58mm f/1.2 is unrivalled. Nikkor standard lens range is AI (aperture indexing) full-aperture metering for manual and autoexposure modes on current Nikons. With the introduction of the mass-market Nikon EM, however, Nikkor has added some cheaper E-series lenses to the range; they have neither the performance nor the ruggedness of the standard line.

Nikon FE

If you want to enter the seemingly limitless world of Nikon accessories for only a modest price, your best choice is the Nikon FE. Introduced in 1978, the FE is an automatic aperture-priority camera with optional manual mode. Basically, it is the same as the all-manual FM: the all-metal casing is the same, and the center-weighted SPD meter range is EV 1 (1sec at f/1.4) to EV 18 (1/1,000sec at f/16 at ASA 100). The

most important difference is in the viewfinder read-out which is an old-fashioned galvanometer needle (instead of a digital display), which enables you to assess any over-or underexposure more accurately, and to work within the limits of the film you are using. In addition, the FE takes 3 interchangeable screens through the lensmount.

For automatic use, the camera includes a $+/-$ 2 f-stops exposure bias and a memory lock. The FE is not as popular as it might be; yet it combines the quality and reputation of Nikon with a very competitive price.

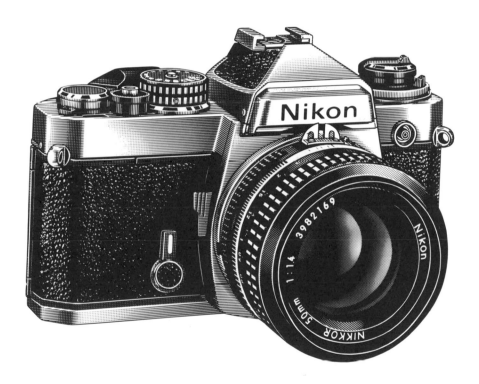

While lacking in glamour, the Nikon FE is a highly dependable camera with aperture-priority automation. It makes an excellent second camera for the professional, while for the amateur it is a good introduction at reasonable cost to the full range of Nikon equipment. The FE has limited but useful interchangeable screen capability.

OLYMPUS OM-2N

There are two trends currently dominating 35mm SLR design and technology—automation and miniaturization. In both, Olympus has led the field. Their first compact SLR appeared in 1972, and what made it and the current OMs so impressive was that it had a full-sized reflex mirror, an extra-large viewfinder, and the latest features, including TTL metering. The full-sized mirror avoided the cut-off experienced with long-focus lenses on a lot of SLRs bigger than the Olympus, and has a high viewfinder magnification (just over 90% life-sized with a 50mm lens). In addition, the OMs are some of the quietest 35mm SLRs on the market.

This compactness, however, was not achieved without certain changes, which some describe as sacrifices. The shutter speed dial was moved onto the front of the camera just behind the lens-mount, crowding focusing, aperture, and shutter controls together in a way that is not everyone's choice.

Currently, Olympus has three models in their ultra-compact style: the OM-10, OM-1N, and the OM-2N. For several reasons, the most notable of the trio is the OM-2N.

The Olympus OM-2N is an aperture-priority automatic, with one of the most remarkable, and most complicated, TTL metering systems in the annals

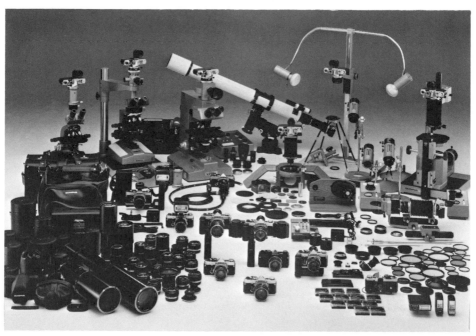

Comparatively speaking, the Olympus system is a new competitor with Nikon and Canon, and in many people's eyes it has yet to prove itself. Of particular note, however, is some of the Olympus flash and macro equipment.

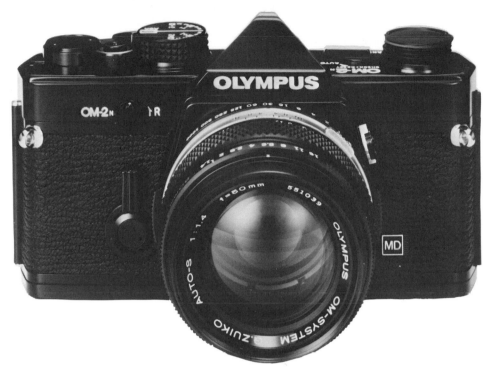

Olympus' OM-2N offers a high degree of sophistication and system flexibility which, with its overall weight reduction, has enticed some working professionals. But because the Olympus system is scaled down, it is not as rugged as some other systems and must be treated with extra care.

of 35mm SLR design. Two SPDs in the downstairs mirror-housing do the actual light metering, and a second set of CdS cells, in the upstairs prism housing, operate a galvanometer needle to provide viewfinder-imaged exposure information. Those bottom-mounted SPDs are aimed toward the film in or der to measure light actually received in the camera's image plane. For exposures between 1/125 and 1/1,000sec the photodiodes measure a pattern of white reflective patches printed onto the front curtain of the focal-plane shutter. For shutter speeds between 1/60 and 1/15sec the sensors react partly to reflections from the shutter curtain, and partly to light reflected from the front surface of the film. At 1/15sec or longer the whole reading is based on film-surface reflections.

In all cases of long exposure—meaning longer than 1/60sec—the Olympus OM-2N sensors continue to read light reflected from the film surface during the course of the exposure, holding the FPS curtains open until the correct light dosage is received. The well-publicized advantage that you'll get is a correctly exposed picture even if light conditions change during the exposure. Thus, the finder-imaged shutter speed (as predicted by that special pair of upstairs CdS cells) may be made longer or shorter, if the downstairs duo of SPDs so dictates.

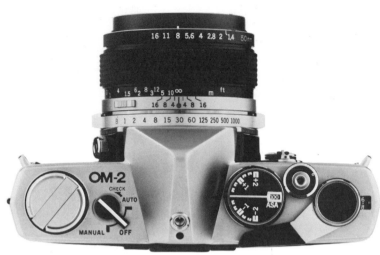

The OM-2N has two exposure modes—aperture priority automatic ("Auto") and manual. In both cases, the light metering is done by two SPDs located in the base of the mirror box which measure light at the image plane. In the automatic mode, they will continue to measure light during the exposure and adjust the speed of the shutter to give the correct exposure.

This off-the-film light measurement makes automatic-flash exposure control possible, without having to rely on now-conventional flash-mounted light sensors. Instead, the OM-2N's twin SPDs take over this function, signalling the "dedicated" (Olympus-built) electronic-flash unit to switch off, as soon as a correct light dosage has been received in the focal plane. All other auto-flash systems, with the exception of Nikon F, depend upon light being received back from the subject by a sensor eye mounted on the camera and pointing exactly in the lens direction. (In most cases the sensor is part of the electronic-flash unit itself, but some accessory sensors are made for more flexible positioning of the unit.)

Two problems occur with external sensors: their readings can't possibly match up with the angles of all the camera lenses or the effects of the filters you're likely to use, and they have to be carefully aimed or adjusted. In most circumstances, they will work well; but the Olympus way is better because it responds to what's actually happening to the film during exposure. When it measures sufficient light for correct exposure, it signals the "dedicated" (meaning electronically integrated) flash unit to stop firing.

The Olympus OM-2N shutter is electronically timed and completely battery-dependent at all instantaneous settings. Only B-for-bulb exposures operate mechanically, without battery power. This doesn't give you any effective backup, but it's still a useful feature because long Bulb exposures eat up camera batteries when the electromagnets have to hold the second curtain of the FPS open for the whole duration. In its auto-exposure mode this FPS gives stepless variable exposures from one to 1/1,000sec.

In its auto-exposure measuring mode the TTL light meter is rather remarkably—some say uselessly!—sensitive, giving an ASA 100 metering range from EV 6 (two minutes at f/1.4) to EV 18 (1/1,000 sec at f/16). The manual-metering ASA 100 threshold is a considerably less sensational EV 1 (one sec at f/1.4). The only automation

override is a plus-or-minus 2 f-stop exposure compensation dial, calibrated in 1/3-stop changes. This dial is located on the right-hand side of the top deck, just where all of your previous cameras had their shutter-speed selectors. A widely shared defect of most current SLRs is the lack of any kind of finder-imaged warning or reminder that some exposure compensation has been applied, so try to remember to reset this. The Olympus OM-2N takes 13 focusing screens that go in and out through the open lensmount. In its auto-exposure mode a vertical shutter-speed scale appears just inside the left-hand edge of the viewfinder field. When you flick the switch for manual operation, this scale moves out of the field, leaving only the galvanometer needle with its set of "+" and "−" alignment marks.

Olympus supplies a power-winder and a motor-drive for OM-1/OM-2N models, both a bit faster than most. The power-winder will give 3 fps if you hold the button down, and the motor-drive can run at 5 fps (assuming a shutter speed of at least 1/125sec). There's also an accessory 250-shot magazine back, with a lot of optionally related hardware.

Olympus has over 30 "Zuiko" lenses in their system, ranging from an 8mm circular fisheye to a 1,000mm f/11 telelens. Olympus has for some time offered a 28mm f/2, and introduced the world's first 24mm f/2. Other useful optics include a 55mm f/1.2, and 18- and 21mm ultra-wide-angles that stop down to f/3.5.

They are good, practical optics, but without the flare-fire brilliance of other lenses, like those on Canon, Nikon, Leica, or Contax cameras. There is a full range of macro lenses, microscope adaptors, copy stands, bellows, slide copiers, and so on, including something really special called the Varimagni finder. This is a right-angle telescope that attaches to the camera eyepiece, with a prism to keep things right-to-left and unreversed. What sets Varimagni apart from the herd of SLR elbow telescopes is that in addition to covering the full field at 1.5x, it can switch to 2.5x magnification of the central picture area, which makes for super-accurate focusing that is often necessary with close-up or macro work.

All in all, Olympus OM-2N is a happy choice for the serious photographer who wants a compact, light-weight body, and is willing to pay for this convenience by avoiding the kind of rough handling many photographers give their equipment.

KONICA FS-1

Japan's oldest manufacturer of films and papers—Konishiroku Photo Industries—have a long tradition of innovation in the field of 35mm SLRs under the brand name Konica. In 1967, against all trends and the general advice of the photo-industry, they introduced the Konica Autoreflex, the first auto-exposure 35mm SLR with a focal-plane shutter and family of interchangeable lenses. The success of such a move is evident today in the increasing number of SLRs with auto-exposure on the market.

Today, the Konica have the first 35mm SLR with a built-in power-winder, the shutter-priority FS-1. The built-in powerwinder is more than just a selling gimmick. They make the camera very easy and quick to use, with minimal extra weight and bulk, and reduce the risk of camera shake. Although the unit doesn't feature electrical rewind (like Canon's autofocus AF35M rangefinder), that is bound to come. The FS-1 is one of the easiest cameras to load with film—an important consideration in these days of compact cameras with tiny take-up spools. Last but not least, the FS-1 has both manual and shutter-priority operating modes, making it very versatile. Its economical price makes the FS-1 one of the best buys on the market.

A large protrusion on the right-hand side of the FS-1 body that looks something like the action grip of a Canon A-1 houses the four AA-sized penlight cells that power the FS-1 transport system, TTL light metering, and electronic shutter-timing. The FS-1 uscs a GPD for full-field meter readings with an ASA 100 meter coupling range from EV 0 (two sec at f/1.4) to EV 18 (1/1,000 sec at f/16).

Because it is a shutter-priority camera, the FS-1 viewfinder shows an f-stop scale, with LED dot-readouts plus over- and underexposure warning signals. The FS-1 viewfinder has one deficiency that Konica really should correct. There's a reflection in the viewfinder that shows about a third of the finder image floating upside-down, underneath the finder field. Some people don't see this at all, and some who do see it don't mind it. If you're going to choose a Konica FS-1, however, please look for this and decide for yourself.

The standard FS-1 package includes a very neat little 40mm f/1.8 "compact lens." This optic gives about ten degrees more coverage than a standard 50mm lens—57 against 47 degrees—and it's long been a much argued-for focal length for candid snapshooting. This particular 40mm has already received a lot of good marks for its crisp image sharpness. This is one of the more than two dozen current Konica lenses that strike a good balance between price and performance, and which include focal lengths from 15- to 80mm, and three zooms.

Konica FS-1 has an automatic film-load and advance feature that winds on to the first frame automatically. So you can practically drop the cartridge into the camera, close the back, and take pictures immediately. The built-in winder enables you to take single shots by touching the release button; hold your finger down on the button and you're shooting at the rate of about two frames per second. Konica makes

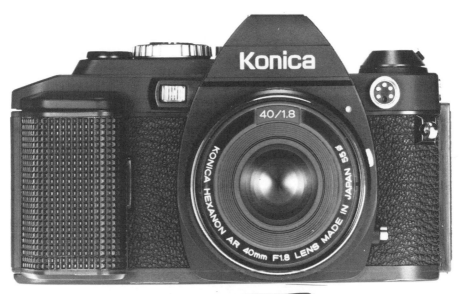

Konica's FS-1 is a very handy, quick camera that is often under-estimated. It has a good shutter priority auto system and a built-in two fps motorized transport. Konica cameras have always been a good value, and the FS-1 can accept more than two dozen lenses of good quality as well as a dedicated electronic flash unit.

a "dedicated" X-24 Auto electronic-flash for the FS-1 which sets the shutter to a 1/100sec synchro speed regardless of the setting on the camera's shutter-speed selector dial. (Incidentally, this is a bit of electronic nepotism, because if you use any other "undedicated" flash, the synch speed is 1/60sec.)

Making the FS-1 battery-holder into a right-handed grip was sheer genius,

and the camera is easy to hold steadily during long exposures. Using those four AA alkaline-type penlight cells as a total power source was another great idea. It frees you from the high cost and questionable service of standard silver-content camera batteries, and gives you a set of cells that's replaceable almost anytime, anywhere.

The FS-1 uses a rapid loading system based on the built-in motorized film advance that probably makes it the fastest-loading 35mm camera. All you need do is place the film leader on the sprocket holes of the transport and close the camera back, and the film automatically is taken up and advanced to the first frame, ready for firing.

CONTAX RTS

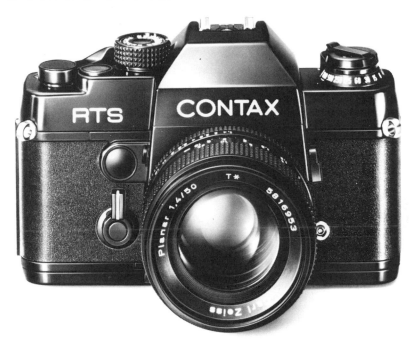

Contax's well-made and well-designed aperture-priority machine (the RTS) has a small but very useful range of equipment, of which the Zeiss lenses are especially noteworthy. The initial cost of the body is high, but is worth considering as a route to using Zeiss optics.

If you are looking for a rugged, reliable 35mm SLR that is well-designed and offers a good selection of top-class optics, the Contax RTS is your best choice. Now owned by Yashica, the aperture-priority RTS is carrying on the greatest tradition of Zeiss cameras and Zeiss lenses.

The Contax RTS has an electronically-timed horizontal-run FPS with speeds from 4 to 1/2,000 sec, with electronic X-synch at 1/60 sec. All shutter settings are battery-dependent—no power, no camera. One SPD in the prism section gives normally center-weighted readings, with an ASA 100 meter coupling range from EV 1 (4sec at f/1.4) to EV 19 (1/2,000sec at f/16). The viewfinder shows full f-stop and shutter-speed information; but its little red diodes light up only when you push a front-mounted "exposure preview button."

In computerspeak, "RTS" means a "real time system" which means that "a result occurs virtually simultaneously with the event generating the data," according to a typical computer handbook definition. If you flick a light-switch, for example, (event) you can

see where the furniture is (data) virtually simultaneously. The same thing happens when you push the switch-button on the Contax RTS: the lights go on in the viewfinder so you can see the exposure information. Actually, this is a very useful feature, as it gives you the option of having an uncluttered viewfinder for composing your image. But there is no real reason why this had to be given a technical name like a "real time system."

The Contax RTS is a fine-looking camera, aperture-priority automation is livable, and that RTS exposure-preview button is enough input for me. This can alert you to a shutter speed that's too low for safe handholding (or subject freezing).

The RTS has a plus-or-minus 2-stop AE compensator dial, and this was the first SLR that actually put a warning signal in the viewfinders so that you won't forget when you've introduced some intentional over- or underexposure.

Contax RTS gives you the choice of a 2 fps power-winder, or a 5 fps motor drive. There's also an RTF electronic flash that can fire as fast as five times per second. But the 2 fps power-winder is more than adequate for most needs.

Two other valuable RTS details are its five interchangeable focusing screens that go in and out through the camera's lensmount, an old Zeiss Contarex idea, and a very clever rewind crank assembly that goes out of gear when folded up. The advantage of this becomes immediately obvious with motor-transport operation—you can't gum up the works with your left hand, or by the camera strap rubbing against the rotating crank assembly. But there's a disadvantage; when loading it's sometimes hard to see if the center shaft is rotating, showing that the film is transporting properly.

Last, and best of all, the Contax RTS uses Carl Zeiss lenses. Their 85mm f/1.4 Planar is one of the best lenses available, and the 60mm f/2.8 S-Planar is a wonderful macro lens. In all, there are 22 Carl Zeiss lenses that fit the Contax, but if lower cost is important you can also choose from the 19 Yashica lenses that fit both Contax and Yashica SLRs.

35mm
SLR Lenses

When it comes to making up a personal 35mm SLR lens set, professionals and amateurs have very different approaches. Professionals nearly always know what they're going to be shooting, and can select their optics accordingly. In most cases, amateurs know only very generally what they'll be photographing, and consequently their optical planning must put heavy emphasis on all-around versatility.

Fisheyes and wide-angles

The widest wide-angles are the so-called fisheye lenses that bend straight lines to crowd enormous angles—sometimes 180 degrees, or more—into the frame. The first modern fisheyes were introduced by Nikon, and made round pictures of just under 24mm diameter inside the rectangular 24x36mm picture frame. These caused a great sensation that soon burned itself out by excessive and not always effective use.

Minolta deserves a lot of credit for starting a trend away from these lenses, toward "full-frame fisheyes," that is, fisheye lenses whose curved perspectives fill up the whole 24x36mm image patch. Minolta's first was an 18mm f/9.5 fixed-focus model, followed by a much better 16mm f/2.8 full-frame fisheye in a focusing mount. Today most manufacturers have these frame-fillers in their lens lists, and they are considered almost conventional. Incidentally, don't expect a full 180-degree coverage from a frame-filling fisheye: with a focal length of 16mm, something like 170 degrees is par for this course. The widest fisheye ever offered was the 6mm f/2.8 Fisheye-Nikkor that covers a 220-degree field. An often overlooked fisheye feature is the ability

Fisheyes are essentially distortion lenses because they have such an extreme effect on the image. The 7.5mm fisheye Rokkor, shown here, is an extreme example and creates a circular image in the 35mm image area. Minolta/Rokkor also makes a full-frame fisheye that does some profound bending, filling the entire 35mm frame at the sacrifice of a wider picture angle.

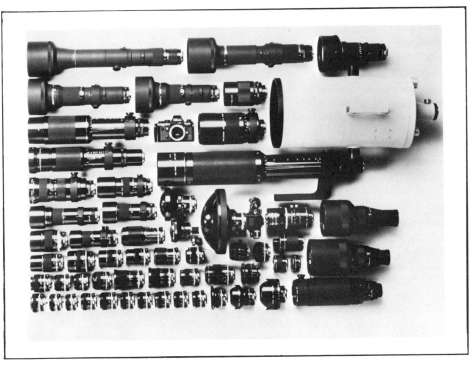

Nikon has such a reputation for innovation in camera optics that the old advertisements warned that any descriptions of the system would be obsolete by the time you read it. Optically the Nikon system leaves very little to be desired, with 70 lenses, from the widest fisheye—6mm—to the longest telephoto—a 2000mm—and many specialist optics.

of these line-bending lenses to provide uniform optical illumination over the whole image field, eliminating natural geometrical vignetting. That is, a fisheye lens will bend straight subject lines, but it won't artificially darken the edges of the picture.

Jumping from the curved world of fisheye optics to the straight-line imagery of wide-angle lenses is more than a matter of millimeters: it's a question of optical correction and pictorial purpose. Lenses capable of recording straight parallel subject lines as straight parallel subject lenses are generally judged to be "realistic" or "distortion-free," although the pictures they make are frequently both unrealistic and distorted. This is because perspective, the size relationship between the images of objects at different distances from the lens, is a function of distance alone. This basic optical truth is constantly being misrepresented in lens advertising and a lot of other places. The fact is, however, that same lens-to-subject distance brings the same picture perspective, regardless of focal length. LIFE-photographer Andreas Feininger once proved this by taking two photographs of Manhattan island from out in the New Jersey marshes. One was

LENSES AND ANGLES OF VIEW

Understanding the picture-taking properties of wide-angle, normal, and long lenses is fundamental to choosing and using them in your photography. The diagrams on these pages illustrate the main differences, which stem from their various angles of view. Wide-angles do not give greater depth of field and long lenses do not flatten perspective. These shibboleths are simply convenient, if misleading, ways of the expressing the various picture angles and magnifications given by these lenses. If you took a 28mm and a 50mm lens and set them to cover the same image area at the same aperture you would find that they had the same depth of field, due to the equal magnification given to the subject. Equally, you can demonstrate that perspective is unchanged by taking two shots, one with a very long lens and the other with a wide-angle and enlarging the center of the wide-angle shot so that it fills the exact image area of the long lens print. The perspective in the two images will be the same.

36°

55mm normal

16mm fisheye — 97°

20mm wide-angle — 84°

35mm moderate wide-angle — 54°

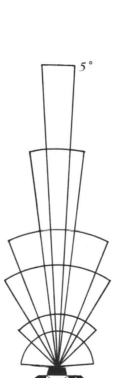

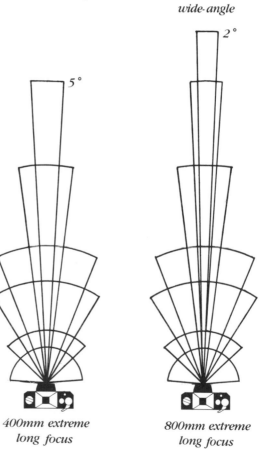

180mm moderate long focus — 12°

400mm extreme long focus — 5°

800mm extreme long focus — 2°

made with a huge telephoto lens that needed two tripods to hold it steady, the other with a very short-focus wide-angle lens. A full-negative enlargement of the tele-lens image and a sectional blowup from the middle of the wide-angle negative produced two pictures with absolutely identical perspective. Of course, the wide-angle picture was very much grainier and not nearly as sharp because of the high degree of enlargement. But that is the real reason for long lenses and short lenses; not for perspective but for filling the negative with the subject-field that you want from a certain shooting distance.

Just as long-focus and telephoto lenses invite long-distance photography with its flattened-out perspectives in which objects at different distances seem compressed together (because the size differences that we see and expect aren't there), wide-angle lenses encourage shooting at very close distances—all too often too close. When this happens, perspective is exaggerated—not because the lens angle is wide, but because the distance is short. You can test this by taking a series of portraits, starting as close as the lens will go, and then increasing the distance a step at a time until you're six or eight feet away. Make a series of enlargements keeping the head size approximately equal, and you'll see that the same lens can produce as many

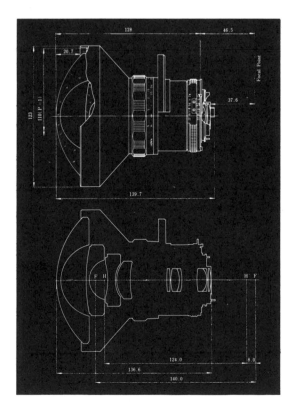

This diagram of the construction of a modern fisheye lens (Nikkor 8mm f/2.8) shows how the lens uses large front elements to take in its wide picture angle. Lenses like this create considerable barrel distortion, a circular effect which increases towards the edge of the film.

This Nikkor 13mm f/5.6 is a rectilinear ultra wide-angle lens that permits a unique spatial effect that does not distort the image and makes it seem to come alive. Unfortunately, the price of a lens like this is more suited to the pockets of well-heeled advertising photographers than to amateurs.

perspectives as there are distances.

The shortest of ultra-wide-angle lenses available today is the Nikkor 13mm f/5.6, which gives a sweeping 118-degree diagonal field. This is an all-time record for straight-line wide-angle lenses, except for the Goerz Hypergon, which was introduced in 1900 for large-format cameras and covers a 135-degree diagonal. Besides, this ultra-wide Nikkor is only theoretically available: it's a special-order item that lists for a truly fantastic price.

Getting closer to reality, non-distorting wide-angles for 35mm cameras start at 15mm with a 110.5-degree diagonal field. This was the focal length of the special three-glass f/8 Hologon, made by Zeiss for a non-reflex camera of their own, and then M-mounted for Leicas. For the SLR, the wave of retrofocus 15mm wide-angles working over the mirror (earlier designs required the mirror to be locked up and an auxiliary viewfinder to be used) and through the pentaprism started with a

15mm Nikkor f/5.6 that was too fat, too long, too heavy, too expensive, and really not up to the Nikkor reputation for optical wizardry. Nikkor now produces a 16mm f/3.5 that is up to their high standards and very competitively priced. Asahi Pentax did better with a 15mm f/3.5 Takumar. Carl Zeiss also showed a 15mm f/3.5 Distagon for Contax/Yashica SLRs a couple of *photokinas* ago, and some have even reached photographers, for a very respectable price.

Two almost-as-wides worth noting are an optically superb 17mm f/4 Canon FD, and an 18mm f/3.2 from Sigma that's serviceable and affordable. Their diagonal fields are 104 degrees for the 17mm, and a flat 100 for the 18mm.

After these, wide-angles crawl degree-by-degree until we reach the second most popular accessory focal length on the market today, the 28mm wide-angle. The thing that helps make the 28mm one of the most useful wide-angles in any one's SLR kit is the fact

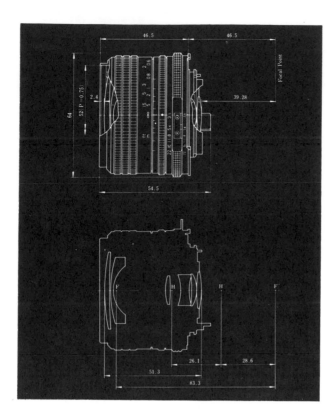

28mm wide-angle lenses have almost usurped the 'normal' lens for many photographers. They find that the compactness of the 28mm and its wider angle of view more than compensate for its slight distortion. The Nikkor 28mm f/3.5, left, is a compact, slow, but sharp optic, while the Zeiss f/1.4 for Contax, below, makes an ideal available-light lens for a premium in weight and cost. At average distances in reasonable light, wide-angles like these can be hand-held at slower shutter speeds than longer lenses, making up for their slower speeds.

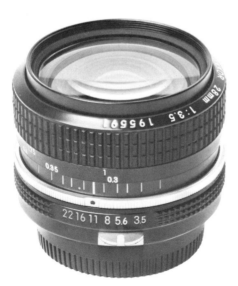

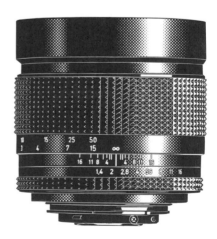

that you can get it up to your eye fast, without concentrating too hard on keeping the back of the camera perfectly vertical. Do this with any shorter lens, even a 24- or a 25mm, and straight lines go flying off in crazy directions, especially indoors. With a 75-degree diagonal, the 28mm wide-angle offers a clear visual contrast with "standard" 50mm lenses. The new popularity of 28s has cut into the sales of 35mm wide-angles, which now sit uneasily between the "normal" focal lengths and true wide-angles. The 35mm lens (with its 63-degree diagonal field) was the standard wide-angle for 35mm cameras for a very long time. It was also the first wide-angle focal length to achieve speed parity with standard-focus lenses. For twenty years the fastest 35mm lens was the f/2.8 Zeiss Biogon. Then, in 1957 and 1958, f/1.8 and f/2 came from Nikon, Canon, and Leica—all rangefinder-focusing optics. Today, 35mm f/2 lenses are offered by most of the leading SLR systems, and there are a number of really good f/1.4's too. One of the best is the Carl Zeiss 35mm f/1.4 Distagon for Contax RTS. This lens has a very special aspherical surface for better high-aperture picture quality.

In the 1960s, as retrofocus wide-angle lenses for the SLR became increasingly popular, photographers made extra trouble for the lens designers by demanding higher apertures and closer focusing distances. Today, f/2.8 is considered a garden-variety f-stop, and a maximum opening like f/2 is beginning to lose its glamour. One technical idea that made these things possible was originated by Nikon, in 1967, when they introduced a 24mm f/2.8 Nikkor with a "floating element." As this lens was focused from infinity to 1 ft. (0.3m), one of its internal lens elements shifted its position within the system to equalize the lens correction over the full focusing range. Today, many of the best wide-angle SLR lenses use this floating element principle, often shifting more than one element, sometimes in the front, sometimes in the back section of the lens. This is a borrowing from zoom-lens design that has done a lot to improve wide-angle lens performance, particularly at the closer focusing distances.

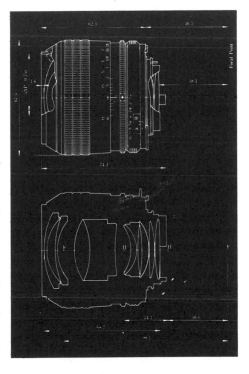

This Nikkor 35mm f/1.4 is the photojournalist's working lens. Other uses include shooting weddings, sports events, and candid portraits.

Standard lenses

This takes us into the realm of the standard 50mm lens. And a wonderful realm it is. Today's 50s are all so good you'll have to go out of your way to find a poor, let alone a bad one. About the only things you'll need to consider when buying a normal lens is your pocketbook and your real (as against your imagined) needs. If you must work under extremely low light conditions, while hand-holding the camera, you'll need a very fast lens, an f/1.2. Such items don't come cheap, and they are larger and heavier than other 50mms. If you really don't expect to do much shooting under poor lighting, you can expect to get good service from an f/1.4 or an f/2 lens at considerable savings. The f/1.4 will be a bit more expensive, heavier, and larger than the f/2, but f/2s are not items most manufacturers lavish much attention on and a compromise f/1.4 would be your best bet.

Medium telephotos

The top-selling accessory lens for 35mm SLRs is the 135mm telephoto. Amateurs like the 135mm for a lot of not-so-good reasons. It gives 2.7 times the image magnification obtained with a standard 50mm lens, and has the impressive heft and "feel" of a "real" telephoto. Beginners, including some budding professionals, often think that

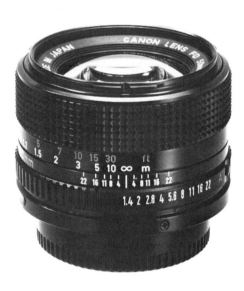

In these days of gimmicky optics, the bread-and-butter 50mm lens is underestimated far too often. 50mm lenses are generally very good optically and do a very workmanlike job for most tasks, often offering some real speed advantages for available-light photography. The Canon FD 50mm f/1.4 (above left) is a fine example of such a standard fast lens, while the Zeiss S-Planar T f/2.8 (above right) provides a bit more focal length and the usual excellent Zeiss optics at a slightly slower speed.

the way to candid, unguarded pictures of people is to stand off at a safe distance, and use a tele-lens. The only thing they accomplish is to stifle any possible development as real photographers. The truth is that shooting candidly depends a lot more on developing personal skills in handling yourself and your camera, and has little to do with relying on the long-lens crutch. Champions of candid photography like Henri Cartier-Bresson almost never use anything except 50mm standard-focus lenses.

Most professionals feel that the 135mm is neither long nor short enough. Outdoors it often performs well for scenic landscapes, but frequently it isn't really long enough to pick out details from a crowded scene. Indoors, it's too tight a focal length (18-degree field) for most situations, including portraits. This is why most working pros skip the 135 in favor of at least two different lenses: something in the 85-to-105mm range, and a really long-reaching 180- or 200mm lens. Optically, however, the 135mm is a quality performer.

The 85-to-105mm group is also notable for really high-quality optics, with lots of speed and good general versatility. Perhaps the best length in this range is an 85mm because of its higher speeds, generally. It is a great "people lens," equally useful for candid work and for studied portraits.

Most manufacturers rate one of their 85-to-105 lenses as the best in their systems, so it is hard to single any out. A few, however, do rate special mentions. The 85-mm f/1.2 Canon FD Aspherical is an excellent lens and the fastest available in this range, with the Zeiss Planar f/1.4 for the Contax RTS the second fastest. Minolta has one of

Capable of focusing down to 1 meter, this Nikkor 105mm f/2.5 is best used for head-and-shoulders portraits.

the most useful portrait lenses ever built, the 85mm f/2.8 Varisoft Rokkor-X, which has three adjustable degrees of soft-focus flattery, plus a setting for real wire-sharpness. There are literally loads of great 100- and 105mm performers, but nothing that can beat the Nikkor 105mm f/2.5. A number of promising new 100mm f/2 lenses are about to appear, with one manufactured by Canon.

Out beyond the 180/200mm look-alikes, there is a lot of interest in 300mm as a preferred focal length today, and a lot of talk about new optical

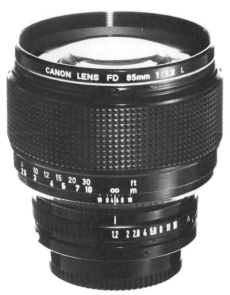

The Zeiss 85mm f/1.4 for the Contax RTS is one of the fastest and sharpest lenses in its focal length, and focuses down to 1 meter.

Aspherics, costly and difficult to make, add to the performance of very fast lenses, such as this top-quality 85mm f/1.2 Canon FD lens.

designs, better color correction, and mirror systems. But before things become too technical, here's another point to remember. Any hand-held tele-lens, especially a 180- or 200mm, should be able to focus as close as 12 times its focal length. This is just enough for a 1:10 image-to-object size ratio, and exactly the minimum distance needed for a frame-filling "head shot." The average adult human head measures about 300mm from chin to dome, and a repro-ratio of 1:10 brings this down to a comfortable 30mm on the 36mm-long side of the picture frame.

Mirror lenses

Mirror lenses were developed to overcome an optical problem that is exaggerated in long lenses—chromatic aberration. Chromatic aberration means that a lens will bring red rays to a long-

er focus than blue ones, with green falling just about in the middle. Normal, good color correction can reduce this blue-red focus shift to one thousandth of the focal length, or a bit better. This sounds good until you consider that one thousandth of a 500mm focal length means a blue-red shift of half a millimeter. At f/8, the image-plane depth-of-focus is no more than 0.48mm, or about 4% less than this chromatic aberration. For the past 200 years, optical engineers have had two traditional answers to the problem of improving color correction (which first arose in the construction of telescopes).

The first answer (originated by Isaac Newton) was to eliminate chromatic aberration entirely, by using curved mirrors instead of lenses. Mirrors reflect all rays equally, so there's no chromatic aberration. Unfortunately, mirrors

seldom work properly without some help from lens elements. Telescopes need eyepieces, photographic mirror lenses need one or two field lenses to get the rays to the right points on the film surface. But the chromatic aberration they introduce is really not worth writing about. What troubles we have with mirrors are the so-called "monochromatic" errors, like spherical aberration. To correct for this was too difficult and too costly for photographic systems. In 1940 and 1941, a specially shaped afocal corrector element, with easy-to-manufacture spherical surfaces, was developed. It was named for one of its inventors—a Russian, the Maksutov system.

Almost all modern mirror lenses use the Maksutov system, or various improvements, to produce excellent resolving power (generally) with not-so-good contrast. From the photographer's point of view, the additional attractions of mirror-lenses (which are also called "catadioptric systems") provide reasonably high effective aper-tures, short overall length, and (usually) light weight. Last, but not least, mirror lenses are cheaper than a telephoto of equivalent focal length.

There are, however, several drawbacks to mirror lenses. They don't have iris diaphragms, can't be stopped down, and work only at their one, full aperture. You can regulate exposure either with the camera shutter, or by using neutral-density filters (which are sometimes built into the back section of the lens). Consequently, there is no way to increase depth of field, and, because of their internal geometry, the depth they do give is considerably less than that of an ordinary refractor operating at exactly the same f-stop. Mirror lenses are also very sensitive to heat and cold, and will perform differently at different temperatures. Perhaps the worst problem of mirror lenses lies in the images they produce. For many picture situations, the out-of-focus blur produced by a mirror lens isn't the solid symmetrical blob that you get with a normal-lens. Because

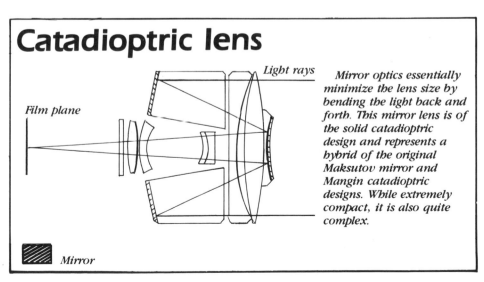

Catadioptric lens

Film plane

Light rays

Mirror

Mirror optics essentially minimize the lens size by bending the light back and forth. This mirror lens is of the solid catadioptric design and represents a hybrid of the original Maksutov mirror and Mangin catadioptric designs. While extremely compact, it is also quite complex.

the aperture of a mirror lens is dough-nut-shaped, its out-of-focus blurs are little doughnut images.

In practical terms, the out-of-focus doughnuts are the principal limiting factor for mirror-lens applications. Suppose you want to photograph a rocket launching, or aircraft in flight. A mirror lens would probably be the best choice. There are no disturbing doughnuts because there's nothing in front of, or behind the subject to be recorded as an out-of-focus image. Also, because of shorter front-to-back measurements, the lens would be easier to swing around on tripods or special military mounts.

Now consider a typical subject for which long-focus mirror systems are usually recommended. You're shooting a tennis match and using a mirror lens because of its light weight. However, the mirror-lens f-stop and focal length produce annular out-of-focus doughnuts which ensure that every spectator in the out-of-focus background has a hole in their head. It's a cartoonist's dream and a photographer's nightmare. In addition, as the players move across the court, you have to take extra care that they aren't moving out of the shallow depth of field given by the lens.

Mirror lenses cannot be condemned out of hand. There are times and places for everything. But their annular rings, the fact that they lack regular aperture rings, and that they perform especially poorly for close-range work means that unless you know exactly what you're going to use the thing for, a mirror lens is a risky investment. Regular refractors in the same focal lengths are more reliable and versatile. If you still want a mirror-lens, it should have a focal length of at least 400mm. Some shorter mirror-systems have been made from time to time (Minolta offers a ridiculous 250mm f/11 RF Rokkor-X), but at focal lengths under 400mm there is really no justification for accepting mirror-lens systems. They just don't make any real sense.

For really long focal lengths, mirror lenses such as this 1600mm Minolta f/11 RF Rokkor have several advantages over conventional optics. A lens like this is relatively compact, although it still must be used on a tripod, and can be made for a realistic (if high) price. A good example of a shot where a lens of this type works well was the recent inauguration of Pope John Paul II when a wire service used a 2000mm Reflex Nikkor to photograph the event from a rooftop several hundred feet away.

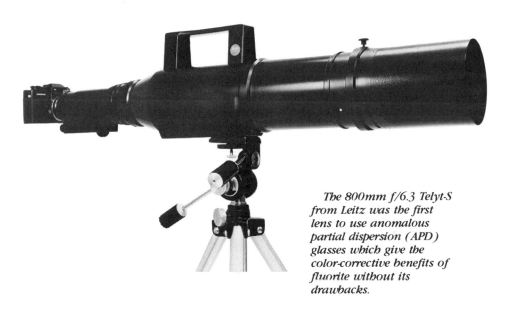

The 800mm f/6.3 Telyt-S from Leitz was the first lens to use anomalous partial dispersion (APD) glasses which give the color-corrective benefits of fluorite without its drawbacks.

Long lenses and telephotos

Mirror lenses, then, solve the problem of chromatic aberration, but only at some expense. The other traditional method for improving color correction is to combine two or more optical glasses with different dispersion values. By combining just two glasses it's possible to bring red and blue rays to the same focus, with a chromatic shift in the green part of the spectrum equal to about one thousandth of the focal length of the lens. These long-focus lenses are pretty good, and give crisp, contrasty images—as long as the maximum aperture is kept down to about f/7 or so. Physically, they're long, thin tubes that handle well with a shoulder-stock for freehand shooting. (Although, of course, the first rule of long-lens work is to put it on a solid tripod, and to use the fastest shutter speed possible.) Optically, what they lack in perfect color correction is made up for by contrasty images. As a matter of fact, their images can be so contrasty that

groundglass-screen-SLR focusing becomes a pleasure, and some of the really good ones can actually focus accurately at small f-stops like f/11 and f/16. One of the best two-glass achromats ever made is the 400-mm Telyt f/6.8 for Leitz Visoflex and Leica reflex cameras. David Douglas Duncan used one of these for his famous coverage of the 1976 Republican Convention for LIFE magazine.

The telephoto lens is more commonly used and is a more complex type, using at least two more optical elements. Originally invented by T.R. Dallmeyer of London in the 1890s in order to shorten the optical path length, modern telephoto lenses are the only way to get wider f-stops through the crowded housing of a modern 35-mm SLR. In their turn-of-the-century beginnings, telephoto lenses traded optical quality for a gain of light-weight convenience. Not so today. Now, tele-lenses are among the very best of all lenses. As a matter of

fact, the telephoto design is used not so much to obtain a short telephoto ratio as to provide a higher degree of optical correction and greater freedom from mechanical vignetting.

Even so, the color correction of telephoto lenses could be better, and this has lead to the use of fluorite, an artificially grown crystal which, when combined with glass elements, enables the designer to eliminate chromatic aberration almost completely. In addition, the optical chracteristics of fluorite—low refraction and very slight chromatic dispersion—make possible shorter telephoto packages than can be achieved by glass alone. These fluorite wonder lenses are correctly called "super achromats," and unfairly termed "apochromatic," or just "apo," which is another and less highly advanced form of color correction. Canon, Konica, Pentax, and a few others began building fluorite systems about a dozen years ago, but the most famous today are the Canon FL 300mm f/5.6, FL 500mm f/5.6, and the FD 300mm f/2.8 Fluorite.

Fluorite telephoto systems give the last word in all-around long-lens correction today. Even though, theoretically, the mirror-lens systems should be a touch better chromatically, the fluorite tele-systems are a lot better in terms of the monochromatic aberrations and give better contrast. (This is because most mirror-lens systems cannot be adequately baffled internally to prevent skew rays—non-image light—from penetrating the system and reaching the film without mirror reflection.)

But fluorite does have its own drawbacks. It is expensive to produce, and more expensive to grind and polish. The crystal material is so sensitive to abrasion that it can't be used for the two outer faces of the lens system, but must be buried inside the lens to keep it clean and scratch-free. Because their heat-expansion characteristics are so different from those of glasses, fluorite elements can't be cemented with glass pieces to form achromats, but must be left free-standing within the system. This same temperature sensitivity makes it impossible to provide a fluorite tele-lens with a mechanical infinity block. This means that you can't bang in to infinity by "feel," trusting the metal-to-metal contact to provide accurate infinity focus. Instead fluorite lenses need to be able to focus in past their infinity mark, and photographers often have difficulty getting perfect infinity sharpness under certain hot or cold temperature conditions when the fluorite lenses change their focal lengths. (This is often a problem with mirror-lens systems as well. Expansion or contraction of the main mirror at the back of the system means changed curvature and displaced focus. To prevent this means adding considerable weight and bulk, using a thicker main mirror, sometimes made of pyrex glass or quartz, and heavier metal mount tubing: all measures which tend to defeat the whole purpose of fast-handling long-focus mirror systems.)

Fluorite elements are frequently used in certain kinds of microscope objectives, and Ernst Leitz (Leica) is one of the world's largest microscope makers. Their long experience with manufacturing this miserable stuff has given Leitz engineers and designers a healthy dislike for fluorite, especially in the big pieces needed for photographic lenses. Accordingly, they set about to find glasses which might provide corrective medicine similar to that of fluorite. Find it they did, in a special

series of glasses with peculiar chromatic dispersion properties. Generally called APD (anomalous partial dispersion) glasses, these were made first in the Leitz Glass Research Laboratory, then by Schott/Mainz, the principal West German glassmaker, and finally by Nippon Kogaku, or Nikon, in Japan.

The first Leitz APD-glass lens was a Telyt-S 800mm f/6.3 using two thin

Teleconverters

A teleconverter (or tele-extender) is a small adapter that fits between the camera body and the lens and effectively doubles or triples its focal length. Most teleconverters today consist of four or more optical elements, though the number of elements is not relevant to its performance. Although they appear to be a considerable convenience, practically and economically they have several optical drawbacks. A unit which supplies 2X magnification (doubles the focal length of the attached lens) cuts the speed of the lens by one-half. A 3X converter cuts the speed of the lens by one quarter. This means that a 100mm f/2.8 lens mounted on a 2X converter, for example, will have an effective focal length of 200mm but a maximum speed of f/5.6 The same lens mounted with a 3X converter will have an effective focal length of 300mm but a maximum speed of f/8.

The greatest drawback to teleconverters, however, is in their optical performance. Most have poor resolving power and contrast under the best conditions, and perform terribly under less than ideal circumstances. To get the best optical performance from a teleconverter you should work at least two, and preferably three, stops below maximum aperture. With the aforementioned 100mm f/2.8, that means shooting through an f/8

aperture set on the lens. That gives you an effective maximum f/11 aperture with the 2X converter mounted, and an effective maximum f/16 aperture with the 3X converter in place. So, if you opt for a teleconverter you'll need a great deal of illumination available.

Nikon 2X teleconverter

One good feature of teleconverters is that they don't change the minimum focusing distance of the main lens. So if you use a close-focusing 50mm lens on a converter you come up with a close focusing 100mm equivalent. But that is almost the only good thing that can be said for them. In general, unless you are uncritical and impecunious, forget about teleconverters. If, however, you must have a teleconverter, only buy one that is specifically designed for your lens, and then be sure to use it with that lens alone.

negative elements of conventional glass cemented against a central positive element made of the APD glass. The new material brought the color error down to about one third of its former value. Trouble is, an 800mm f/6.3 isn't exactly what's needed to set the photographic world on fire, and the improved color correction of this big Telyt was noticed more by competitive lens designers than by working photographers. In 1976, Leitz used this new glass again, in a 180mm f/3.4 telelens called Apo-Telyt-R, a complex 7-glass, 4-group system. This particular lens produced very sharp images but very few professional friends. With its close-focusing distance of about 8⅓ ft (2.5m), tight frame-filling head shots were ruled out. At best it could produce an image-to-object size ratio of 1:12; competitive 180mm lenses like the Zeiss Sonnar and Nikkor f/2.8 rack in to 5¾ ft (1.8m), giving a 1:8 repro ratio. In general, professionals know that a minimum of 1:10 is needed in many situations.

In the meantime, Nikon's lens designers turned to the same APD-glass idea. Nikon decided to call their new lens series ED, (extra-low dispersion glass.) Then came their own Nikon-designed APD-type glasses, and nine Nikkor ED lenses, probably the best range of telephotos currently on the market for 35mm SLRs. These are: Nikkor 200mm f/2 IF-ED; 300mm f/4.5 IF-ED; 300mm f/2.8 IF-ED; 400mm f/5.6 IF-ED; 400mm f/3.5 IF-ED; 600mm f/5.6 IF-ED; 600mm f/4 IF-ED; 800mm f/8 IF-ED; and 1,200mm f/11 IF-ED.

Note that "IF"; it has nothing to do with "ED," but may prove to be even more important. "IF" stands for internal focusing, that is, adjusting the distance focus by moving some internal lens elements, instead of the whole lens. There are four reasons for this.

First, internal focusing gives some corrective advantage, similar to the "floating element" idea already described in connection with wide-angle lenses. Second, moving relatively small internal lens elements eliminates the weight, bulk, and cost of ordinary helicoid long-lens focusing mounts. Third, internal focusing means fast focusing because the amount of movement needed to go from infinity to any given close-in focusing distance is very much smaller. Finally, IF is going to make possible a new generation of professionally acceptable electronic auto-focusing cameras and lenses.

The third point—rapid focusing—needs some comment. The focusing travel of a lens for any given focusing distance is proportional to the focal length. A series of lenses which gives close-in distances equal to ten times their focal lengths, for example, means 25mm worth of travel for a 200mm lens, 50mm for a 400mm, and so on. Double the focus, and you double the amount of travel that's needed for achieving the same image-to-object size ratio. This is why all kinds of sliding-tube rapid-focusing devices are constantly being invented and reinvented for long-focus optics. Much the same is true in the mirror-lens field where a sort of internal focusing has been known and practiced for many years, usually by moving either the main or secondary mirror, although some designs have actually focused by movement of the refractive relay optics at the end of the system. Maybe the fastest-focusing of all has been achieved by Minolta in their big 500- and 800mm RF Rokkor mirror systems. A side-mounted focusing lever whips

through the distance range with a flick of your fingers. Fast focusing is very important for all sorts of action photography, and it makes for better focusing accuracy because it doesn't give your eye enough time to accomodate to an imperfectly focused image.

Perhaps the only competitor to Nikon in the field of telephoto lenses is Canon's FL system. The most famous of these is the 300mm f/2.8, the lens an Italian paparazzo used to photograph a secret NATO document held by Henry Kissinger. This lens comes with a special 2X teleconvertor which transforms it into a 600mm lens with an effective maximum aperture of f/5.6.

Macro lenses

Today, there are more dogmatic definitions of the word "macro" than anyone needs. Most photographers understand a macro lens to be an optic that attaches directly to the camera's lens-mount, and without any additional accessories gives a focusing range from infinity to at least half life-sized, a 1:2 image-to-object size ratio. A few macro lenses actually extend out far enough to give a full life-sized (1:1) repro ratio, but most stop at 1:2 and need an extension tube to bridge the gap between half- and full-sized imagery. For a 1:2 image/object ratio the lens extension has to be equal to half the focal length; at 1:1 a full focal length's worth of extra tubing is needed.

The first lens of this type came from Germany, about 25 years ago. This was the 40mm f/3.5 (later f/2.8) Kilfitt Macro-Kilar, which went all the way to 1:1. Most modern macro lenses have focal lengths between 50- and 60mm. For 1:2 reproduction this means a subject-to-film distance of 4.5 focal

lengths, 225mm for a 50-, and 270mm for a 60mm macro lens. (At 1:1 this drops to a subject-image distance of 4 focal lengths.)

The old problems over calculating exposure in close-up work have been solved for almost all work by modern TTL metering, but there is still a difficulty in getting the lighting right from such cramped quarters. Ring lights and macro lights help, but increased camera-subject distance is the best solution in most cases. In order to achieve

This Micro-Nikkor 105mm f/4 focuses down to 1.55ft (0.47m) and can be used to photograph products or insects.

Close-up lenses

The cheapest and simplest way to begin close-up photography is by using supplementary close-up lenses. These are thin, single-element lenses that attach to the front of the camera lens enabling you to obtain results up to half life-size (1:2). Their strength is expressed in diopters; diopter is calculated by dividing the focal length of the close-up lens (in mm) into 1000. Thus, a +1 supplementary lens has a focal length of 1000mm. Positive (+) supplementary lenses decrease the effective focal length of the lens they are being used with; negative (−) supplementary lenses increase the prime lens' effective focal length. Obviously, those used for close-up work are all positive. Companies like Vivitar make close-up lenses at reasonable prices ranging in strengths from +½ to +10.

To increase your subject-magnification still further, you can combine two close-up lenses, which will produce a dioptic power equivalent to the sum of their two strengths. Use no more than two lenses together and always put the highest powered element next to the camera lens. Depth of field is further reduced in close-up work by close-up lenses, and above a power of +4 it is so shallow that accurate focusing is extremely critical.

These lenses do not produce the same quality as other close-up equipment like bellows or macro lenses, but if they are used at the smallest possible apertures and with subjects where contrast and resolution, particularly at the corners of the image, are not critical, they will produce acceptable results.

Magnification with close-up lenses

Supplementary lens power	Focus setting (inches)	Working distance (meters)	Magnification
+1	Infinity	1	0.05x
	1.0	0.5	0.10x
+2	Infinity	0.5	0.10x
	1.0	0.3	0.15x
+5	Infinity	0.2	0.26x
	1.0	0.16	0.32x
+10	Infinity	0.1	0.52x
	1.0	0.09	0.58x
+20	Infinity	0.06	0.95x
	1.0	0.05	1.0x

this there's a new breed of longer macro lens on the market today, with focal lengths of 90-, 100-, or 105mm. These give infinity to half life-sized reproduction ratios, and for 1:2, the same 4.5 focal length gives adequate object-to-image distance.

Macro lenses have apertures of f/2.8 or f/3.5 in the 50-to-60mm range, while the 100- and 105mm models start at f/4. Macro lenses in the 50- to 60mm focal range are often chosen as all-around standard-focus lenses by photographers who value their close-focusing abilities more than a really big aperture. For a great deal of work f/2.8 or even f/3.5 is speed enough; so if this strikes you as a possibility, consider a macro lens as a substitute for a high-speed standard-focus lens. (Of course, if you're rich, there's no problem.)

Many macro lenses have simple 4-glass/3-group Tessar-type designs, but the really good ones today have complicated Gauss-type designs similar to those used for high-speed standard-focus lenses. Examples of this are the 6-glass/4-group designs of the notable 60mm f/2.8 Zeiss S-Planar Macro (which goes to 1:1) for the Contax RTS, the 60mm f/2.8 Leitz Macro-Elmarit-R, the 50mm f/3.5 Canon FD/Macro, and the 50mm f/3.5 Minolta Macro-Rokkor. One of the very best macro lenses is Nikon's 55mm f/3.5 Micro-Nikkor, which is a 5-glass/4-group design. A new version of this lens was announced just as this book went to press: a 55mm f/2.8 Micro-Nikkor with floating-element correction. Using floating elements to even out the aberrations in a lens that goes

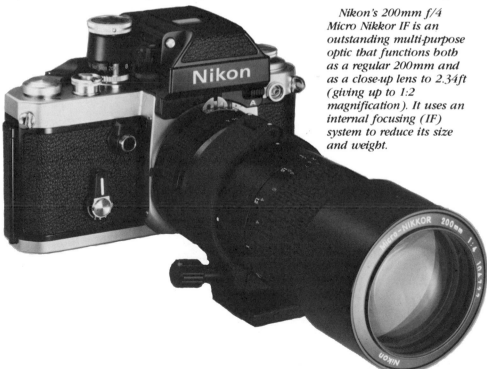

Nikon's 200mm f/4 Micro Nikkor IF is an outstanding multi-purpose optic that functions both as a regular 200mm and as a close-up lens to 2.34ft (giving up to 1:2 magnification). It uses an internal focusing (IF) system to reduce its size and weight.

from infinity to 1:2 is long overdue, and it's significant that once again Nikon is doing the optical innovating.

Probably the most amazing of all macro lenses for 35mm SLRs is the 200mm f/4 Micro-Nikkor IF. The word "unique" is overworked and misused nowadays, but there is really nothing else like this lens: it is neither a normal single-focal-length lens nor a zoom lens, but something in-between. At infinity it's a 200mm lens, but as you use its internal-focusing (IF), see page 62, ring to come into 28in (0.71m) for a 1:2 reproduction ratio, its focal length slides down to only 150mm. It's a long, thin lens that gives razor-sharp images with super-quick internal focusing. If you can settle for f/4, it's a good lens to use for everything from landscapes at infinity to half life-sized close-ups, with a close-in object-to-image distance of 675mm, or about 26½ in, which is a lot of macro elbow room.

Bellows attachments

The majority of 35mm-SLR bellows units do not offer any lens-board movements other than focusing. Some of the most expensive, however, do offer limited swings (of around 25°) and shifts (about 11mm maximum) of the front standard. These movements enable you to alter in a limited way perspective and the plane of sharp focus (using the Scheimpflug principle, see p. 152) in order to obtain sharp focus in subject planes not parallel to the film. But, unlike bellows on large-format cameras, 35mm bellows units do not offer the kind of rises, falls, or tilts that correct perspectives in architectural work.

Most camera manufacturers also include special "bellows lenses" in their systems. These are specially formulated for macro work and, since they are meant to be used on a bellows unit, they never have a focusing mount of their own. Two notable examples of such specialized optics have recently appeared from Canon: a 20mm f/3.5 and a 35mm f/2.8, both optimized for magnifications ranging between 1.8X and 10X.

For a 35mm SLR, if you want high magnification (from 1:1 to 1:10 or more) beyond the range of macro lenses on extension tubes, with top quality results, you should use a bellows unit. These units fit between the camera body and the lens enabling you to vary the camera-lens distance (and therefore the magnification) continuously. Bellows units are available as part of every 35mm SLR system, although nearly all units are manufactured by a few independent companies and sold to the camera producers.

The most important feature to look for on a bellows is the strength and rigidity of the runners and of the front standard, which when locked should remain firmly in position and not be moved by the bellows or lens. Basic units are a simple bellows on a monorail, while more sophisticated units feature diaphragm automation, dual rails (so that the camera and bellows can be moved as a single unit for focusing), and a facility for reversing the lens (to increase subject magnification still further).

An unusual optic that almost turns a 35mm SLR into a small view-camera is the Minolta 35mm f/2.8 CA Shift Rokkor-X. Unlike other shift lenses, this lens not only retains full automatic-diaphragm operation but also features Minolta's variable, field-curvature-lens design that permits the area in focus to be adjusted to fit an image on a flat plane, so that the image can be in- or out-of-focus selectively.

Shift lenses

Rising, falling, and sideways-sliding lensmounts were once considered standard camera features, and these "shifts" are still built into practically all large-format cameras. Traditionally, the principal purpose of a rising front was to include the full height of tall buildings without having to tilt the camera upward. Parallel vertical subject lines will be recorded as parallel lines only if the camera back is kept vertical, that is, parallel to subject verticals. If the camera is tilted upward from ground level, these verticals will converge to look like a pyramid. If the camera is tilted downward from a high shooting position, exactly the opposite effect will be produced, and the rising verticals will appear to diverge.

Thus, when you want architectural accuracy you should move your lens but keep the camera back parallel to the subject lines. To do this, you need a lens capable of covering a much larger image circle than your normal film format, and a lensmount that permits off-axis shifts (while still keeping the lens parallel to its image plane). This idea was introduced into 35mm SLR photography in 1962, when Nikon first produced a so-called "PC" Nikkor 35mm f/3.5 lens. This "perspective-control" or "distortion-avoiding" lens was provided with a lensmount permitting lateral shifts of as much as 11mm in any direction. The current Nikon system includes two PC Nikkors, a 35mm f/2.8 and a 28mm f/4. Both of these PC Nikkors permit maximum shifts of 11mm along the 36mm long side of the frame, and of 8mm in the short 24mm direction.

A great many "shift lenses" for 35mm SLRs give the same 11- and 8mm maximum shifts as the PC Nikkors. One that doesn't is the very conservative Schneider PA Curtagon 35mm f/4 lens that gives a maximum shift of only 7mm. Using the factor

principal above, this means a gain or loss of 7/35 = 0.2 times whatever shooting distance. It is very important to note that the much advertised 11mm shift is only permissible along the 36mm side of the frame. If you go 11mm off-center along the short, 24mm frame side, the lens will soon vignette (the longest movement possible along the short side is 8mm).

Today's most outstanding shift lenses are those of Minolta and Canon. The Minolta 35mm f/2.8 CA Shift Rokkor-X is the only shift lens on the market today with an automatic aperture mechanism. All of its many competitors have either manual or manually preset aperture rings. A manually preset lens has two engraved aperture-control rings. The preset-control ring is click-stopped, usually at full stops. You use it to choose your aperture but it does not set the lens diaphragm itself. The diaphragm-control ring, which has no click-stops, actually positions the diaphragm blades. You should focus and compose with the diaphragm-control ring set for maximum aperture. Then, before shooting you should turn the diaphragm-control ring until it stops against the preset-aperture for the correct exposure. Note, however, that although the Shift Rokkor diaphragm does open and close automatically like a conventional modern SLR lens, it does not couple to the Minolta full-aperture coupling mechanism, and readings must be made in the neutral position by the manual stop-down method, as is the general case with other shift lenses today. Obviously this type of lens can present more problems than it solves.

A valuable advantage of the Minolta

Shift Lenses and Subject Distance

A shift lens will not solve every problem of shooting tall structures. If, for example, you are taking pictures on the streets of Manhattan and are unable to move very far back, a shift lens will only enable you to include a few extra stories of skyscraper. Any advantage given by using a shift lens is thus very much dependent on shooting distance. Its particular value in any case can be calculated, either as the amount of foreground or background height gained or lost, by using this simple equation:
subject dimension gained/lost =
(shift distance/focal length)
× shooting distance

If the shift distance and the lens focal length are in millimeters (which they usually are), your shooting distance can be in any units you like. For example, a full 11mm shift with a focal length of 35mm and a shooting distance of 100ft produces the following calculation:
(11/35) 0.3;
and 0.3 × 100 30ft.
This means that if you use an upward shift ("rise") of 11mm you gain 30ft of undistorted height about the subject. Conversely, a downward shift ("fall") of the same 11mm will produce an additional foreground depth of 30ft.

shift lens is its special two-axis sliding mount that automatically prevents shifting too far in the wrong direction. With every other shift lens you can use the full 11mm shift in the wrong (short frame dimension) direction and thus produce badly vignetted pictures. The Minolta mount has two lock-screws set at an angle of 90 degrees. If you loosen both of these you can simply shift and shoot with perfect safety, and using first one and then the other shifting direction you can "fine-tune" your result. This lens does, however, contain one very questionable feature: its variable curvature of field (CA) control, which is supposed to permit optionally curved fields that are either dished inward toward the lens, or bent outward away from the lens. Unfortunately, it is almost impossible to detect any recognizable difference, let alone advantage, from the several plus or minus CA ring positions, and most users leave this control locked in its neutral (no effect) position. It is sometimes claimed that this choice of inward or outward field curvature can be used to increase or to decrease the depth of field, but even this is doubtful, because the differences introduced are so very small. Nevertheless, Minolta's Shift Rokkor-X is the fastest-shooting, easiest-handling of all shift lenses, also inviting use in candid street-shooting and other non-architectural applications where you want to either eliminate or enhance foreground areas.

The Canon 35mm f/2.8 shift lens is labeled TS. TS means tilt and shift, and this is the one SLR shift lens that permits an angular tilt in order to control the plane of focus. The tilting angle is 10 degrees, sufficient to control the plane of focus, according to the Scheimpflug rules (see page 152).

Shift lenses (most of which have focal lengths of 35mm) add a new dimension of technical and creative image control into 35mm SLR photography. One often overlooked aspect is the many possibilities they make available for dealing with the difficult pictorial problems of empty foreground areas in wide-angle (or semi-wide-angle) picture-making.

Zoom lenses

The advantages of a zoom lens are both economical and practical. A single zoom can replace several lenses in your camera bag at a fraction of the cost, weight, and bulk. The variable length of a zoom enables you to change the cropping and composition of each shot more exactly; and, with fast-moving action subjects, you can more easily follow your subject simply by altering the focal length. Finally, zooms enable you to create special effects, such as zooming during the exposure.

When you change the focal length of a zoom it should hold its focus. With a typical 80–200mm zoom, for example, if you focus in the 200mm position (a good idea because the bigger image means greater focusing accuracy), it is now possible to zoom down to the 80mm position without changing your preset distance focusing. This is a tremendous convenience, and in fact defines the difference between a "true" zoom lens and a "varifocal" design which has to be refocused every time its focal length is changed.

Mechanically, there are two sorts of zoom lenses, those with separate rings for focusing and zooming, and those equipped with a single ring that's turned for focusing and pushed forward or backward to zoom through the

focal range. From their 35mm SLR beginnings in the late 1950s, this aspect of zoom lenses has been a controversial point. A single-ring focus-and-zoom control certainly sounds good, but a great many experienced photographers today prefer the more conventional arrangement, with separate control rings for zooming and focusing. A principal reason is that although it may be faster, the single push-pull and rotating ring introduces an extra element of anxiety as to whether the focus was held when zooming. Another reason is that separate controls make for better mechanical precision and probably superior optical performance.

The truth is, however, that the very best, and most expensive, still-camera zoom lenses are only almost as good as high-quality lenses of unit focal length. This is because zoom lenses are very much more complex—they require many more individual lens ele-

ments, and groups of these elements have to move in relation to each other in order to change the effective focal length of the zoom lens and to maintain the same distance focusing for all focal lengths.

From a practical point of view, zoom lenses should be examined for three principal defects. First, shoot some strongly back-lighted subjects, like a person silhouetted against the sun or some other strong light source. Almost all zoom lenses—even the very best—will show considerably more flare and noticeably poorer contrast than good-quality single focal length lenses that fall within the zoom range.

The next thing to look for is rectilinear distortion, the bending of straight subject lines. Rectilinear distortion can cause either an inward ("pincushion") or an outward ("barrel") distortion. This is often present in pictures made at the two ends of

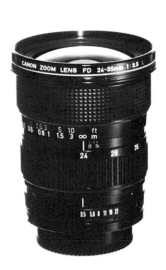

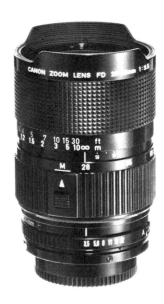

The use of zooms in shorter focal lengths is becoming more common today as their optical quality improves. For these lenses, the 24-35mm left and 28-50mm right, Canon uses aspheric optics to produce the highest performance. Slight changes in these short focal ranges creates a very visible difference in the image.

the zooming range, and frequently becomes apparent in the long-focus setting. To see for yourself, shoot a tall building with lots of straight-line details, using the zoom lens at its long-, middle-, and short-focus settings.

Finally, a lot of the cheaper zooms tend to vignette, meaning to darken artificially the edges of pictures made in their short-focus zoom positions. Some pictures of an evenly illuminated subject can quickly reveal this defect.

Most still-camera zoom lenses provide a focal ratio of less than 3:1. Notable exceptions are Nikon's pair of huge 50–300mm Zoom-Nikkor f/4.5 lenses. The second of these is an ED version using the special low-dispersion optical glasses discussed in connection with telephoto lenses. The ED zoom gives improved quality and a slightly shorter overall length. Both lenses are extremely costly, with the ED's price way out of most people's reach. Another notably big-ratio zoom is Minolta's 100–500mm f/8 MD Zoom Rokkor-X, which weighs about $4\frac{1}{2}$ pounds. These are show-piece lenses, not really of much use for practical photography.

Two fairly new manufacturing/marketing trends in zoom-lens design are worth noting. The first of these is the so-called "macro zoom" that gives a maximum close-in reproduction ratio of something like one-half or one-quarter life-sized. In the early stages of development, about five years ago, these lenses were equipped with a release-lever or catch that opened up a second close-in focusing range. Now there are many standard zooms like the 80–200mm models from Canon and Konica, that focus continuously from infinity right on into their close ranges. Usually, you'll get macro performance, like a 1:2 image-object ratio at the long-focus zoom position. Frankly, macro zooms do not match the very high standards of image quality that have been established by genuine (non-zooming) macro lenses.

The other current trend is toward so-called wide-angle zooms, often with zooming ratios of less than 2-to-1. The 28–45mm Nikkor was one of the early examples. It's been recently discontinued in favor of more useful 25–50mm f/4. One particularly good zoom in this range is the Canon 24–35mm f/3.5 FD/L with its expensive aspherical construction. Although this zoom has a ratio that's less than $1\frac{1}{2}$-to-1, it allows tight, accurate framing. Don't get too carried away by the zoom ratio alone: what really counts is the difference in angular field coverage. Using diagonal field angles, the 24–35mm zoom is really an 84-to-63 degree lens, a substantial angular difference. A standard 80–200mm zoom has a 2.5X zoom ratio, but the angular difference of 30-to-12 degrees is a bit less. With all wide-angle zooms, a real advantage is the ability to adjust depth of field and perspective quickly.

One of the handiest combinations now appearing on the market is 28–80- or 85mm. Many independent lens manufacturers are successfully selling the same 28–80mm f/3.5 zoom that seems to have come first from Makinon.

35mm SLR
Accessories

ELECTRONIC FLASH

Electronic flash gives a hard, bright light (with the same color temperature as daylight) of brief duration—around 1/50,000sec. Flash equipment is probably one of the most confusing areas of 35 mm SLR accessories, at least partly because it is one in which the equipment is changing so rapidly. These technological improvements, however, are making electronic flash easier to use and have expanded its range of photographic possibilities.

Large flash units (strobes) have always been a part of professional studios. These units trade portability for sheer light-giving power—even the most basic studio unit gives about 30 times as much light as a portable amateur unit. Until recently, however, studio and portable small units were generally used for different tasks. Studio units would be used as a reliable and consistent light source which would be modified, using diffusers or reflectors, whenever necessary. Portable units, until the advent of fast, ASA 200 and 400 films, were generally used simply to provide enough light to take a picture. This can still often be the case, but faster films and the greater versatility of flash units today have opened up wider possibilities for use of the light.

Uses of flash

You can use even the most unsophisticated units in a variety of ways in your photography—to isolate your subject by underexposing the background, for example, or to use a faster shutter speed and thereby "freeze" motion. In close-up work, one or two flash units are vital in overcoming the kind of lighting problems that occur at close quarters, in eliminating subject or camera motion from the picture and in enabling you to compensate for reduced depth of field by using a small f-stop.

There are no rules as to when or where to use portable flash. Because of the hardness of the light, many photographers prefer to use it only as a secondary source: to fill in shadows (when shooting a strongly back-lit subject, for example) or as a rim-light, back-light, or side-light. The unnatural hardness of the light is often cited as one of the main defects of flash, particularly in portraiture, and some means of softening it—through bouncing or diffusing—is often recommended. But one only has to look at the work of Weegee or Diane Arbus to see how the stark unflattering light of direct flash can in fact be appropriate to some subjects.

There are many special effects possible with flash. Some models have a multiple-flash feature (a series of low-powered flashes, each a few milliseconds apart) which enable you to do the flowing kind of multiple-image motion work that used to be the exclusive province of a few professionals with very expensive gear.

Setting flash exposure

Because the duration of the light from a flash is so brief, its operation must be synchronized on FPS cameras with the operation of the shutter. Leaf-shutter cameras do not have this problem,

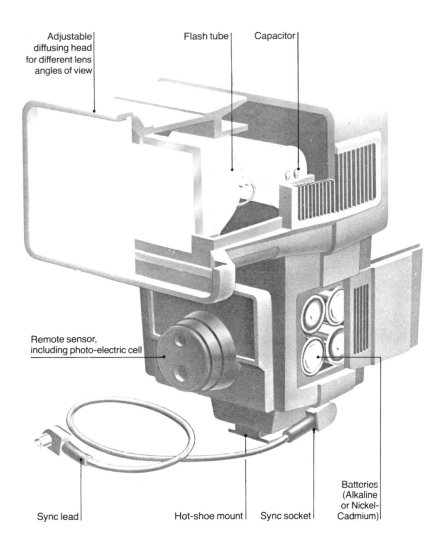

Adjustable diffusing head for different lens angles of view

Flash tube

Capacitor

Remote sensor, including photo-electric cell

Sync lead

Hot-shoe mount

Sync socket

Batteries (Alkaline or Nickel-Cadmium)

A typical modern electronic flash unit is extremely advanced compared to models of even a few years ago. Most now not only offer more power in smaller units, but also have auto-exposure control over a range of several f-stops, incorporate energy-saving thyristor circuitry, allow automation in bounce flash, and accept a variety of power sources and reflector attachments.

Because of the generally undesirable lighting given by direct on-camera flash, flash manufacturers have made a considerable effort to make their units

flexible so that the light can be diffused even when on-camera. Many, like this Sunpak unit, can tilt or swivel their reflectors horizontally or vertically.

Combined with auto-exposure control, this feature permits wall or ceiling bounce lighting with the convenience of on-camera flash.

but the action of the focal-plane shutter means that, if the flash is not synchronized, then you will obtain either a partly exposed image (the shutter speed was too fast) or a double exposure (the shutter speed was too slow). 35mm SLR cameras have a single speed for synchronization, usually 1/60sec, 1/90sec, or 1/125sec. With the flash connected to the camera's hot-shoe and this X-synch speed set, there should be proper synchronization.

With the shutter speed set, you use the aperture alone to control expo-

sure. Exposure depends primarily on the distance from the flash to the subject. As this distance increases, the light from the flash disperses proportionally and you must compensate for this by opening up the lens further. Manual units include recommended working apertures for a given film speed and subject distance, or they can be calculated from the unit's guide number (GN), which is an indication of the unit's power. For example, a typical small manual unit will have a GN of 30 for ASA 25 film. This means

that it will have a GN of 120 for ASA 400 film, since this film is four times as fast. To calculate exposure (aperture setting) for a subject you divide the subject distance into the appropriate GN. Thus, using ASA 400 film and with your subject 20ft away, you should set f/5.6 on your lens.

There are three types of portable electronic flash currently available: manual, automatic, and dedicated. Their basic difference lies less in the power or versatility of their output and more in the means of setting exposure.

Manual units

Small, manual flash units are the basic, cheapest flash units currently available. Most have guide numbers of between 30 and 40 (ASA 25 film), which is certainly enough power for most situations. Although they lack, in nearly every case, movable heads or energy-saving circuitry, they are ideal units for fill-in lighting or as secondary "slave" units. If you intend to do a lot of photography with flash, however, it is worth spending the extra on a larger unit with thyristor circuiry.

Automatic units

Even with "automatic" units, the key element in using flash is getting the best exposure, and this depends primarily on the distance from the flash to the subject. As this distance increases, the light from the flash disperses and becomes less bright, and you must adjust your lens aperture (or flash output) accordingly. On manual units, working apertures are recommended for different subject distances—increasing with the distance—within the unit's range. Automatic units have sensor circuits which adjust the duration of the flash according to

Small pocket flash units, like this Vivitar model, are very practical for fill-in lighting or for carrying around with you. Most such units are powered by AA batteries and have a guide number of around 30–40.

the light reflected back from the subject. You still set the f-stop from a calculator dial on the unit, using the subject distance, to get the desired exposures.

Two main problems occur with sensor units: first, filters, tele-convertors, and the like need extra exposure which the sensor cannot account for; second, you must make sure that your sensor is pointing directly at your subject. Certain poorly designed units include tilt-heads that also tilt the sensor, thus making it redundant.

The invention of the thyristor circuit made the truly portable automatic electronic flash possible. Early automatic units controlled exposure by measuring the amount of light reflected back from the subject during the

Vivitar's popular 283 electronic flash unit has helped give shoe-mount units a more professional image. Its auto-exposure sensor permits a choice of 4 f-stops, can be used in remote operation and works to camera/subject distances of 43ft. Among its numerous accessories is a rapid ni-cad charger and battery pack that fully charges in a speedy 15 mins. It also has a good guide number of 60 with ASA 25 film.

discharge of the main flash tube with a photo-electric cell. When there was sufficient light for exposure, the main flash tube was shut off and the excess energy transferred into a second flash tube, which emitted no visible illumination. The flash always discharged all of its energy, whether that energy was needed or not. Obviously this was wasteful, resulting as it did in long recycling times, however close you might be working, and short battery life.

Nearly all modern automatic units now incorporate a thyristor circuit which eliminates the second "black" tube. With thyristor circuitry an elec-tronic-flash unit saves the energy left in the capacitor after the flash tube has generated enough light for exposure. This feature increases the performance of units of every size considerably. For example, when used over short distances with large apertures, a thyristor flash unit can manage to recycle at rates as high as two flashes per second—fast enough to keep up with a power-winder. High-voltage battery-pack adapters that plug into the flash units reduce the recycling time even more and permit working at longer distances with smaller apertures, or even with motor-drives.

Electronic-flash systems

Electronic-flash systems offering a whole range of accessories are available for those who feel they need such gadgetry. Vivitar was one of the first to introduce these accessories and their 283 unit has probably the most comprehensive selection of attachments. Not only does it have a clip-on lens to give wide-angle coverage (although many flash units have an angle of coverage of over 65°, enough for a 28mm lens), but also a lens for moderate telephotos that concentrates the light. With a wide-angle attachment the light given by the flash is effectively reduced because it has been spread over a wider area, and you must compensate for this in your exposure. Conversely, with the telephoto attachment the output is concentrated, so that the effective light output is increased and the operating range is also greater. The Vivitar unit also offers various filters to color the light, and a neutral density filter to reduce the intensity of the light for close-up work.

But the two most useful features of system units are the detachable remote

sensors and their choice of different power sources. The detachable sensor enables you to use the flash off-camera on automatic. Normally this creates problems in getting the right exposure, as the unit's automatic sensor would not be reading the same light that reaches the lens. But an accessory sensor mounted in the camera's hot-shoe and connected to the flash by a cord ensures that exposure is determined by the light reaching the lens.

The Sunpak Auto 522 "potato masher" features Sunpak's unusual but very useful exposure control. Like most other units, the 522D permits multiple f-stop control, but it also allows you to manually cut the power to as little as 1/64 the full output. This allows you to control lighting ratios accurately for multi-flash shots, macro work, and fill-in lighting.

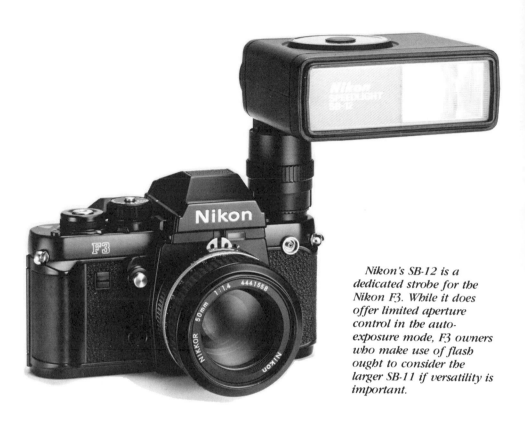

Nikon's SB-12 is a dedicated strobe for the Nikon F3. While it does offer limited aperture control in the auto-exposure mode, F3 owners who make use of flash ought to consider the larger SB-11 if versatility is important.

Remote sensors are practically indispensible to any electronic flash system, as they allow you to position the flash anywhere off-camera and still retain auto-exposure control through the sensor in the camera's hot shoe. This Sunpak unit is typical: it works over a four stop range and multiple settings.

The Olympus OM flash system's reputation is based around the Olympus OM-2N 35mm SLR. The OM-2N has a unique metering system that meters light off the film plane during exposure, and this means that both normal and flash exposure is simplified and very reliable.

The most common power source for portable electronic flash is two or four AA alkaline cells, which give anywhere between 80 and 200 full-power flashes. Energy-saving thyristor circuitry and close-up work will increase this potential several times. Units larger in size and capacity are generally powered by rechargeable nickel-cadmium (ni-cad) cells which will recycle the unit in about half the time but give less flashes before needing recharging than alkaline batteries. Nearly all system units can take either the alkaline or the ni-cad batteries and will also work directly off your domestic power supply. With any type of work, these options are very useful. In the long run, re-moveable rechargeable ni-cad cells are likely to be the most practical, and it is worth the extra expense to purchase the cells and their charger. Full recharging takes several hours for most units. Vivitar's 283 unit, however, operates with an incredibly fast recycling time of only 15 mins.

Dedicated flash
The latest and most sophisticated flash units to appear are the integrated, or dedicated flash made specifically for certain cameras. On these cameras they will automatically set the shutter speed, or aperture, or both. On other cameras they will work automatically in the normal way.

Canon's latest dedicated flash system, the Speedlight 199A, is typical of such units. When mounted on Canon A-1 or AE-1 cameras, this system automatically sets the camera's shutter speed and aperture to match X-synch requirements and the ASA and subject distance settings you make on the flash. As in a normal "automatic" unit, the flash head's built-in sensor operates the thyristor circuitry in order to control light output.

Olympus OM-2, the Nikon F3, and the Contax 137 and 139 all boast dedicated flash systems that are controlled by the camera's own TTL metering systems. The meter cells, located on the floor of the mirror box, actually measure the amount of light during the exposure that bounces off the film. When the film has been properly exposed, the power is cut off, via energy-saving circuitry. These systems also automatically set the shutter speed to its X-synch rate, read the lens-aperture set, and provide a ready-light in the viewfinder when the unit has fully recharged. The ready-light in the F3 blinks when the Nikon SB-11 or SB-12 Speedlight is incorrectly mounted, or after an improperly exposed frame has been shot; and the ready-light in the OM-2 and Contax cameras will also tell if the last frame was properly exposed.

Besides metering sophistication, all units offer fast recycling time. The Olympus T-32 flash, when equipped with an accessory grip containing an optional set of batteries, can keep up with the OM-2's motor-drive at most camera/subject distances—a feat previously limited to expensive non-portable strobe units.

Several independent companies have announced a type of electronic-flash product that is a hybrid of the dedicated flash. This latest development is system flash with interchangeable feet, allowing it to be used with several different cameras as a fully dedicated unit. The Sunpak Auto 422D, for example, will work in its automatic mode on the Olympus OM-2, or with a change of feet, as a stand-alone automatic-system flash. Other feet will be made available to allow fully automatic dedicated operation on other cameras designed to utilize dedicated flash.

Ring lights

Ring lights are electronic-flash systems in which the flash tube is circular and fitted to a circular reflector which fits on to the front flange of the camera lens. Ring lights are not meant for general photography, but were developed to provide soft, shadowless sources of light ideal for macro-light; and they are capable of illuminating tiny subjects only inches or less from the front element of the lens.

The Olympus OM-2 has probably the most advanced automatic dedicated ring-light unit on the market that eliminates the problem of exposure determination at high magnifications. With the Olympus system the exposure light itself is read, as it is reflected from the film into tiny meter cells on the floor of the mirror box, to control the output of the ring light.

One problem with ring lights is the fact that their output is, for all practical purposes, shadowless; so modeling, which depends on strong contrast between light and shadow for its hard-edged effect, is difficult to achieve. Canon has recognized this and has designed a variation of the ring light that can vary the quality of its lighting. The

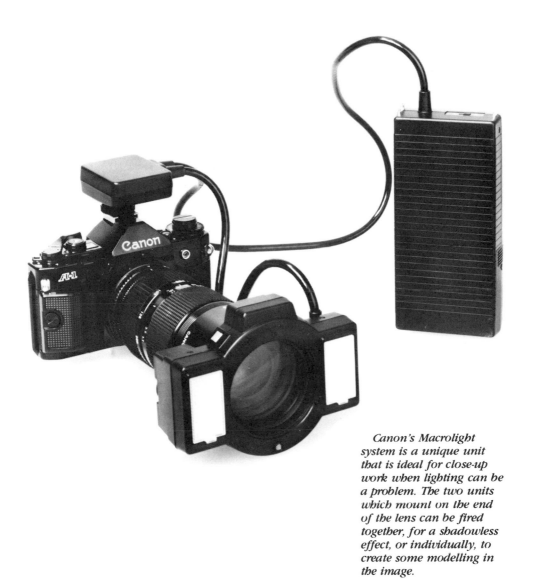

Canon's Macrolight system is a unique unit that is ideal for close-up work when lighting can be a problem. The two units which mount on the end of the lens can be fired together, for a shadowless effect, or individually, to create some modelling in the image.

Canon Macrolite ML-1 consists of a bracket holding two tiny electronic-flash tubes in reflectors that mounts on the front flange of a camera lens. Either or both of the tubes may be fired, at various angles to the subject. This al-lows the user of the Macrolite ML-1 a choice that ranges from shadowless diffused illumination (one tube fired at a sharp angle) to more direct light that accentuates contrasts (both tubes fired directly at the subject).

MOTOR-DRIVES AND POWER-WINDERS

Motor-drives and power-winders are a lot older than most photographers realize. The German Robot Camera was motorized in 1937, a baseplate drive was offered for Leicas only some months later, and the French Sept, an 18x24mm "half frame" camera was churning out motorized snaps in the 1920s. These early motors, and even some postwar followers like the Bell & Howell Foton, used no batteries. They were spring-driven, powerful, and fast. Indeed, it is only in the very recent past that a few 35mm electrically-driven cameras could match the framing rates of the fastest spring-powered cameras. Fotons and Robots gave six frames per second long before Nikon even had a pentaprism.

Modern motor-drive developments
Though modern battery-powered motor-drives are generally slower, they do offer two fundamental advantages over the clock-work motor of the Robot and its kind. First, they are gentler, and more easily controlled. With a motor-drive one always faces the possibility that the motor will actuate itself and start turning before the camera shutter has completed the exposure. In a modern SLR, with its instant-return mirror, instant-reopening lens diaphragm, and reciprocating focal-plane shutter, this can only spell disaster. Electrical devices can be timed more easily to reduce the risk of such unthinkable internal disasters. The second advantage of electrical motor-drives lies in its power source. No form of energy is so easily transmitted as electricity.

The Praktina FX was a very early spring-driven motorized SLR that provided single-frame film advance. The Praktina was quite popular in its time because when it was combined with some of its long lenses, it was excellent for sports and other events.

All you need is a length of wire, and you can control a battery-powered camera from a distance. (The larger SLR systems—Nikon, Canon, Olympus, and the like—offer a variety of radio transmitter remote devices for firing your camera.) Obviously, this is not so easy with spring-driven cameras, which depend on things like fingers or thumbs. If you want to fire remotely, in any case you need something like an electromagnet, operated from batteries and these are already present in modern motor-drives.

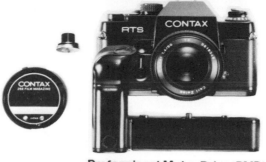

Professional Motor Drive [PMD]

250 Film Magazine

250 Film Back

PMD Power Pack

AC Control Box [100V]

PMD Power Pack Jacket

PMD Control Cord 100

PMD Control Cord

Motor-drives today are like the cameras that they are designed to be used with—complete systems. Most systems, like this for Contax, include remote control equipment which is particularly useful for wildlife, sports, aerial, or surveillance work. A typical remote operation requires either an interval timer and long cable release, or a radio transmitter and receiver to fire the camera. Frames, singly or several at a time, can generally be fired by the photographer or at pre-set intervals. For remote photography, your camera should be sturdily mounted and preferably be fitted with a bulk film back. An automatic-exposure system is a great asset for remote work.

The post-war electric-motor boom started, not unusually, with Nikon's in their discontinued CRF cameras. Professionals wanted to take pictures faster than they could with thumb-operated lever winds, and again for two reasons. First, the photojournalist lives in fear of pressing down on an un-cocked shutter, losing some fleeting moment of immortality. The motor-drive gives the quick-shooting professional something much closer to the ideal of an ever-ready camera than can be had by mechanical means alone. The second raison d'être for the motor-drive is sequence photography—following an action through its paces with repeated exposures. After all, the ability to freeze motion, often capturing events that the eye misses, is possibly the characterizing feature of photography as a medium. As early as 1874 Eadweard Muybridge produced his famous sequence photographs that established the true movements of a galloping horse. Today, every action photographer from John Zimmerman to Gerry Cranham uses several motor-drives and some specialized high-speed cameras.

Motor-drives are very much in fashion: every major 35mm SLR family today has a model with a maximum potential of 3 to 6 frames-per-second (fps). This means they can run through a 36-shot reel in 6 to 12 seconds, and in terms of film this can be very costly. A power-winder is a less-muscled version of a true motor-drive, and will usually give a maximum cycling rate of a calmer 2 fps. Winders were introduced a few years ago as an amateur-oriented (but still exciting) alternative to the faster motor-drives, which are bigger, heavier, and costlier. If a power-winder has any practical justification, it is that same desire for an ever-ready camera. Two-frames-per-second may be debatably fast or slow, but the fact is that a good photographer with a good thumb-lever camera can shoot at 2 fps with little effort. The logical conclusion should be to make the power-winder an integral part of the camera itself, buried among all of its other innards. This is what Konica thought with their FS-1, an idea that is already being followed by Yashica in the Contax 137, and doubtlessly will be by practically everybody else.

In the main, power-winders attach to the camera baseplate, hug its architectural outline, add only about an inch and a half more height and not much additional weight. They are also reasonably affordable, costing a third or less of the price for a motor-drive. Certain types of photographers find them

This Canon VI-T is a very simple "motor" camera which uses a base trigger winder that is manually operated but very fast. Canon cameras of this vintage had very good range-finders and accessory lenses but unreliable shutters.

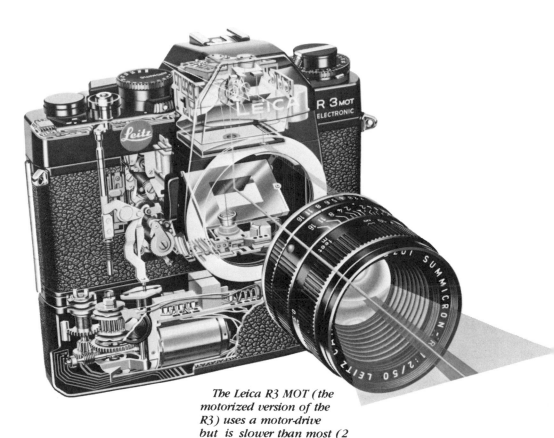

The Leica R3 MOT (the motorized version of the R3) uses a motor-drive but is slower than most (2 fps). It works well with the Leitz-Copal shutter.

either indispensable or at least very handy. When fashion photographers use 35mm, they almost always use the camera vertically so that the image is better suited to the proportions of a magazine page (or the models themselves!). But, because 35mm cameras are designed for horizontal lever-action they use a motor-drive to wind-on film without having to remove the camera from their eye. Another argument for motor-drives applies when the end-result is a 35mm color transparency and you require dupes. Dupes are costly, and their quality is questionable.

Use with a power-winder or high-speed motor-drive and you've got your extra slides immediately.

Because most of the motor-drives and/or power-winders offered by the major 35mm SLR systems are basically similar, your initial choice of a camera brand should not depend upon the qualities or characteristics of its motorization. Exceptions to this rule crop up from time to time. If you're really looking for the fastest drive on the mass market in 35mm, Nikon F3 has its 3-to-6 fps MD-4 unit. On the other side, that lump they hang underneath the

Leica M4-2 might put you off range-finder photography permanently. But generally you can choose your SLR or any other camera by its camera-body characteristics, or by the optical opportunities of its interchangeable lenses. Take it from a jaundiced eye: if you've seen one motor-drive you've almost seen the lot.

Electrical re-winding

All the companies that don't have electrical re-winding will tell you how dangerous this is because of the resultant static-electricity discharges (these leave tiny marks on your film as the sparks expose the sensitive emulsion) and scratches. Nonsense. Nikon's new MD-4 for the Nikon F3 is their second electric-rewinding model, and the Minolta XK-M (which has a big baseplate-style motor-drive permanently built onto the camera body) was rewinding electrically five years ago without these problems. (So do some smaller 18x24mm models, like the old Olympus EM.) Static is not a real problem. Motor-drives are already pulling the film forward faster than any electrical rewind mechanism is pulling it backward, and even high-speed motor-drives don't produce speeds much different from those generated by hitting a thumb-lever advance with full force.

The bulk-back question

Another consideration when choosing a camera/motor-drive combination is the availability of a bulk-back. Since motorized cameras go through film at a furious pace, shooting 36 frames in a matter of seconds, a bulk-back is an important accessory if you want to avoid losing precious time in reloading. Bulk-backs replace the normal camera back and have their own film

and take-up chambers. They are usually provided with light-tight cartridges for both these compartments, which will take about 33 ft (250 frames) of film (a 36-exposure roll is about five feet long). Aside from their cost and size, one of their drawbacks is that you have to bulk-load your own cartridges and find a lab which will handle your 33-ft loads. Perhaps the most annoying problem with all bulk-backs is the omission of any kind of frame counter, so that unless you have a very good memory you can only guess when you are nearing the end of a reel.

The black-and-white photographer now has a cheap and practical alternative to buying a bulk-back that has recently arrived on the market, the Ilford 72-exposure Autowinder film. This is their HP-5 emulsion (ASA 400) coated on an ultra-thin film base (it is about half as thick as a regular base, but extra tough to resist tearing), enabling Ilford to cram 72 frames into a standard 35mm cartridge. Certainly this is an important advantage for motorized photography, but it does introduce its own problems. Because of its thin base, you have to take extra care that the film is firmly attached to the take-up spool. In addition, it will be twice as hard to keep flat in the film gate; after your frame counter passes '36' you will have to rely on your memory to know how many frames are left; and if you process your own film, you will have to buy extra-large processing reels (and here you may find the curling and twisting of the film an even greater annoyance).

Remote firing

This is an inherent (and exciting) capability of motor drives, and you should make sure that your model has

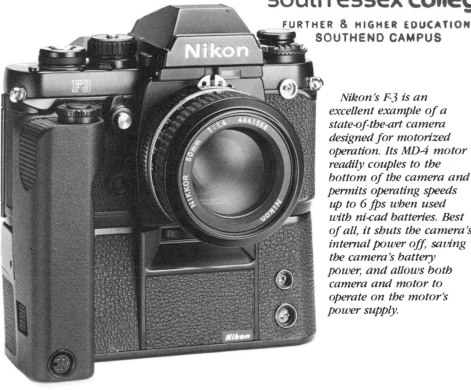

Nikon's F-3 is an excellent example of a state-of-the-art camera designed for motorized operation. Its MD-4 motor readily couples to the bottom of the camera and permits operating speeds up to 6 fps when used with ni-cad batteries. Best of all, it shuts the camera's internal power off, saving the camera's battery power, and allows both camera and motor to operate on the motor's power supply.

some kind of plug to permit firing by means of an electric wire, or that it can be operated by one of those ultra-sophisticated radio controls of the sort employed to control model airplanes. Radio control is just the beginning of the remote possibilities with a motor-drive. With a little electronic ingenuity or a small outlay, you can attach devices that will operate your unattended camera when a light goes on or off, a noise is made, the temperature changes, and so on, and so on. Several professional-camera manufacturers include this sort of equipment in their systems, but the most impressive selection is offered by Nikon with not one but two intervalometers, an elaborate light-linked remote control, and a radio remote unit.

Caring for the film

In these high-speed designs, it's essential to have an electrical cut-off linked to the frame-counter. On the back of the drive you can set a number corresponding to a frame number, and after this frame has been fired the unit stops. If it doesn't you run the risk of ripping the film off of its supply spindle. Kodak films are very strongly taped onto their cores, and such mishaps merely result in filling the chamber with torn perforation spacings, and sometimes stripping gears. But should this happen with one of the new ultra-strength polyester-base films, like Ilford's Autowinder Film or Kodak's 2475 Recording Film, you will do permanent damage to your camera. When films aren't so ruggedly attached to the

35mm Accessories 89

supply core—and most European and Japanese films are not—the film is trapped on the camera's take-up spool until you can get into a darkroom (or a portable changing-bag) to rescue it without fogging. (You can tell if you've sucked the whole roll, tape and all, onto the take-up spool by pressing the rewind-release button and feeling the resistance when you manually operate the rewind crank. No resistance means no film left on the supply spool.)

It almost goes without saying that camera wear is a function of camera use; less obvious, but just as valid, is that camera wear is a function of operational speed. The faster you pump the frames through the camera, the harder the wear. Put both these facts together and you find that a motor-drive with its faster framing rates can do more for your camera repairman than it will for your photography. The slower pace of a power-winder, plus the fact that winders require the shut-ter button to be depressed for each frame fired, may cause you to opt for a winder if you want to see your camera survive to a comfortable old age.

While it is true that motor-drives are fast, no drive can be faster than the shutter curtains and still record images. Motor-drive frame rates are a function of the shutter speed selected. Most often, 1/60 sec is the most important gating speed, since high framing rates are impossible at slower shutter speeds, but this limitation varies from camera to camera and should be thoroughly investigated before you purchase any drive that claims to be "super fast".

One inconsistency among motor-drives is the use of a frame counter. Most drives, but not all, have it. If being able to fire off a burst of a pre-set number of frames while holding the trigger button depressed is important to you, check to make sure this option is available. Some, but not all, motor-drives

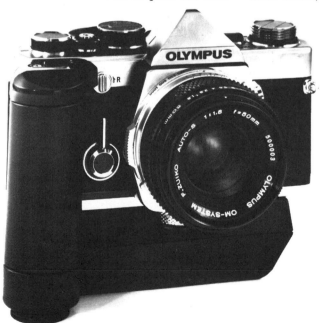

The Olympus OM-1 exemplifies some of the precautions necessary when using motor-drives. A small, lightweight camera promising a system as extensive as Nikon's, the OM-1 is a less durable mechanism (lighter weight means thinner parts), and thus one particularly prone to the dangers from motor-drive overuse.

also demand that you tell them the rate at which you want to shoot your pictures. That means that you have two more control-knob settings to remember prior to each take. If only on the principle that it is better for you to be in control of the camera, rather than vice versa, this feature seems preferable to allowing the motor-drive to determine the rate of exposure.

Flash and camera connections
Some automatic cameras come with provision for motors or winders. If the camera is an aperture-priority machine, it will automatically revise its shutter speed constantly, and thereby at times its framing rate, if you pan from sunlight to shadow, for example.

Remember that if noise is a consideration, and it is in photographing wild-life or certain sports, like gymnastics, you'd do well to avoid both winders and motors, though of the two winders are probably the least offensive. Noise levels vary, with Leica CRF cameras probably offering the quietest.

There isn't an on-camera flash in the world with a recycling rate fast enough to maintain the firing rate of a high-speed motor-drive for long, though some of the thyrister-circuited automatic ones can keep up at reduced framing rates, and even then only if the subject is no more than a few (two to three) feet away, the lens is wide open, and only a few frames are being shot. In general, on-camera electronic flash and motor-drive or power-winder should be thought of as incompatible under ordinary circumstances.

These days film loading/unloading is not impeded by motor-drives or power-winders, though this was not always so. You won't have to consider this problem unless you are looking for an old used camera with motor-drive.

Using the motor-drive wisely
The real danger of motor-drive photography isn't what it can do to the camera, but to the photographer. The motor-drive can be a security blanket of illusion. The fact is that the camera will be closed and unseeing for more time than it is recording. To take a prime example: in any sequence of action shots, even if you do time the first exposure perfectly, it is the motor-drive that controls every shot after that one. Of course, you will have plenty of pictures and some are likely to be better than others, but this approach was the basis for George Bernard Shaw's remark that "the [Leica] photographer is like a codfish that lays 100,000 eggs in the hope that one will bear fruition."

Motor-drives should be used only when really applicable, and then sparingly. They give the photographer a "second strike" capability of questionable value. Good photography, in particular good sports, action, and general-sequence photography, depends on getting the right images at the right time, rather than certain number of exposures, and this does not require a motor-drive.

HULCHER CAMERAS

The Hulcher 70 is a lightweight medium-format Hulcher giving 2¼×2¼in images. Ideal for aerial photography, it can run anywhere between 5 and 15fps and take 150ft of thin-based 70mm film.

The 112 Hulcher can fire up to 60fps and is probably the fastest 35mm camera you can get. The basic camera is surprisingly compact, but for very fast framing rates an added power unit must be fitted to its base. Continuous focusing is possible through the use of a beam splitter that allows about 70% of the light to reach the film and about 30% for focusing. The bulk back takes 100ft of standard film.

For those photographers who become bored with the pedestrian rates of standard motor-drives, there is always a Hulcher. Charles Hulcher, based in the United States, makes several custom-order still cameras, originally designed for scientific use, that can stop the motion of a bullet or the service of Bjorn Borg. Framing rates of Hulchers can be set at anything up to an incredible 60fps and, unlike movie cameras, the film in a Hulcher stops for each exposure so that the prints are as sharp as from a normal still camera. Although Hulchers don't come cheap, many photographers outside scientific and technical fields, in sports and action photography, have found a place for them alongside more conventional equipment.

ROBOT CAMERAS

Two Robot Star models are available: the Star 25

(25 exposures) and the Star 50 (50 exposures).

Both produce 24×24mm images on 35mm film.

The Robot Motor-Recorder replaces the characteristic spring motor of other Robot cameras with an electric motor

with a top speed of 3fps. Shown here are the bulk magazines, taking up to 500ft in film.

Chances are you will never see a Robot camera, but they do have their place in photography. Long before motor-drives appeared for 35mm SLR cameras Robots offered this as a built-in feature for scientific research and other special applications where fast sequences or remote operation is required. Lenses for the Robot range from 24mm to 360mm.

The Robot-Star is billed as the "world's fastest 35mm camera," some-thing that does not hold up easily in light of other modern machines, but it is fast for a spring motor-drive camera. The 7fps spring motor is part of two Star models, one for 25 exposures and one for 50 exposures. Spring motors are not considered to be very reliable and these cameras are not cheap, but photographers have continued to choose Robots, and the reason for this is probably their excellent inter-changeable Schneider optics.

Tripods

Tripods and camera supports are probably one of the least glamorous and consequently least discussed types of photographic equipment. How you feel about them probably depends on the kind of photography you are most interested in. Photographers who work primarily in studios with large– or medium–format cameras can't conceive of life without them. On the other hand, 35mm SLR or CRF owners often look upon tripods as abominations. Still, even with these smaller formats there are many situations when a tripod is essential. If you're using a telephoto lens, for example, or if you want to use a slow shutter speed (under, say $\frac{1}{30}$ sec, with a "normal" lens), or if you want to do the kind of still-life work that requires fine control over the camera distance and angle, a tripod is obviously invaluable.

Weight and stability

While any tripod is inherently stable when resting undisturbed on a solid support, ideal conditions seldom exist in the real world. Wind and vibration will buffet it, and even the apparently solid support of a polished floor can become unstable if the tips of the tripod legs slide over its waxed surface, causing the poor device to do a three-way split.

Although initially a light-weight tripod might seem to be the best choice for travel or field photography because of its portability, it is almost axiomatic that a light tripod is a poor tripod. In a breeze, light tripods react like saplings: they bend and they sway. Even middle-weights vibrate in a bit of wind, sometimes at frequencies and amplitudes that you can't even see or feel. As a result, instead of the clear, sharp

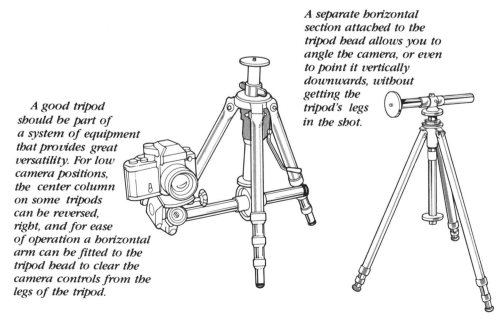

A separate horizontal section attached to the tripod head allows you to angle the camera, or even to point it vertically downwards, without getting the tripod's legs in the shot.

A good tripod should be part of a system of equipment that provides great versatility. For low camera positions, the center column on some tripods can be reversed, right, and for ease of operation a horizontal arm can be fitted to the tripod head to clear the camera controls from the legs of the tripod.

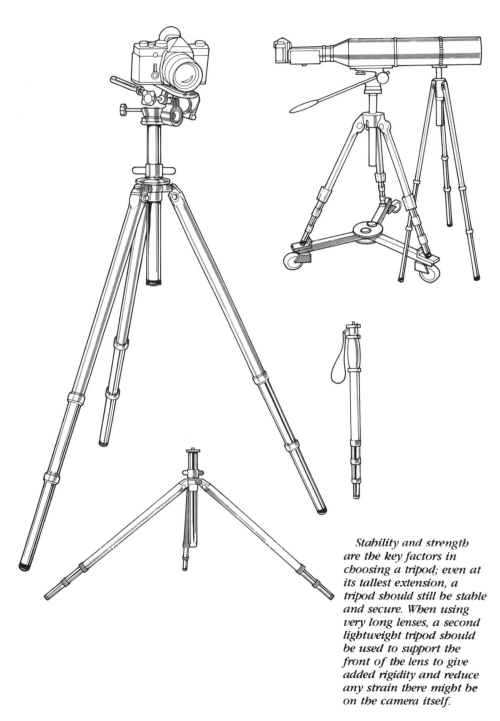

Stability and strength are the key factors in choosing a tripod; even at its tallest extension, a tripod should still be stable and secure. When using very long lenses, a second lightweight tripod should be used to support the front of the lens to give added rigidity and reduce any strain there might be on the camera itself.

pictures that you set up your tripod to get, you'll wind up with a series of blurry blotches.

So do avoid light tripods: they're worse than useless. However, if you do find yourself in a situation where you need to stabilize your tripod, try filling a pail or can with water or sand and tying it to the top of the tripod (before you've mounted your camera) so that the container hangs suspended between its legs. But be careful to start with a small amount of ballast and only gradually increase it to attain maximum stability, so that you avoid collapsing the tripod.

Stability and leg design

Obviously, the design and construction of a tripod's legs will have a good deal to do with determining its basic stability. Virtually all tripods feature extendable legs. While the tubular design is probably the most common, other designs are just as strong and can provide various advantages. C-channel aluminum, for example, can accommodate flip-style locks, which are quicker to use than twist-friction locks. The rectangular-tube design attempts to combine the rigidity and strength of the tubular design with the relative ease of the flip-style lock. Finally, of course, there are the heavy solid-wood legs of professional tripods; these pro-

vide stability, strength, and, naturally, weight that the other designs can't match.

Although the shape of its legs is an important contributor to a tripod's stability, other factors in its design are also important. The number of sections in the legs, for example, will determine both the convenience of a tripod's collapsed size and the thickness and durability of the material used to manufacture those legs. Again, while a light-weight or inexpensive design might seem appealing initially, it is important to remember that weight and stability are necessarily linked. Before buying any tripod, carefully test it for sturdiness by subjecting it to pressure, and watch to make sure that the legs don't buckle or slide. Then decide on your own compromise between weight, stability, and price.

The different types of leg-locks are also factors in a tripod's stability. Increasingly popular are lever-operated cam locks, or flip locks, which can vary widely in quality. Their advantage lies primarily in the speed with which they allow you to set up or break down a tripod, but if they are cheaply manufactured, they will tend to slip. In addition, when they are mounted on the outside of the legs, they can catch on objects, causing unforseen quick-release. When in doubt, look for the

Miniature tripods should be able to hold even fairly cumbersome equipment steady at low levels and should still allow a variety of camera positions.

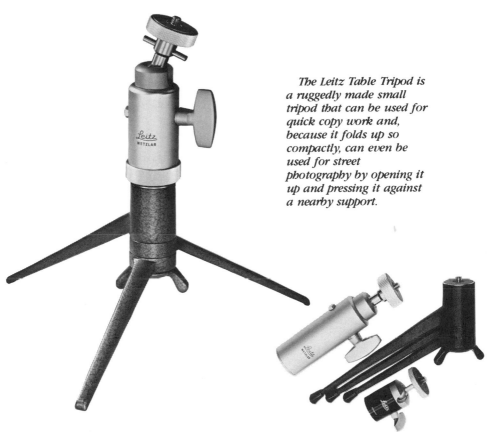

The Leitz Table Tripod is a ruggedly made small tripod that can be used for quick copy work and, because it folds up so compactly, can even be used for street photography by opening it up and pressing it against a nearby support.

old-fashioned type of tripod that uses knob-operated, screw type (twist-friction) locks.

Any good tripod should have some kind of dual leg-tip arrangement to give it stability on different surfaces. The most common arrangement is a steel spike inside the rubber pads. For use outdoors you can screw up the rubber pads out of the way of the spikes, and impale them into the ground as anchorage. Indoors, you screw the rubber pads down until the steel spikes disappear, and let your tripod rest on the pads.

Perhaps the best way to get your tripod to stand still is to spread its legs as far as they will go, and lock them

that way. You can lock tripod legs in a more secure way using the collapsible three-legged brace anchored to the tripod's center tube (not all tripods have center tubes, but those that don't are probably too light anyway). The trouble with this solution is that sometimes there just isn't room enough to spread the tripod legs out to their stops and still get enough elevation. To get elevation you have to extend the tripod legs, and the further you extend the legs, the more room the fully spread legs require: it's a vicious circle. One answer is to find a tripod with a lower-leg brace that slides up and down the center tube. This type of brace either can be locked

The Slik 1200G combines light weight and compact portability with a versatility that makes it a useful all-purpose camera support. With its Multi-Directional Tilting Center Column, it can serve as a high-angle or low-angle tripod, copystand, light stand, or microphone boom; while the center column itself, which extends to 100in, can be detached from the 1200G and used as a monopod.

at intermediate settings or else has so much friction in its joints that it won't slip easily.

The center tube is another item worthy of consideration. It, too, must be substantial, because when it is fully extended from the apex of the tripod, it is essentially a monopod in the middle of the tripod. If at all possible, keep the center post retracted outdoors or where any vibrations are present, since it will only make your tripod more sensitive to such disruptions. Of course, in a quiet, vibration- and breeze-free studio, a long, substantial center post can be a very useful feature indeed.

High and low working heights

Height is an important consideration in choosing a tripod. Four and a half to five and a half feet is the range for typical shooting. A tripod should also collapse to a manageable size, although, as mentioned earlier, it should do so with a minimum sacrifice of strength

and stability in its operating position.

There are several small devices designed to hold a camera in position where a full-sized tripod can't be used. These devices are often called table-top tripods. E. Leitz has an excellent model with a choice of two different ball-and-socket heads. It is a well-made unit, but it ought to be, since complete with one of the heads, it costs about the same amount as a professional quality tripod with a pan/tilt head.

Another alternative, perhaps the best, is to simply remove the pan/tilt head from your normal tripod (the vast majority of them are fixed to the tripod shoulder with a single screw and are easy to remove) and mount it on a Bogen Superclamp. So mounted, your pan/tilt head can easily be affixed to any surface up to two inches thick the width that will fit between the jaws of the Superclamp.

Still another possibility is the peculiar device called the Saunders-Omega

Magnetic Easel Base. This unit is normally used in the darkroom for positioning easels at odd angles, but when its magnetic top plate is unscrewed and a camera is screwed on in its place, it becomes a first rate table-top tripod that can be rigidly attached to any smooth, non-porous surface, by means of its vacuum base.

Monopods and other supports

A monopod is normally used in very cramped situations, since its one leg allows it to manouever in spaces where a tripod can't. It can take any type of tripod head, but doesn't really need the pan or tilt features, since those can be nearly duplicated by manipulating the monopod itself.

Like monopods, pistol grips require that you use your body to brace your camera, but they can be very helpful for use with telephoto or zoom lenses. The grip has a trigger attached by a cable release to the camera's shutter

release, allowing for a smooth and vibrationless firing.

The cheapest, and certainly the easiest to use, of all types of camera supports is one you can make at home—a beanbag stuffed with styrofoam pellets. This serves to cushion the camera when you rest it on some firm object for support.

Tripod heads

The pan/tilt head on a tripod is very important and should be selected carefully. Very heavy, very expensive, professional tripods end abruptly with a flat platform atop the apex or center tube, and you can select from the range of heavy, expensive pan/tilt heads that will crown your tripod. Tripods of medium and low price often come equipped with a pan/tilt head.

Pan/tilt heads have three basic movements. Two of them are tilts, the other is pan. Pan is probably more important to movie-camera operation

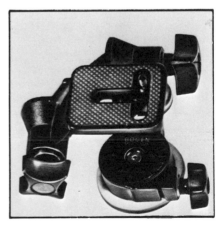

Mounting a camera securely in places that are too confined or otherwise inconvenient for a tripod is always a problem.

Bogen's Superclamp accepts a pan tilt head and can be attached to a pole, table or other surface up to 2in thick.

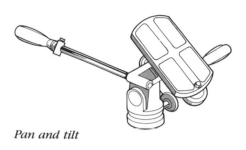

Pan and tilt

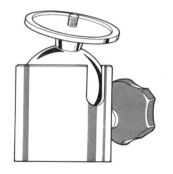

Monoball

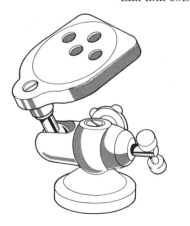

Ball and socket

than it is to the use of still cameras. If the movement is a good one, it allows you to swing the camera smoothly around the horizon to follow action. Pan movement should be damped (restrained) to prevent either quick, jerky motions or overshooting the desired pan distance. The movement must be very smooth otherwise it will be visible in the images shot during the pan. The pan motion for still-camera application can often be a bit shaky and remain acceptable because most still cameras are brought to a halt before the shutter is tripped. The important exception here is when pan motion is used to take a still shot with a slow shutter speed, as, for example, in the type of still photograph that employs blurred lines to impart a sense of motion.

Some inexpensive tripod heads don't have a pan motion at all. Such units do not have geared center tubes but instead offer a clamped friction collar to control center tube extension. With such tripods you free the center tube clamp and pan the whole center tube. But be very careful if you do this when the center tube is extended, because if you let the camera slip, both it and the center tube will slide down to the tripod collar.

Tilts enable you to swing the camera from horizontal to vertical and to reach any intermediate setting in either of two mutually perpendicular vertical planes; that is, the tilt movement lets you point the camera up and down. Good tilt movement is damped, smooth, and lockable, although the movement can be a bit shaky and still remain acceptable.

The primary features to look for in pan/tilt heads are smooth, vibrationless motion with selectable friction drag for the pan motion (circular horizontal

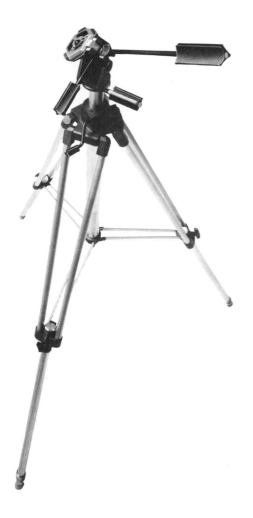

The Bogen 3040 is a versatile tripod with sufficient strength to hold a large-format camera. It has a crank-operated reversible centerpost, retractible spike cushion tipped feet, and a 73 in elevated height that can be stretched to 92 in with additional extension legs.

Bogen's Pan Head is designed for quick adjustment of the camera both horizontally and vertically with graduated tilt and pan markings and spirit levels for precise work. It also has a quick-mount plate system for rapid camera changes.

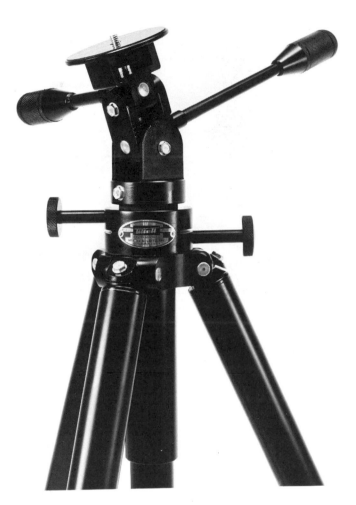

The Tiltall, now made by Leitz, is probably the world's most famous tripod. While there have been copies of it, the Tiltall has been unequalled for strength, stability and versatility in most photographer's eyes. Made almost entirely of heat-treated aluminum, it can handle cameras up to 4×5in in size and features a pan/tilt head on a reversible centerpost. Leitz also now makes a compact version of the original model with a black finish.

motion), easy adjustment of the two tilt axis movements, solid locks for all three motions, ease of camera mounting, incorporation of bubble levels for camera leveling, quick-disconnect pads to allow fast camera changes, and, of course, strong, heavy construction.

Ball-and-socket heads on the other hand, have a single lock control. Release that, and the camera can be moved to any designed position. The biggest advantage to ball-and-socket heads is the speed with which the camera can be repositioned.

Choosing a model

Most of the best tripods are of the very heavy, professional type, and they are the only ones you should consider, even if it's only a little Olympus OM-1 you want to mount.

There are several highly regarded tripods offered by Davis and Sanford, Gitzo, Bogen, Linhof, Slik, and Leitz. For general work, two units deserve special mention: the Bogen 3040 and the Tiltall.

The Bogen 3040 tripod (2-section) and the Bogen Model 3047 3-Way Pan

Head with mounting plate together weigh in at nine pounds, 14 ounces, but perform as well as units almost twice as heavy. The two-section legs feature a bi-post upper section and monopost lower. A set of extension legs can be obtained to convert the 3040 to use with 3-section legs to get a total elevation of 92in, if you are not content with the normal (two-section + elevated center post) elevation of 73in. Lower-leg extension is controlled by means of knob-operated screw locks, one to each leg. The screw-lockable, crank-operated centerpost is geared and offers 19in of travel. The centerpost is reversible for copying and low angle work. Minimum tripod elevation is 34½in. The legs are equipped with convertible cushion/spike tips, and for some reason there is a built-in spirit level in the shoulder.

The 3047 Pan Head is equipped with two spirit levels, one for each of the tilt axes, which are best used for camera leveling. Tilts and pan movements are controlled by means of long, oversized, easy-to-use knobs, and each screw locks solidly in place. The pan movement is smooth and well-damped. Perhaps the best feature this pan head offers is its quick-change camera pads. These are small, light, sturdy, hexagonal, aluminum-and-rubber plates that are attached to camera bodies and simply left in place during a take. A screw-locked chucking device allows you to disconnect the plate and the camera attached to it from the pan head in a single action, and to install another plate-mounted camera in its place quickly.

Justifiably the most famous name in tripods is Tiltall. Now distributed by Leitz, the acclaimed Tiltall design was the brainchild of two Italian brothers who ran an ice cream business in Manhattan. One of the brothers was a keen amateur photographer and, frustrated by the limited head movements of his tripod, he designed his own tripod head that could also tilt the camera. When the Depression hit their ice cream business, the brothers turned to making the heads full-time and later to making complete tripods in an all-metal design that was lighter and sturdier than that of contemporary tripods.

The modern Tiltall comes in two varieties: the standard and the compact. The compact unit extends to a maximum 49½in (compared with 70in for the standard), weighs less, and is a full 12in shorter when closed. The Tiltall head combines strength with ease-of-operation, making it the best all-round unit on the market today.

Data Backs

If your camera has a user-remove-able/replaceable back, there may be a data back in its manufacturer's line which will fit it. Data backs are designed to imprint data on film frames as they are being exposed. The most usual arrangement is for the back to imprint up to three two-digit numbers, thereby allowing you to add day/month/year, or day/hour/minute for future reference. Formerly, data backs required the user to set this data manually prior to each shot. Contemporary models are fully automatic, incorporating quartz, digital-watch movements that automatically and continuously keep the data current, right up to the instant the shutter button is pressed. The data is usually imaged inconspicuously in one corner of the frame.

One of the latest data backs is the Recordata Back 3 for the Olympus OM-1 and OM-2N cameras. It not only is fully automatic (you do, of course, have to set its clock initially, and select year/month/hour, or day/-hour/minute recording) but also has an LCD display on the camera back that lets you see the exact data being recorded on film, so that if you want to shoot at a precise instant all you need to do is watch the camera back until your time comes up, and then press the shutter button. The Recordata Back 3 is also unusual because with the latest model OM-1s and OM-2s it electrically couples directly when mounted on the camera. On most other data backs, as well as on older OM-1s and OM-2s, a synch-cord connection was required.

Hand-held exposure meters

Unless you're a born guesser, or a believer in those paper slips they pack with each roll of film, there's sure to be a light meter in your future. Most amateurs today trust light meters built into their cameras, measuring light coming through the lens (TTL). Professionals have been slower to accept inboard metering and still rely, at least partially, on separate or "hand-held" light meters.

Hand-held meters display at a glance all the possible aperture and shutter speed combinations for an exposure. Another reason for their popularity with pros is that they can be used to take very specific readings or to take readings without changing the camera's position when it is set up on a tripod.

Hand-held exposure meters measure either light reflected from the subject (brightness), or light falling on the subject (incident light), or both. Incident light, or "illumination" cannot be measured by built-in SLR meters. An incident light meter has a three-dimensional light receptor, usually shaped like half a ping-pong ball, and you take your measurements with the light-sensitive receptor pointing toward the camera from the subject position. This means that you're measuring the same light that's illuminating the scene. The reading is unaffected by the brightness or contrast of the subject, unlike reflected light readings. Incident light metering is especially favored by fashion and studio photographers in cases where subject illumination is produced by several lamps or other light sources.

Most reflected-light or "brightness-range" light meters (or dual-purpose exposure meters used in their reflected-light models) have an acceptance angle that permits them to measure light within a 30- or 40-degree angle. This means that you have to be careful about how you point the meter, and make sure that you're measuring the right part of the picture. TTL light meters make this a lot easier because the viewing screen shows exactly what's being measured.

There are several "spot meters," many of which measure reflected light in a tight one-degree field. This is usually shown as a little circle in the middle of some sort of a small telescope that serves as an aiming viewfinder. Some zoom-type light meters also give variably adjustable light-measuring fields which enable you, like spot meters, to cope with very contrasty lighting or to match the angles of various camera lenses.

Even if you have a built-in TTL-metering camera, a quality hand meter can be more than just an emergency backup. Incident-light meters give highlight-biased exposures that are best for color reversal (slide) films, meaning that they measure exposure more for the bright part of the scene than for the shadows, thus eliminating much of the danger of washed-out highlight areas. This is one reason why the bubble-type incident-light meter—originally called the Norwood Director—was invented by famous Hollywood cinematographer Karl Freund, and why this type remains the favorite among professionals of the motion-picture industry.

Much can also be said in favor of dividing your metering loyalties between an SLR's TTL system and a one-degree

Typical hand held meter characteristics

Meter	Type	Cell	Range EVS	Range ASA	Range f stops
Bewi Quick	Reflected	Selenium	6 to 19	1 to 3200	f/1.4 to 22
Copal/Sekonic Auto Leader L-188	Reflected	Cadmium sulfide	3 to 18	6 to 12,000	f/1 to 22
Copal/Sekonic Spot-View L-438	Reflected variable spot	Cadmium sulfide	3 to 18	6 to 64,000	f/1 to 90
Minolta Auto-Spot II Digital	Reflected 1° spot	Silicon	1 to 19.9	12 to 6400	f/1 to 90
Gossen Luna-Pro	Reflected and incident	Cadmium sulfide	–8 to 24	6 to 25,000	f/1 to 90
Minolta Autometer	Reflected and incident	Silicon	–4 to 17	6 to 25,000	f/1 to 90
Minolta Flashmeter III	Reflected and incident. Flash and continuous	Silicon	1 to 18.2	12 to 3200	f/1 to 90

All meters are battery-powered except Bewi Quick

Today's exposure meters offer a wide choice of options, and well-equipped photographers often own at least two meters, including perhaps a spot meter or a flash meter, to cover different tasks. System meters are the most popular for the serious advanced photographer because they offer greatest versatility. The lowly selenium meter should not be ignored, despite recent advances, because it works well in cold weather and requires no batteries.

spot meter. Often, this tight angle is the only really reliable way to measure accurate exposures. Don't let that one-degree statistic put you off: at a shooting distance of 25 ft, a one-degree measuring circle has a diameter of 5¼ inches. For circus, stage, and many other kinds of trickily illuminated indoor spectacles, there just isn't anything better than a one-degree spot.

Hand-held meter systems

As in cameras and flash units, there are systems in hand-held light meters. The Minolta Autometer II is an excellent example of the system hand-held meter. By simply interchanging its several bayonet–mount accessory components and setting a switch position, you can convert this one device from incident light measuring to reflected-light mea-

Remarks
Inexpensive, but limited range
Inexpensive but limited range
Spot angles:3°,4°,6°,10°
Illuminated digital readout
Accessory spot angles 7½° and 15°
Wide range of accessories including 10° spot. Motor-driven scales
Times 30sec to 1/1000 sec. Accessories include 10° spot and LCD digital read-out

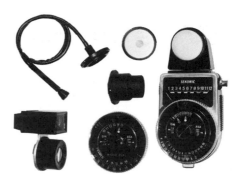

System is the byword in modern photography, and this Sekonic meter is an example of its use. The L-428 has a silicon photo diode receptor and can measure reflected or incident light, and illumination intensity. It also accepts a 10° spot attachment, an enlarging disc, microscope adapter, fiber optic probe, and a movie dial.

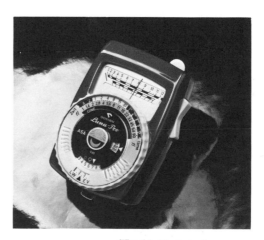

The highly popular Gossen Luna Pro is a good example of why hand-held meters are still very popular, despite the prevalence of built-in TTL meters. It boasts extreme sensitivity in either incident or reflected light use, gives all of the equivalent exposures at a glance and accepts five special attachments.

surement. Other accessories include, a standard spherical diffuser as well as optional 4X and 8X ND (neutral density) spherical diffusers for use when incident light is two to three full stops beyond the normal EV 17 range of the instrument. A flat accessory diffuser disk permits measurement of lighting ratios between main and auxiliary lighting sources and the determination

"EV" explained

EV stands for exposure value. Every exposure value represents all the combinations of shutter speeds and lens openings that will yield a perfect exposure of the light reflected from an 18%-gray card on a film of a given speed. For instance, if your reflected-light meter, be it hand-held or TTL, indicates that you should shoot Kodachrome 25 at f/4 at 1/30 second, it would be reading an EV of nine (EV 9). Several other aperture-/speed combinations satisfying EV 9 conditions would include f/1.4 at 1/250 sec, f/2 at 1/125 sec, f/8 at 8 sec, f/16 at 2 sec, and so on.

The diagram, right, will tell you the EV in any situation once you know the aperture and shutter speed. In the example illustrated, if your exposure is f/5.6 at 1/125 sec, the diagram shows that you are working with an exposure value of EV 12. You will sometimes see the notation EVS. It refers to an exposure value determined with film rated at ASA 100.

Light value (LV) is numerically equal to EV but unrelated to exposure. Strictly, an incident meter should be read in LV because it is measuring the light falling at some point in space. That point might be reflecting none of that light and so the measurement of light falling upon it would be irrelevent to a photographic exposure.

f. stop	E.V.	Time
		4min
		2min
1	-6	1min
1.9	-4	30sec
2	-2	15sec
2.8	0	8sec
4	2	4
5.6	4	2
8	6	1
11	8	1/2
16	10	1/4
22	12	1/8
32	14	1/15
45	16	1/30
64	18	1/60
		1/125
		1/250
		1/500
		1/1000

MINOLTA
Auto Meter II
System

The Minolta Auto Meter II is a second generation system meter that has been copied since its widespread acceptance by many professional photographers. It automatically adjusts for high or low light levels and uses a galvanometer that acts as a servo motor to set the exposure scales.

of illuminance. A spot mask (a flat, opaque disk with a small hole in its center) allows the use of the Auto-meter II as an on-easel enlarging spot meter in the darkroom. A Mini Receptor (a small spherical diffuser at the end of the long flexible arm) plugs into a socket at the base of the meter and enables incident light to be measured remote to the meter itself, in inaccessible or dangerous locations. There is even a device called a Booster, which, when plugged into the Auto-meter II enables you, for example, to read the luminance of a tiny spot on the groundglass of a view camera (TTL metering in an 8x10in camera is a convenience that has to be experienced to be believed). That exhausts the Auto-meter II's accessories for its incident reading mode but, with the flick of a switch the unit converts to a reflected light meter with a choice of either a

10 angle of acceptance attachment (which includes its own 10° viewfinder) or a 40 angle of acceptance attachment.

To make all of this even more interesting, Minolta has cleverly designed all the attachments so that they will work with another of their meters, the Flash Meter III. This device does everything the Autometer II does, except make low-light measurements (the Flash Meter III reads down to only EV 1 whereas the Autometer II reads all the way down to EV4). However, it will do even this with the addition of the Booster, which takes the Flash Meter III's range all the way down to EV6.3. In addition, though, the Flash Meter III can read the illuminance provided by electronic or bulb flash, or any combination of flash and continuous illumination. And its readout is digital (LCD) rather than analog.

35mm
Rangefinder
Cameras

Reflex cameras were known and used long before the invention of photography, when the camera obscura was used for sketching (or should we call this copying). From the time that 35mm really caught fire as the candid camera of the 1930s until the beginning of the 1960s, rangefinder focusing dominated the precision-camera field. The coupled rangefinder is a kind of optical distance meter built into the camera and coupled to the lens—even to a family of interchangeable lenses. Two great coupled-rangefinder (CRF) cameras actually established 35mm photography by their optical and mechanical excellence. These were the Leitz Leica II, and the Zeiss Contax I, both introduced in 1932.

Before these great CRFs, 35mm film was thought suitable only for motion-picture cameras—the original purpose of Oskar Barnack's first Leica was to test motion-picture film. Still-photography then was a world of big negatives and heavy, clumsy cameras. In those days, photographers pontificated upon the hopelessness of "miniature" (35mm) negatives, and there was a good deal of truth to their arguments. At that time, film was awful stuff (grainy, slow, inconsistent) compared to what we have available now. But, in spite of this, the irresistable logic of the speed, portability, dependability and hardiness of the little 35mm cameras somehow managed to prevail, and to win more and more converts, until, eventually, the 35mm format itself became respectable and the quality of 35mm film began to catch up with the mechanical and optical genius of the original CRF designs.

Today, the CRF is still the camera of choice by professionals from Elliot Porter to Lee Friedlander and, of course, Cartier-Bresson. A CRF enables them to do quiet, fast, unobtrusive work, under almost any lighting conditions. There is no big, noisy, flapping mirror in a CRF as there is in an SLR. There is just a little, almost inaudible click when the shutter is tripped. An equally quiet 35mm SLR may never come into being. All these properties, combined with the simplicity and near indestructability of the best of the CRF breed, to say nothing of the obvious high quality of the images they produce, guarantee that there will be CRFs among us for as long as there is film to load into them—35mm SLRs not withstanding.

The rangefinder focusing system

Rangefinder focusing was, and still is, very much more accurate than any sort of SLR screenery. This is because CRF focusing doesn't depend upon the relatively poor resolving power of the human eye. Instead, you set the distance by merging two images of the same object (coincidence rangefinder), or by reconnecting a broken subject line (split-image rangefinder). Because the two sets of rays used in CRF focusing are widely separated (the baselength effect) focusing is incredibly accurate. In addition, rangefinders work accurately and easily in almost any sort of dim, low-contrast light where SLR-type groundglass focusing is an eye-straining difficulty.

But focusing accuracy isn't everything, and the main reason for the decline in popularity of the CRF was summed up about twenty years ago, when Leitz was still defending the rangefinder principle *über alles*, this sentence appeared in an issue of their magazine *Leica Photography:* "The

LEICA-STAMMBAUM
LEICA FAMILY TREE
ARBRE GENEALOGIQUE LEICA

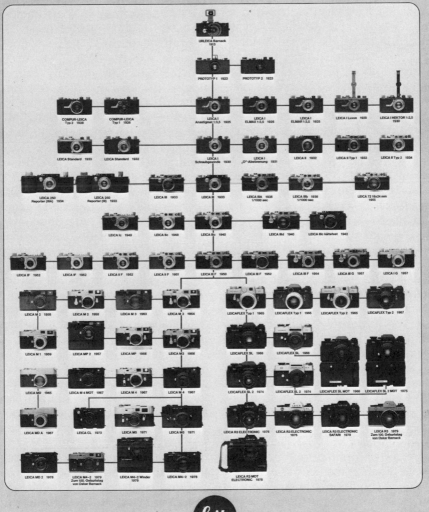

The oldest 35mm camera still in production, the Leica, set the standards for 35mm cameras and equipment for over fifty years, and some say it still does. The beauty of the Leica·design is its simplicity—and even the earliest models are still in service today.

rangefinder camera focuses with su-perb accuracy, but it doesn't see very well. The reflex camera sees beautiful-ly, but it doesn't focus worth a damn." And that is still about the size of it.

The CRF viewfinder camera is small, a lot too small for comfort. In addition, there is parallax, the viewing error in-troduced by taking the picture through one optical system, and previewing it through another. (In an SLR, the same lens does both jobs, and there's no par-allax at all.) Finally, consider the ques-tion of interchangeable lenses. The top-ranking CRF camera of all time, an M-type Leica, accepts interchangeable lenses with focal lengths from 21- to 800mm. But M-Leica viewfinders give frames for 35-, 50-, 90-, and 135mm lenses only. Shorter lenses (21- and 28mm) need separate viewfinders that you plug into the accessory shoe on top of the camera. Longer lenses need something archaic, clumsy, and heavy called a reflex housing, a mirror-box accessory that fits between the camera body and the lens.

On the positive side, if the range-finder camera is mainly good for han-dling lenses from 35- to 135mm in focal length, these are the most useful optics in the field. It's no secret that nearly every Cartier-Bresson picture that you've even seen was made with a Leica with a 50mm lens. The CRF is still the first choice of the sort of pho-tographers who put people first, who seek the fleeting moment that reveals the human condition. No camera is so quiet, or so quick. None focuses faster, or more accurately. For available-light work with high-speed lenses, the CRF in general, and the Leica M-camera in particular, has no peer. And they are compact, light-weight cameras for which excellent work-horse optics are still available.

The Leica series

The legendary Leica M3 appeared in 1954, and was steadily improved until its discontinuation in 1966. The "M" stood for *meBsucher*, the German word for measuring viewfinder, the "3" for its trio of built-in focal frames for 50-, 90-, and 135mm lenses. These brightly illuminated frames "floated" diagonally in the finder field so as to provide automatic parallax compensa-tion as the lens was focused from in-finity to the conservative Leitz close distance, usually one meter for 50mm lenses, although later Leica 50s for M2, M4, and M5 bodies did close in to 0.7 meters, about 28 inches. The most amazing thing about the Leica M3 is its still-unrivalled central rangefinder fo-cusing field. No subsequent camera had such a bright rangefinder, which seems to cut through darkness like ra-dar. And no viewfinder system was ever so free from disturbing reflections. All of the M-Leica rangefinders featured a uniquely sharp rectangular outline, so that the patch could be used either for coincidence or for split-image range-finding.

The viewfinders of the M2 (1958), M4 (1967), and M5 (1971) contained built-in parallax-compensated frames for 35-, 50-, 90-, and 135mm lenses. For this reason, the magnifying power of the combined range-viewfinder had to be reduced, from about 0.9 to 0.75, thus introducing a slight loss of range-finder baselength. The Leica M4 intro-duced a really effective quick-loading system using an open cage instead of the traditional Leitz removable take-up spool, and this was the first Leica to have a rapid rewinding crank. The M5 was the Leica with the built-in TTL light meter—much like the smaller Leica CL introduced in 1973. This model met with mixed reviews, mostly

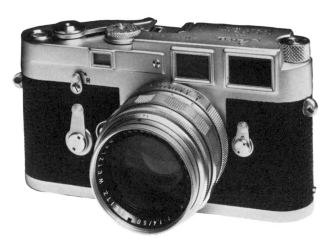

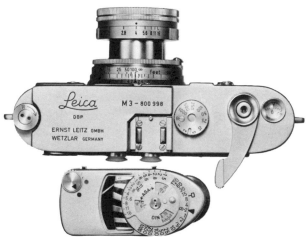

The Leica M3, the original modern rangefinder camera, is considered by many to be the best 35mm camera ever made. Leading camera technicians rank it with the Nikon F as the 35mm camera upon which any professional can stake his or her reputation. Two interesting options for it (and the other M cameras) are the collapsible Leitz lenses (now discontinued) which make the camera more compact, and the MR meter, which couples to the shutter speed dial atop the camera and measures a narrow angle of reflected light (equivalent to about that of a 90mm lens).

The M4-2 is the only professional interchangeable-lens 35mm rangefinder on the market today. It, and the original M4, are extremely well-balanced units when fitted with the 35mm f/2 Summicron lens, the "standard" lens for many Leica photographers.

negative. It is a huge camera by Leica standards, its light meter covers very narrow spot-metering acceptance angles (depending upon the focal length of the lens being used), and the light-metering readout system was both difficult to use and subject to unLeitzlike breakdowns. Whatever friends it may have won among the Leica loyalists, when Leitz Canada decided to return the Leica rangefinder cameras into production in 1976, they chose to revive not the M5, but the M4, now M4-2.

Leicas today
Today, the Leica M4-2 is the only rangefinder-focusing system-camera in production, this task having been assumed by the Leitz factory in Canada, which is indicative of the smaller worldwide demand for this camera type. The Leica M4 and its M4-2 incarnation give built-in floating frames for 35-, 50-, 90-, and 135mm lenses. The M4-2 also accepts just about the biggest, slowest, and worst auto-winder on the market.

Simply said, the greatest rangefinder camera, and maybe the greatest 35mm

camera of all time, was the Leica M3. As already stated, the M3 reigned between 1954 and 1966, with only minor technical modifications. The very first M3's had a two-stroke thumb-lever, later versions a multi-strokable lever, and both established a standard of smooth speed and reliability that has never been seriously challenged.

Even though now out of production, the Leica M3 remains a potent force in photography, and is still the first camera of many distinguished image-makers. The reason is quite simply that a Leica M3 camera body is the best possible piece of machinery to place behind a 50mm lens for general photography. No focusing is faster, easier, brighter, or more accurate; even post-M3 Leica siblings never matched the mighty M3 rangefinder.' The M3 does also include built-in frames for 90- and 135mm lenses, but these are focal lengths best represented by a modern SLR. The 35mm wideangle, or semi-wideangle, has a pair of built-on eye-glasses to correct the camera's 50mm vision to that of a 35mm focal length. These are great in theory, not so great

in practice: too many reflections in the viewfinder, and a loss of that indefinable M3 viewing pleasure.

Most Leica buyers go another route, abandoning the M3 for one of its successor camera bodies with a built-in, and quite Leitzlike 35mm frame. These are the M2, M4, and M5. The best advice to a Leica buyer is to buy an M4 if you can afford it, an M2 if you can't. The trouble with all Leica purchases today is the army of well-heeled collectors who are willing to pay totally ridiculous prices for "mint-condition" Leica camera bodies. As a result, used Leica prices are at least twice what they would be if based solely on their quality and utility. In this connection, one additional point needs putting on the line. Leica CRF cameras are really very simple mechanisms that are easily repaired. As long as there are camera repairmen, they will be repairing Leicas—even the oldest screw-mount models. (In a famous British book of 1954, *"Miniature and Precision Cameras,"* the author, J. Lipinski, makes the charming statement that *"It can safely be said that the Leica mechanism has evolved around its focal-plane shutter.*

There is hardly anything more in it—there is indeed remarkably little inside a Leica anyway." M&PC is long out of print, but better libraries have copies.)

Competition from the Contax

Leica's first real competitor was the Zeiss-Ikon Contax, introduced in 1932. This was after seven years of Leica production, but coincided with the introduction of the first Leica with CRF focusing, the Leica II. Four basic Contax models were produced between 1932 and around 1941. Model I without slow shutter speeds, and Ia with speeds from $\frac{1}{2}$sec, had remarkably clumsy front-mounted winding knobs. Consider these only as collector's items today. In 1936 came Contax II and Contax III, the latter with one of the world's first built-in light meters.

Contax II and III were far beyond their time in design, and glittered with the glory that was Zeiss. They introduced the single-window range-view-finder; previous Contax models, and all Leica cameras built before the Leica M3 of 1954 used separate eyepiece systems for the focusing and framing functions. They were gorgeous creatures

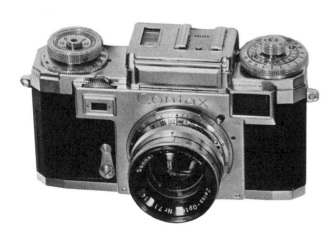

Although the Contax rangefinder camera was developed to compete with the Leica, the originator of the Leica, Oskar Barnack, worked for Zeiss in Jena before joining Leitz. While the Zeiss Contax produced some very good machines, they never attained the performance level of the Leica. Post-war Contax IIas and IIIas are reliable machines with good lenses that are still worth considering.

whose architectural beauty has never been matched. But their major drawback lay in their focal-plane shutter (speeded to a top of $\frac{1}{1250}$ sec) which was made up of metal slats. Zeiss was careful to point out that with metal blinds there was no danger of burning sun-spots in the curtains, as happened so frequently when cloth-curtained Leicas were left staring at the sky with uncapped lenses. What they omitted to say, however, was that these metal blinds were supported entirely by cloth—genuine silk, actually—ribbons, and that these were subject to stretching and disintegration. But the real disadvantage of the prewar Contax shutters is the loss of the prewar Con-

tax factory, in Dresden, now part of the Communist German state, which has never produced any spares or replacement parts for the great old Contax II and III. For this reason, neither of these models can be recommended to real image-makers. Almost no Contax III's are in actual use today, because of the inferior quality of the 1936 light meter, and Contax II's are hardly ever used today, even by their loving owners.

The postwar Contax
But now come the still-usable, still-reliable postwar versions, made between 1950 and 1960. These are Contax IIa without, and Contax IIIa with light meter. In all optical respects, these post-

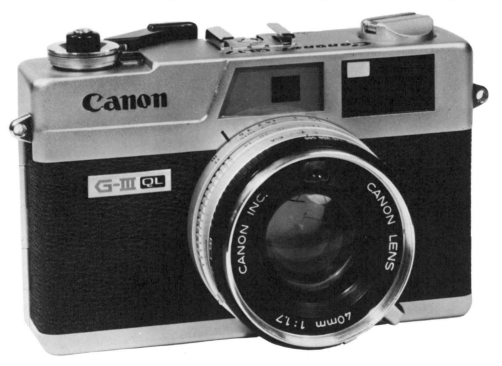

While it lacks interchangeable lenses, the Canon G-III 17 represents *a very reliable, basic rangefinder. It features a sharp 40mm f/1.7 lens,* *fully automatic exposure, accurate focusing, and manual-exposure control.*

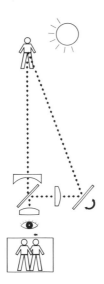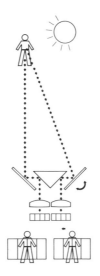

The three focusing systems shown here are all essentially rangefinder types. The passive system of autofocusing

(Honeywell's Visitronic), center, uses the rangefinder with a comparator to determine correct focus, while the

Canon active system, above, basically substitutes an infrared beam for ambient light as a means of setting the correct focus.

war "-a" Contax versions were inferior to their prewar paradigms. Their viewfinders are smaller, their rangefinders dimmer and less contrasty. But they work as cameras because almost every postwar mechanical attribute is superior. The bodies are smaller, lighter, handier. And their shutters snap with reassuring reliability. This is still a metal-slat blind (which was described by the same Mr. Lipinski as " *a masterpiece of misplaced ingenuity"*), but new springing and gearing, and some very sensible simplification, resulted in a more dependable mechanism.

The great Zeiss Contax 50mm lenses were the Sonnar f/2 and f/1.5, and the Tessar f/3.5 and f/2.8. Before the Second World War, the Sonnar f/2 and both Tessar types were issued in collapsible lensmounts. After the war, Carl Zeiss Oberkochen, in Western Germany, dropped the f/2.8 Tessar, and supplied all three remaining Con-

tax 50s in the same "rationalized" mount, this being the f/1.5 Sonnar size. All of the Contax 50mm lenses are triplets, with only six air-glass interfaces. The Sonnar f/1.5 uses seven glasses, and the f/2 six, but they're still triplets, with all that this means in terms of enhanced image quality.

If you intend buying a Contax CRF camera, look carefully at the lens: top-quality Carl Zeiss Contax lenses of any focal length are identifiable by the simple engraving "Carl Zeiss," name-of-lens, focal length in millimeters, f-stop, production serial number, and nothing else. Do not buy any lenses with "T", "Opton", or "Jena" engraved on them: these are post-war lenses of unreliable quality.

Today, Contax IIa and IIIa cameras are only beginning to become "collectibles," so they can still be had with good Zeiss optics for an affordable price. For photographers who want the

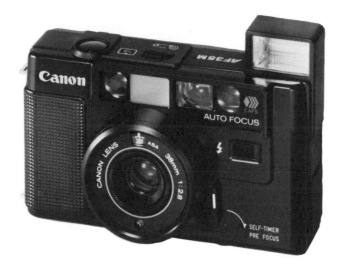

Canon's AF35M is the epitome of the modern snapshot camera. It features an autofocus system using an infrared beam, built-in electronic flash, auto-exposure control, motorized film advance, and a selftimer. Its autofocus system works well under dark or low-contrast lighting, and is rivaled only by the Polaroid Sonar auto-focus system.

advantages and simple enjoyment of a CRF and perhaps cannot afford a Leica, they are an excellent choice.

One last word about the Contax IIIa. The selenium meter is built-on, uncoupled, but very, very good. Its threshold light-measuring sensitivity is more than an f-stop better than that of a Weston Master, and actually almost exactly equal to the sensitivity of the first inboard CdS TTL systems that hit the market in the mid-sixties. In addition, these onboard selenium meters have a back-mounted zero-adjust screw, so a lot of minor troubles can be solved simply by the photographer, without visiting the repair shop. These IIIa meters are extremely good, a lot better than most non-users and photodealers think. As a result, you'll often see a IIIa actually priced below a IIa of similarly used condition. On the other hand, because it doesn't have the meter, the Contax IIa is just a bit handier, with longer probable life.

Non-system 35mm cameras
Rangefinder cameras are represented in shops nowadays by 35mm cameras that have non-interchangeable lenses with leaf built-in shutters. Perhaps the best of these, and one which has achieved the respectability of a "second camera" with many professionals, is the Canon G-111 17 model. It sports a really sharp 40mm f/1.7 lens, a bright rangefinder focusing patch, and optional automatic manual exposure control. When one takes into account its price, it becomes a serious contender among 35 mm cameras. Canon is also the manufacturer of the best 35mm autofocus camera on the market—the AF-35M. Unlike the visitronic systems of the competitive Konica, Fuji, Chinon, Yashica, and Minolta models, Canon's autofocus system is not upset by poor lighting or low contrast. It focuses using high-frequency infra-red rays, and is almost as foolproof as Polaroid's sonic system on their SX-70. In addition to its excellent focusing system, the Canon AF-35M offers an unbeatable array of features — built-in motor-drive, motorized rewind, and built-in automatic pop-up electronic flash.

Medium-Format Cameras and Equipment

Medium-format is the general title for those film sizes that lie between the 24x36mm frames of 35mm cameras and the 4x5in sheet films that mark the lower end of large-format work. Currently, this includes four picture sizes on No.120 paper-backed rollfilm: 4.5x6cm (1⅝x2¼in); 6x6cm (2¼x2¾in); 6x7cm (2¼x 2¾in); and 6x9cm (2¼x3½in). (These frame sizes are nominal because rollfilm cameras, and accessory rollfilm backs for large-format cameras, actually give slightly smaller filmgate rectangles. A typical 4.5x6cm camera,

for example, will give an actual frame measurement of about 45x56mm, and 6x6cm cameras nearly always give real frames between 56x56mm and 58x 58mm.)

There are a still a few sheet-film cameras for the 6x9cm (2¼x3½in) format, but ignore these, because sadly that is exactly what the film manufacturers are doing. There is, for example, no Kodak E6 Ektachrome sheetfilm available today for this format. Of all the rollfilm formats, 6x7cm has become the most widely popularized as the 'ideal format' because its propor-

The Asahi Pentax 67, below, is really an oversized 35mm SLR camera with all the corresponding controls that gives you a large 6×7cm image. Although it has much of the versatility that has made its smaller relations so popular, many people find that the increased size and weight make it cumbersome and difficult to handle.

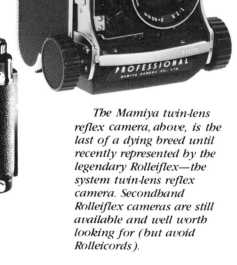

The Mamiya twin-lens reflex camera, above, is the last of a dying breed until recently represented by the legendary Rolleiflex—the system twin-lens reflex camera. Secondhand Rolleiflex cameras are still available and well worth looking for (but avoid Rolleicords).

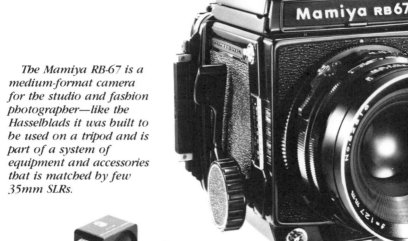

The Mamiya RB-67 is a medium-format camera for the studio and fashion photographer—like the Hasselblads it was built to be used on a tripod and is part of a system of equipment and accessories that is matched by few 35mm SLRs.

The Linhof Technorama is a medium-format machine designed to give panoramic images 2¼×6¾in in size. While the image rendered is unique, this is primarily a special purpose machine for occasional use in commercial or industrial work.

tions most nearly match a standard sheet of 8x10in enlarging paper.

The 120 medium format film is a legacy of the legendary Kodak Box Brownie. Since the emergence of the highly versatile and practical 35mm cameras, however, medium-format has become associated more exclusively with fashion and studio work, some portraiture and those fields that demand a considered, formal approach. Gone are the days when most working photojournalists had at least one Rollei in their equipment.

Advantages of medium-format
An image from a medium-format camera will be at least twice and as much as four times the size of the 35mm frame, and this fact alone has led to their enduring popularity in areas where the technical and qualitative demands put on the image are high. Contact prints or transparencies from a Hasselblad or the like are large enough to be viewed critically by a client or art director and have lower apparent grain, improved tonality, and higher resolution than 35mm frames. In addition, as every art director knows, retouching, even if it means removing half the image and replacing it with something else, is a realistic possibility with the larger images.

Negative color film, in particular, benefits from the larger image size

since it has not kept pace with the improvements made in color reversal and black and white films. The possibilities of pushing are also extended in the larger image sizes, with less fear of excessive graininess.

With one or two notable exceptions, medium-format cameras offer nothing like the extensive range of accessories of the leading 35mm SLRs. If you're the kind of photographer who intends using an underwater housing, or any other unusual equipment, then you had better check its availability before selecting a model. The cameras themselves, however, are very diverse. Several—most Hasselblads, Bronicas and Mamiyas—are SLRs, a diminishing number are TLRs (twin-lens-reflexes) and a handful are rangefinders. Most of the SLRs and the TLRs are designed primarily for use at waist-level—an important factor in studio work. At waist-level, most photographers find that precise composition is far easier, they have a large, bright ground glass screen to work on, and image and subject can be viewed separately and compared in a way that is not possible with a 35mm SLR at eye-level.

But, after increased image size, perhaps the most important technical reason for the popularity of medium-format cameras among studio photographers is its capabilities with electronic flash. Focal plane shutters (FPS) for 35mm SLR cameras sometimes synchronize flash units at 1/125sec, but most are as slow as 1/60sec for a unit whose blast of light may have a duration as short as 1/50,000sec. Leaf shutters, of which Compur and Copal are probably the most famous makes, mounted inside the lens don't give very high shutter speeds, usually limited to a top of 1/500sec, but they can synchronize (synch.) with electronic flash at any speed. This means that the light from the flash can be used more creatively. More importantly, under strong ambient illumination, the slow synch. of a focal plane shutter would result in two images—one from the flash and another from the 1/100 or 1/125sec exposure. This rules out any reasonable sort of flash photography in sunlight— the technique of using the flash to kill harsh shadows under conditions of strongly directional sunlight. Perhaps for this reason alone, the leaf-shuttered Hasselblad models 500CM and 500EL are the top rollfilm reflex cameras for advertising and fashion photography. It also explains why all of the major FPS medium-format camera systems today also offer at least one lens with a built-in leaf-type shutter. (To work these special lenses on an SLR body with a focal-plane shutter you have to open the back shutter by using its Bulb or Time setting.)

Rollfilm

Rollfilm is used in all medium-format cameras. Although it has been in production for nearly a century—since 1888—it still contains a surprising number of problems for the user. No. 120 rollfilm, the standard length, is sold on a cartridge with a continuous strip of backing paper that serves as the leader for the take-up spool. Compared to 35mm or sheetfilms, rollfilms are physically thin and weakish. But the backing paper, which is discarded before development, sometimes creates more problems than it solves. It does supply support for filmgate positioning and when winding on, but because backing paper prevents a really flat film plane, there is some cost in sharpness.

Nearly all medium-format cameras use leaf shutters built-in between the lens. The exposure efficiency of a shutter is defined as the percentage of light transmitted in a given exposure time (solid area in diagram), compared to the amount of light that would have been transmitted if the shutter had been open for the full time (dotted area). However rapidly the shutter operates it takes some time for the blades to clear the lens fully and then to close again. As a result, the film receives more exposure at its center than its edges. This is most noticeable at high shutter speeds and large apertures but only becomes critical in color transparency work where there is little latitude in the film.

Originally, the backing paper did away with any need for mechanical frame counting: numbers printed in different rows on the back were (and sometimes still arc!) read through little red or green peepholes. But there is actually no international standard to define the exact point at which the film is attached to the backing paper. This means that some 4.5x6cm rollfilm reflex cameras that should deliver 16 pictures on a No. 120 roll actually give only 15. (This is a safety-factor to cover for sloppy manufacturing.)

A further problem arises with the design of interchangeable magazines for rollfilm. Modern interchangeable rollfilm magazines were really born in 1948, with the first model of the famous Swedish Hasselblad 6x6cm SLR. To achieve the speed and convenience of film interchangeability, Hasselblad wound the 120 film backward because the film-feed rollers and take-up spool were right at the very edge of the 6x6cm pressure plate. Although these magazines enable film to be changed mid-roll, the backward bending of the film introduces a reverse curl that results in a wobbly filmplane. This worsens optical image quality in general, and more particularly when lens apertures wider than about f/4 are used. The condition is further worsened when the film remains in the magazine for long periods of time, giving the film

base a reverse-curl "set" that produces additional bulging when it is transported. Prestigious Hasselblad is far from the only 120 rollfilm backward bender; other modern offenders include Mamiya, Bronica, and Rollei SL-66 120-film SLRs. Experienced users of these cameras know that if they're going to shoot a f/2.8 or f/4, it's best to use the film up before it has a chance to gain this "set."

Increasing exposure capacity
No. 220 film is a double length of 120 rollfilm on the same spool as 120 film, but without the backing paper, which will give you twice the number of exposures per roll. Short "leader" and "trailer" strips of opaque paper serve to keep the roll light-tight before and after exposure. But because there's no protective paper backing, 220 can obviously not be used in any older rollfilm camera designs using transparent picture counting windows. More importantly, 220 can only be used in cameras equipped with some kind of a mechanical 120/220 switch to permit counting twice the normal (meaning 120 film) number of exposures.

The range of 220 films is more limited than 120 rolls. Eastman Kodak supplies only three 220-spooled emulsions: in black and white, Plus-X Pan and Tri-X Pan Professional; and in color, Vericolor II Type S color negative film. Not all cameras will take the 220 rolls either. Mamiya produces 220 magazines (and magazine inserts) for their RB67 and 645 rollfilm reflex cameras. Hasselblad offers a 220-only magazine to fit all of their models, and the latest Bronica film magazines have 120/220 switches similar to those supplied for the Rollei SL-66 SLR. New Pentax 67 cameras can switch to the 20-frame long count on 220 rolls (old-er versions of this camera actually gave an extra 21st frame, due to a sooner starting point for the first frame). The new Rollei SLX electronic camera has 120/220 switching.

Another route to greater medium-format rollfilm exposure capacity is through the use of double-perforated 70mm, like Hollywood Technicolor 70mm release prints. For still pictures, Hasselblad's 70mm magazine is the best, loading a 100ft roll—enough for very nearly 500 2¼-square pictures. Shorter, 15ft 70mm magazines are also supplied by Hasselblad, and by Bronica for their 4.5x6cm ETR model.

The length advantage of 220 film is somewhat diluted by processing handling difficulties. The 66in length of limp rollfilm is awkward to load on to stainless-steel developing reels, and the better sort of extra-diameter 70mm reels are hard to handle and expensive. Color labs discourage 220 for dip-and-dunk processing, preferring to use roller-transport machines.

Wide-angle lenses
In a 35mm SLR world, there are lots of reasons for complaining about medium-format camera optics, particularly if you're thinking of high-speed or wide-angle lenses. The choices are few, and the few aren't fast. But wide-angle photography works far better in the bigger frame sizes of rollfilm cameras. A 28mm wide-angle lens on a 24x36mm (35mm) frame gives almost exactly the same field angle as a 55mm optic on 6x7cm rollfilm. (The exact diagonals are 75 degrees on the 35mm frame, 78 degrees for the 55mm lens on 6x7.) But every item inside the 6x7cm frame will be almost exactly twice as big and in the crowded images given by wide-angles, this is particularly important.

Hasselblad and Bronica both offer 40mm f/4 wide-angles with 89-degree diagonal coverage, and both have 50mm lenses with 77-degree fields. Bronica's is an f/2.8, while Hasselblad has an f/4 with a built-in Compur shutter, and an f/2.8 without. Shutterless Hasselblad optics are for the remarkable 2000 F/C model which has a back-up focal-plane shutter in addition to working with leaf shutters. For the popular Mamiya 645 there is a 45mm f/2.8 and a 35mm f/3.5. These are fast and wide lenses for the rollfilm reflex field, but hardly sensational in 35mm terms. The shortest lens for the Pentax 67 has a focal length of 55mm, with an f/3.5 aperture.

The only medium-format optics wider than a 35mm f/4.5 non-distorting straight-line lens for the now-defunct Kowa line of 2 1/4-square SLRs, and the optically outstanding 38mm Zeiss Biogon f/4.5 for the nonreflex Hasselblad Super-Wide camera are full-frame fisheye lenses with their distinctive barrel distortion and ultra wide-angle field coverage. Hasselblad has a 30mm f/3.5 fisheye lens that splits apart near the middle to take screw-in filters, an amazingly awkward and very expensive idea. Pentax 67 offers a 35mm f/4.5 fisheye with its own built-in filter wheel. (Before the Zeiss Distagon-F appeared for Hasselblads, this Pentax 67 fisheye was reasonably priced. Then, noting that Zeiss and Hasselblad were offering a lot less lens for a lot more money, Pentax pushed its price upward, although leaving it under half of the Zeiss price.)

Mamiya provides a 24mm f/4 fisheye for their 645 cameras, and a 37mm f/4.7 fisheye for the big RB67. The utility of this particular 180-degree fisheye is enhanced by the long bellows draw of the Mamiya RB67, which enables

you to focus on your own thumb pressing against its front glass surface. Incidentally, filters attach to this lens's back element. In all such cases of rear-mounted filters, always focus with the filter in place because mounting the filter after focusing will cause loss of sharpness.

"Normal" lenses

Most "standard" medium-format roll-film camera lenses today are apertured at f/2.8, although Asahi does offer a 105mm f/2.4 for their amazing Pentax 67. For use with its focal-plane shutter mode, the Hasselblad 2000 F/C has a great Carl Zeiss Planar-F 110mm f/2, barrel-mounted without a Compur. And Mamiya 645, the camera that touched off the whole modern 4.5x6cm medium-format mania, boasts a fast 80mm f/1.9 standard-focus lens as an option.

There are a lot of good, old speed lenses with sufficiently long back focus for practical adaptation to rollfilm reflex cameras with focal-plane shutters, like the Pentax 67. Such classics as f/2 and f/2.5 Cooke lenses from England, the incredible 150mm f/2 by Astro/Berlin, and that 7in f/2.5 Aero-Ektar made by Kodak during the Second World War, can be adapted for use on rollfilm reflex cameras.

Telephoto lenses

Doubling the normal focal length of medium-format camera lenses with built-in leaf shutters (for the standard Hasselblad and Bronica ETR 4.5x6cm SLRs) costs a full f-stop's worth of lens speed. Hasselblad goes from a 150mm f/4 Sonnar in Compur shutter to a shutterless Sonnar 150mm f/2.8 for the 2000 F/C. And the same 150mm f/2.8 specs turn up in the Bronica ETR and Pentax 67 lines.

When you start to think about big telephoto lenses for medium-format cameras you have to consider weight and bulk—and the absolute necessity of a really strong, steady tripod.

Should you be considering long-lens medium-format work, the Mamiya 645 and the Pentax 67 look like the best prospects. But, the Pentax 67 seems to have the edge with its advantages of a bigger negative format, greater choice of optics over 200mm, all with fast f/4 maximum apertures. On the other hand, there is a Bronica-built adapter to fit the long Nikkor lenses on to the 645. The principal technical attributes to keep in mind when looking at medium-format cameras for use with long lenses are a fast focal-plane shutter and the possibility of adapting non-brand optics. Mamiya SLR bodies give top focal-plane shutter speeds of 1/500 or 1/1,000sec, most other medium-format focal-plane cameras give a top of 1/1,000sec. The one costly exception is the Hasselblad 2000 F/C, speeded to 1/2,000sec. Maybe this body's focal-plane shutter will convince Hasselblad to bring some fast long-focus optics into their new F/C program. That 1/2,000sec is great for beating the long-lens shakes, if you've got enough light and the right f-stop.

Zoom and shift lenses
A few zoom lenses are available for medium-format cameras today, although it is unclear why. In the 4.5x6cm class there's a 125–250mm f/5.6 for the Bronica ETR, and a 105–210mm f/4.5 for the Mamiya 645. Hasselblad actually offers a big Schneider 140–280mm f/5.6 with an integral Compur shutter. There are two versions of this heavy, unhandy lens; amazingly, neither has an integral tripod bush so that all the

The Zenzanon-E 70-140mm f/4.5 macro zoom for Bronica cameras has an astonishing short minimum focus distance of approximately 10in in the macro mode. On the lens is a diaphragm selector, an A-T switch, and a depth-of-field preview button.

weight is put on the poor lensmount. Both are fantastically expensive; type F stops down to f/32, and type C, which costs marginally more, to f/45.

Tilting and shifting as in viewcamera technique is not significant enough to have much of a useful role in either

35mm or medium-format rollfilm photography, but the lenses are a useful selling gimmick. There's a 75mm shift lens for the Pentax 67. Bronica ETR has an expensive 55mm f/4.5 Schneider Super-Angulon that both shifts and tilts. What's more, this Schneider has auto-aperture operation via a pair of internal cable-releases—marvelous, but expensive and semi-pointless.

Macro photography

The combination of macro lenses and medium-format pictures is a bonus of our times. Not only do you have a large image, but there are so many close-focusing options for medium-format cameras, that you don't have to use improvised amateur-oriented accessories, as did LIFE magazine photographers in the 1930s, using Proxar close-up lenses on their twin-lens 2¼-square Rolleiflex cameras.

Hasselblad's 500C with leaf-shutter lenses, is an excellent choice for macro work since it has auto-aperturing extension tubes. This makes it much easier to hand-hold macro pictures because the lens diaphragm remains open until the moment of exposure. But, Hasselblad's 500 EL with its integral motor-transport is probably the best hand-holdable macro camera. To cap this off, Hasselblad offers a wonderful 4x chimney-styled magnifier for the macro-photographer, which gives a highly detailed groundglass image.

In today's medium-format systems there are many special macro lenses, like the 135mm f/4 Macro-Takumar for Pentax 6x7, the 140mm f/4.5 Mamiya-Sekor Macro for the RB67, and the Zeiss 120mm S-Planar f/5.6 for Hasselblad and Rollei SL-66.

Unlike the majority of 35mm SLR macro lenses which focus from infinity

The Rollei SL-66 has a built-in bellows with limited 8° tilts that makes it an ideal choice for close-up photography. The 50mm draw on its bellows lets you shoot down to 1:1 with the 50mm wide-angle lens and the tilts enable you to extend depth of field.

to 1:2, most medium-format macros only go down to something in the range of 1:3 and 1:4, because of the massive tubing that would be needed to bring their longer focal lengths nearer than this. Two splendid exceptions are the long-bellows systems of the Mamiya RB67 and the Rolleiflex SL-66. The Rolleiflex SL-66 incorporates 50mm worth of bellows draw into its camera body. With the 120mm S-Planar this gave a close-in reach of 1:2.4, and if you used their 50mm wide-angle as an impromptu macro lens you could go straight out to 1:1. The long-bellows Mamiya RB67 which lets you go to a full life-sized image with the 90mm f/3.8 lens, and to about 1:1.5 with the 140mm macro. Mamiya's 645 model has its own 80mm f/4 macro lens that behaves almost like a 35mm SLR, going in to close to 1:2 with the regular lens-mount, and all the way to 1:1 with an

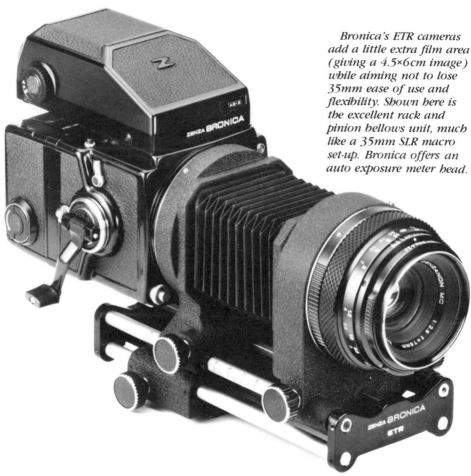

extension tube. In addition, the Mamiya's field coverage is nearly 4X that of a 35mm camera.

Another macro plus for Mamiya is that their cameras let you switch focusing screens in mid-roll, so that you can change to a plain groundglass, or some ruled screen for close-up photography. (The extra "M" designation on current Hasselblad 500 C/M and EL/M cameras means the same thing: user-changeable focusing screens.)

Exposure automation

Exposure automation in the medium-format camera field is available, but better avoidable. If you consider this 35mm feature essential, look at the Rollei SLX, a genuine 6x6cm camera with shutter-priority automation. Hasselblad's AE solution should make you wince: several of their expensive Zeiss lenses are offered with clumsy, impractical, meter-controlled servo-motors built right into and on to the poor optics. Less ungainly add-on automation gadgets are provided for the Mamiya 645 and the Bronica ETR, if 4.5x6cm is your format. The Bronica EC is an electronically automated 2¼-square SLR of the aperture-priority persuasion that's often in short supply.

HASSELBLAD

The leading family of rollfilm cameras are Swedish Hasselblads, with impeccable optics by Carl Zeiss, and Compur shutters from another German Zeiss-group factory. "The Hasselblad" is both concept and camera and is undoubtedly the first choice among rollfilm equipment. Briefly, the Hasselblad camera is a 6x6cm 120 rollfilm reflex with waist-level groundglass or eye-level prism focusing, and the largest interchangeable lens lineup in the medium-format camera field. Its guiding principle is quality before cost.

Today, Hasselblad offers the 500C/M, 500EL/M, and 2000F/C, which are SLRs, and the Superwide C/M, which is not. The model number is the camera's top shutter speed, and the alphabetical trailers give additional information. The "500" in 500C/M and 500EL/M is the top speed given by the leaf-type Compur shutters built into each of their lenses. "C" is for Compur, "EL" means electric-motor transport, and the final "M" is from the Swedish word for ground glass, indicating that these models provide user-exchangeable focusing and viewing screens.

The 500C/M is the basic camera, with manual advance by exchangeable crank or knob, and no instant-return mirror or automatically reopening lens aperture. Winding on brings both functions back, drops the mirror down again, and sets the lens at full opening. Actually, if you work with a look-down open hood, this isn't nearly as archaic as it sounds. But with a prism finder the blackout becomes noticeable and

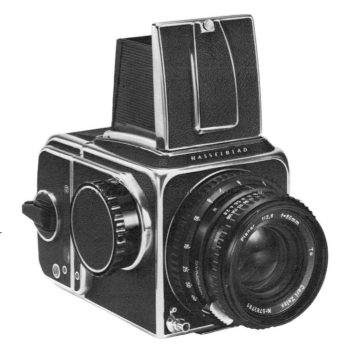

Hasselblad's classic 500C/M is essentially the same camera it was when it was introduced over 20 years ago and offers a totally modular approach to gearing up for an assignment. Primarily made by hand, it is a professional camera, although it is somewhat fragile. While every part of its extensive system is costly, its accessories do not suffer from obsolescence and have been the standard equipment for top professionals since the early 1950s.

annoying. This is one of the arguments for the 500EL/M; its electric motor drive cycles the camera at about ½ fps, dropping the mirror and opening the aperture each time. This motor runs from rechargeable nicad batteries, has a long-established reputation for reliability, and sits like an undercarriage beneath the main body.

The latest Hasselblad is the 2000F/C, meaning that it is speeded to a top of 1/2,000sec, and has both focal-plane ('F') and Compur shutters ('C'). This makes the Hasselblad 2000F/C truly amazing, as it accepts the standard range of Hasselblad lenses with individual Compur shutters, or a number of new lenses mounted conventionally in barrel, without shutters. The Compur lenses can be operated with

this shutter, or with the faster fps which has more effective action-stopping power. The 2000F/C also has an improved mirror mechanism that's controlled by a three-position switch giving (1) historical Hasselblad wind-on return, (2) instant return, and (3) mirror lock-up. Some 2000F/C users have grown disenchanted with the instant-return mirror option, which is faster but very noisy. Again, it's really a question of whether you're working the Hasselblad at waist or eye-level. In the first case wind-on return means little, and is ever so quiet; in the second, instant-return operation eliminates the sudden finder black-out.

In many respects, Hasselblad 2000F/C is an optical camera, built to permit progress in lens design that is

The Hasselblad SWC/M, below, is a wide-angle camera with non-reflex viewing and a fixed 38mm f/4.5 lens. This camera is worth buying for its lens alone, which gives an almost distortion-free 90° diagonal angle of view, making it ideal for scientific or architectural work.

Above is Hasselblad's latest camera, the 2000FC, which uses an electronically governed focal plane shutter. Without the impediment of built-in leaf shutters, lenses for the 2000FC are significantly faster than others in the Hasselblad line—one, the 110mm, is as fast as f/2.

blocked by the necessity to accomodate Compur shutters. Because the maximum opening of the size 0 Compur is only about 12mm, this limits the sizes of lens entrance and exit pupils, restricting the lens designer in terms of the maximum apertures he can provide, as well as the correction of aberrations sometimes possible with larger optical dimensions. Some evidences of these advantages exist in the form of three new Carl Zeiss lenses for Hasselblad 2000F/C only, lenses which do not contain Compur shutters.

The important new non-Compur lenses are a 50mm f/2.8 Distagon-F that's a full stop faster than the 50mm f/4 Distagon-C, which remains in production. Similarly, a new 150mm f/2.8 Sonnar-F augments the long-time vet-

eran 150mm f/4 Sonnar-C. It should be noted that both the 50mm Distagon and 150mm Sonnar in their older f/4 Compur-shutter incarnations have absolutely unrivaled reputations for optical excellence and will doubtlessly continue as the "standard wide-angle" and "standard telephoto" of the Hasselblad system. The new no-Compur versions also offer some real gains in potential image quality. But, for most professionals the loss of Compur X-synchronization is enough to retain their support for the 500EL/M.

The latest optical argument for the 2000F/C is a genuine speed lens, the 110mm f/2 Planar-F, a truly lovely piece of glass that works real magic with Kodak's Ektachrome 400 high-speed reversal film. The 110mm is a

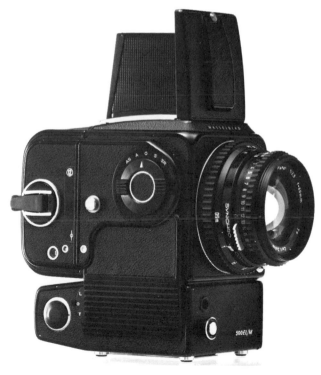

The Hasselblad 500EL/M is designed to overcome one of the main disadvantages of the 500CM. The EL/M includes a motor that cocks the shutter and advances the film after each shot, returning the mirror to viewing position. This last step is the cause of viewfinder blackout in the C/M that makes it difficult to use with moving subjects.

30mm Distagon f/3.5

50mm Distagon f/4

120mm S-Planar f/5.6

150mm Sonnar f/5.6

Hasselblad connected itself with Zeiss to produce the best medium-format optics for its camera *range. Zeiss lenses are very expensive indeed but they are extremely good, and since even the older* *Compur types fit the latest 2000FC, non-obsolesence makes them a fine investment. The Zeiss*

new focal length in Hasselbladery, fitting between the 100mm f/3.5 Planar-C (perhaps the best all-around lens made in the world today) and the 120mm f/5.6 S-Planar-C (a lens whose glories lie in the close-up ranges). Diagonal fields are three degrees apart for these focal lengths, 43 degrees at 100mm, 40 at 110-, and 37 at 120mm.

As might be expected, Hasselblad offers the most extensive range of interchangeable lenses and accessories in the medium-format field. Interchangeable Hasselblad magazines for 120 rollfilm are type A12 (twelve 6x6cm exposures), A16 (sixteen 4x6cm), and A16S (sixteen 4x4cm so called "superslides" which can be put into 2x2 mounts and handled by many of the better slide projectors). The A24 magazine is for twenty-four 6x6cm exposures on 220 film, and magazine 70 takes 15ft lengths of 70mm double-perforated film in light-tight cartridges. The type 100 Polaroid pack back makes 6x6cm exposures on 107/108

and 665/667/668 3¼x4¼in Polaroid filmpacks. This back fits all Hasselblads, including the 2000F/C. There's also an 87/88-tye Polaroid pack back for these smaller films, that doesn't fit the 2000F/C.

Hasselblad provides viewfinding accessories galore: five interchangeable screens for all "/M" models plus the 2000F/C; four different focusing prisms; a 2.5x magnifying focusing chimney; and two types of open-frame sports finders. The meter-prism provides a built-on but not coupled CdS-type light meter with internal eyepiece readout, and fits all three current Hasselblad SLRs. In addition, there's an extensive line of macro gear beginning with a set of three Proxar supplementary close-up lenses, auto-aperture extension tubes, and two different focusing bellows. In all, a breathtaking range of equipment that lives up to its name and reputation as the mainstay of almost every top fashion and advertising studio for over 20 years.

350mm Tele-Tessar f/5.6

range is probably the most comprehensive among medium-format cameras, with 15 leaf-shutter lenses,

from a 30mm fisheye to a 500mm telephoto, and 5 non-shutter lenses for the focal-plane 2000FC,

ranging from a 50mm wide-angle to a 150mm and including a shutterless version of the 140–280mm zoom.

PENTAX 6 x 7

Pentax 6x7 is the best of the "ideal format" 120 rollfilm cameras. It is huge, it is heavy, it is good. It's a scaled-up version of the legendary Pentax 35mm models, with the same general shape and layout and is ideally suited for 35mm-style work, when the quality given by a larger image is demanded. It's 6x7cm negs that could hardly be sharper: the camera is quality-built from its excellent lenses to its straight-line film transport that doesn't bend the film backward. The TTL light-metering is manual, built into an optional accessory prism viewfinder, and uses a CdS cell that isn't quite as sensitive as

it should be and should be replaced with an SPD system. The rest of the camera's features are laid out like a typical overgrown 35mm SLR, with all the standards like a bayonet lensmount and a focal-plane shutter that gives you one to 1/1,000sec exposures.

There are two main complaints about the 67: because of a complex, three-layer screen design, these can't be interchanged, except for a camera repairer or an official Pentax service service station; and the camera should have multiple-exposure switch.

The Pentax 67 has a family of 15 "super multi-coated" SMC Taku-

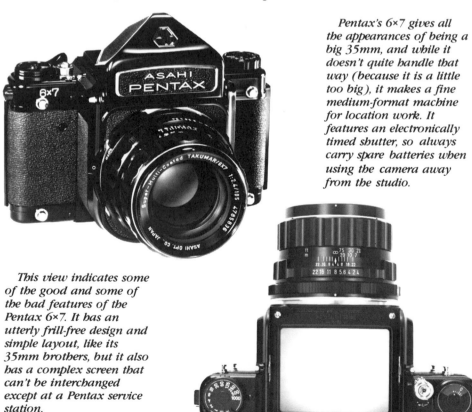

Pentax's 6×7 gives all the appearances of being a big 35mm, and while it doesn't quite handle that way (because it is a little too big), it makes a fine medium-format machine for location work. It features an electronically timed shutter, so always carry spare batteries when using the camera away from the studio.

This view indicates some of the good and some of the bad features of the Pentax 6×7. It has an utterly frill-free design and simple layout, like its 35mm brothers, but it also has a complex screen that can't be interchanged except at a Pentax service station.

mar/6x7 lenses. This includes some unusual medium-format optics, like a 35mm f/4.5 full-frame fisheye and a 55mm f/3.5 78-degree nondistorting wideangle. There is also a macro 135mm f/4, and a 75mm f/4.5 shift lens. Their tele-lenses 200-, 300-, 400-, 600-, and 800mm are fast at f/4; and there is a 1,000mm f/8 mirror system.

Good macro gear includes the Pentax 6x7 bellows unit, slide-copying attachment, and auto-aperture extension tubes. For faster flash synchronization there's a 90mm f/2.8 "SMC Takumar 6x7 Leaf Shutter Lens" with a built-in

central shutter speeded from 1/30 to 1/500 sec for professional studio and synchro-sunlight flash. There should be at least two more lenses like this in the system, something like a 50-or 55mm wide-angle, and a tele-lens in the 150- to 180mm range.

Pentax 6x7 is a large, heavy camera that seems to gain a pound an hour as you use it, but it's a great machine with a great film format, and most importantly is one of the few rollfilm cameras that can be used easily for the sort of rapid picture taking eye-level viewing facilitates.

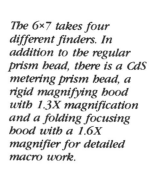

In keeping with its 35mm SLR associations, Pentax attempts to offer a broad range of accessories for the 6×7, such as this cumbersome underwater housing.

The 6×7 takes four different finders. In addition to the regular prism head, there is a CdS metering prism head, a rigid magnifying hood with 1.3X magnification and a folding focusing hood with a 1.6X magnifier for detailed macro work.

MAMIYA RB67

The next recommended camera is also an "ideal format" rollfilm reflex, and even bigger than the Pentax 6x7. This is Mamiya's RB67, newest models of which carry the additional appelation of "Pro-S," whatever that may mean. RB67 is a really deluxe studio camera that's a pleasure to use. Two reasons for RB67's big bulk are a rotating back that lets you turn the film magazine for horizontal or vertical 6x7cm framing, and a built-in bellows front that brings you into comfortable close-focusing or even macro ranges, depending upon the lens in use. Its lenses have built-in leaf shutters—1 to 1/400 sec—for high-speed X-synch. A compact but capable eleven-lens system gives the RB67 all the optics that most of us will ever need. The short end is a 37mm f/4.5 full-frame fisheye and a 50mm f/4.5 non-distorting (83-degree) wide-angle. With useful focal stops of 65-, 90-, 127-, 140-, 150-, 180-, 250-, and 360mm, the longest lens comes with a 500 mm f/8.

Mamiya RB67 has been marketed since 1972, and has won a reputation as a solid studio performer. You can take it on location jobs, but RB67 is really a tripod camera, not something for using hand-held outdoors.

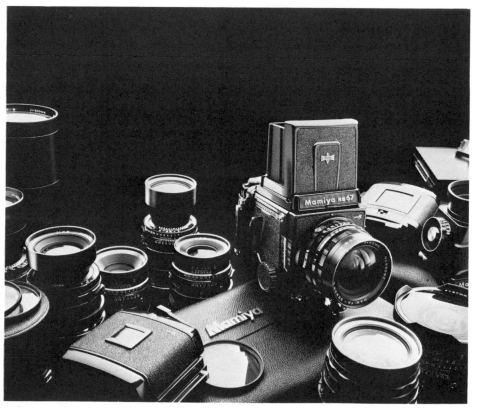

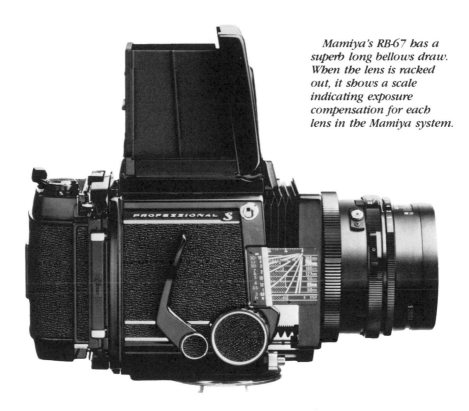

Mamiya's RB-67 has a superb long bellows draw. When the lens is racked out, it shows a scale indicating exposure compensation for each lens in the Mamiya system.

Eleven leaf shutter lenses, from 37mm to 500mm, are available for the RB-67. The back rotates to change from horizontal to vertical format (particularly useful when working on tripod), and several film holders are available, including the ubiquitous Polaroid back and a 70mm film holder.

MAMIYA TLRs

Mamiya's TLRs are clumsy, ugly-duckling twin-lens reflexes (TLR) that offer two interesting advantages: interchangeable lenses and very low prices. The two cameras in question are the Mamiya C220, and its deluxe sister model C330F.

From their earliest beginnings, with the model C22 of 1958, the Mamiya TLRs have been a special favorite of serious beginning professionals.

The C330F extra features include a rapid–transport crank (Rollei-style), interchangeable viewing screens, a parallax-compensation top frame, an exposure factor scale near the finder that lets you keep track of its focusing track, plus a folding focusing hood. Accessories for both models include eye-level prisms, magnifying focusing

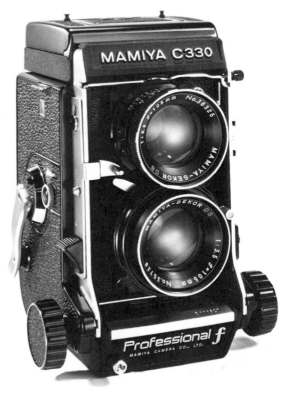

The Mamiya C330f is the better model of the two Mamiya TLRs and, while it is twice as expensive as the 220, it is still cheap. Its main advantage is that you don't have to cock the shutter each time after advancing the film.

Mamiya's TLR cameras are highly professional machines that offer good performance at comparatively low prices. They accept seven lens pairs with built-in leaf shutters (which aren't the easiest lenses to change) and a complement of finders and other accessories.

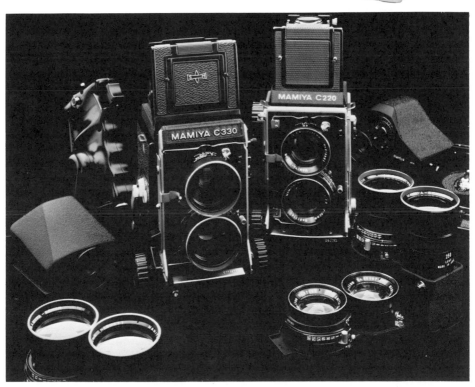

Probably the most popular of the interchangeable lenses for the two Mamiya TLRs is the 105mm f/3.5, a very useful portrait lens.

hoods, and a papamender that raises the camera after focusing to knock out the displacement distance between the top (viewing) and the bottom (taking) lenses. There's also a CdS porrofinder for TTL light metering, but the Mamiya C220/C330F is really a professional studio and location camera that was born to be tripod-supported, so use a bubble-style incident-light meter and play the game to the full.

The optics are the real reasons for this old-fashioned 220/330 bulkiness (which includes rack-and-pinion straight-line track focusing, with a pair of right- and left-hand focusing knobs). First is an 80mm f/2.8, with the bottom lens in a 1 to 1/500 sec M/X·synchro leaf shutter. Now, similarly paired on interchangeable boards with bottom-lens shutters are: 55mm f/4.5; 65mm f/3.5; 105mm f/3.5; 135mm f/4.5; 180mm f/4.5; and 250mm f/6.3. This

is a large number of lenses, and together they provide a good deal of versatility for a 2¼in square TLR. This was an idea tried several times in past photographic history, but successfully only by Mamiya.

It is no insult to Mamiya 220/330 frames that during the rise of the one-eyed SLR, it became known variously as the "poor-man's Hasselblad," or the "beginner's down-payment on a Hasselblad." Maybe most Mamiya TLR types do go on to other lovelier and livelier SLR rollfilm reflexes once they've earned the scratch behind these wonderful ugly ducklings, but even this is a compliment to a basically down-to-earth camera design that produces the kind of rollfilm image quality that's needed for professional work. Every beginner should at least be aware of these great workhorses, the interchangeable-lens TLRs.

ROLLEIFLEX SLX

In the 6x6cm, or 2¼-square field, there is one camera that can be considered alongside Hasselblad—the Rolleiflex SLX. The SLX is a shutter priority electronic motor-driven electronic medium-format SLR. Although the SLX looks like a 1930-styled reflex plate camera, it is probably the most

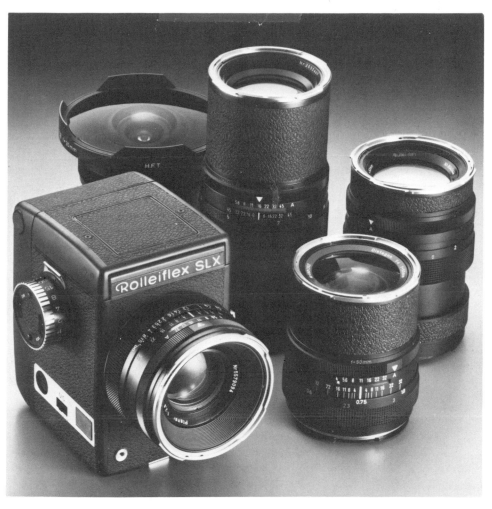

The Rolleiflex SLX is a shutter-priority 6×6cm SLR with a motor-driven transport. A special Rollei linear motor system in each lens controls the aperture and shutter speed. This, and the SPD receptor meter and fast built-in winder, make the SLX a good choice for action photography.

advanced technology on the medium-format market today. Made by Rollei in their Singapore factory, the SLX finds the f-stop after you preset the shutter speed. Its interchangeable lenses—Zeiss designs made by Rollei—are controlled by "linear motors." TTL is by SPD; interchangeable film holders can be preloaded for rapid film-changing; and the motorized transport runs on to the first frame automatically. You can shoot as many as 3 frames in 2 seconds, and make as many exposures on the same frame as you like (with a non-transporting multiple-exposure firing rate as high as 10 exposures per sec.).

Lenses for the Rolleiflex SLX are available with a unique "linear motor" system for aperture and speed control. The linear motors are actually linear-action coils moving in permanent magnetic fields, and each coil acts directly, by means of a rotating ring, on the shutter and iris blades respectively. The opening and closing of the blades set exposure times and apertures.

Large-format cameras

Modern large-format cameras are the direct descendants of the picture-taking boxes used by the Victorian pioneers of photography. Indeed, a late 19th-century photographer would find very little that was unfamiliar about even the most sophisticated of today's models. Most modern large-format cameras are made of metal (as against the wooden models of yesteryear) and are constructed on a monorail. Those of a more traditional design extend on rails fixed to a baseboard.

This wooden flat-bed large-format camera from the late 19th century illustrates how little modern models have changed in design and operation.

The large-format revival
Always the mainstay of the studio and still-life work—where fine control and maximum resolution of detail are essential—and architectural work—where its characteristic "movements" are vital to the control of perspective—the large-format system has become popular again with non-commercial photographers for technical reasons and for the considered approach to subject matter it demands. (Here it should be noted that one of the reasons behind the trend towards large-format work has been snobbery. As the intense competition among the SLR manufacturers has pushed the prices of even the best models down and out of the snob market, so other, new areas have been opened up by status-seekers, of which Leica collecting is only one. Large-format cameras have also suffered from camera snobbery, and it is worth emphasizing that there are no "serious" cameras, but only serious photographers—large-format work is only one of the many paths to good picture-taking.

Comparing the formats
Strictly, large format means film size 4x5in and upwards. Professional photography and the graphic arts fields commonly use film formats up to 20x24in. Today, "large format" is really synonymous with the most popular size in this range—4x5 and 8x10. Despite its very beautiful side ratio, 5x7in films have never been able to command more than a weak minority position. One reason is probably that although a 5x7 camera (and image) is much larger than a comparable 4x5, the additional jump to 8x10 actually adds very little more size and weight.

One of the most obvious benefits of large-format work is its size. The bigger the negative, the smaller will be the noticeable effects of "grain" in the image. Grain, the pattern of minute clumps of silver particles which comprise a black-and-white image, or the dye clouds surrounding the space left vacant by such silver-particle clumps in a color image, is the limiting factor in photographic tonal quality and resolution. Each clump, or cloud, on a 35mm negative will be enlarged eight times to make an 8x10in print. In contrast, the same size print contracted from an 8x10in negative contains grain clumps, or clouds, ⅛ the size of those found in the enlarged 35mm image.

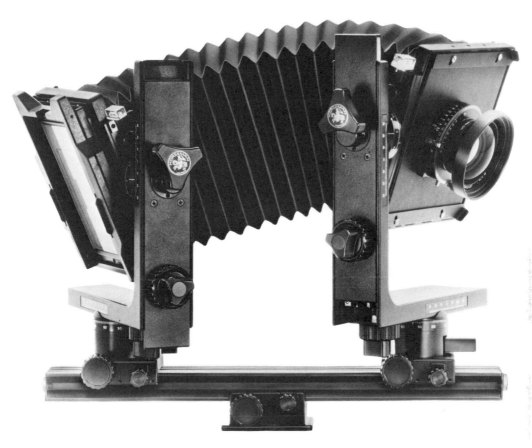

The Horseman 450 is a good example of a modern monorail viewcamera. The *Horseman and similar advanced cameras have identical front and back* *movements which give unequaled sharpness and perspective control.*

The effect on the image is analagous to the dot screens used in printing with ink. Coarse dots provide contrasty images with very little recognizable detail, such as those found in newspaper comic strips. Fine dot screens provide for greater range of tones, and allow much more image detail to be seen in high quality printed material, such as the expensive reproductions of photographs or paintings often sold in museum stores. In the same way, the very fine grain structure of a print made

from a large-format negative at low magnification can give a very full range of image tones and allow incredibly fine detail to be rendered accurately. These characteristic qualities of large-format photographic images are particularly important in color work, where the films themselves have inherently poorer grain structure and therefore lower resolving power.

So, the first argument for large-format photography is that it is larger. Contact prints from 8x10in negatives

show fine detail and good quality. In fact, well-exposed and properly-processed large-format contact prints have a very special beauty that you can see in the work of such magnificent craftsmen as the late Edward Weston and Paul Strand. The commercial photographer knows that in many cases a large-format shot will actually be reduced for reproduction. But today, the grain and gradation advantages of the large-format camera count for far less than before, simply because of the great advances in the quality of films which have benefited smaller camera formats more than larger formats. Actually, there are at least five reasons, four technical and one aesthetic, for choosing a large-format camera today, and only the first is size.

Aesthetic consideration

More serious photographers—amateur as well as professional—are turning to big cameras today because they provide an alternative to the nervous "snapshot ethic" that has dominated so

Polaroid makes three backs that fit nearly all large-format cameras. The 405 and the 545 (shown here) are for 4×5in cameras; the 8105 for 8×10in cameras is used with the 8101 processor.

much photography since the Second World War. Cartier-Bresson's "decisive moment" is a great and a most respectable concept, but it is not everything. There are times and places, subjects and situations, and photographers for whom a slower, quieter, more deliberate approach better suits their photographic aims and ambitions. The big camera on its tripod, focused on a full-sized groundglass under cover of a black cloth, then patiently loaded by inserting a film-holder and pulling its protective darkslide, requires an entirely different approach and philosophy than a Leica loaded with high-speed film. Some very talented people will find room for several formats in their photographic scheme of things. One such is the magnificent portrait photographer Arnold Newman, who uses both a 4x5in viewcamera and a 35mm Nikon SLR. The great Walker Evans was famous for his combined use of an 8x10in Deardorff and a 35mm Leica for a large portion of his Depression reportage.

Probably the most important reason for the enduring popularity of the large-format camera is its "movements"—the swings, tilts, and shifts that permit you to eliminate (or to create!) perspective distortion, and to control the plane of picture sharpness. Such lens-board and film-plane gymnastics (explained presently) are the true province of the large-format camera. The possibilities resulting from the twisting and shifting capabilities of a viewcamera cannot be compared with the minor movements built into some wide-angle lenses for 35mm and 120 SLRs. (Once upon a time there was a genuine monorail 35mm viewcamera with all the swings and tilts and shifts of a Linhof. Called the KI-Monobar,

made by a British firm called Kennedy Instruments, it was designed for producing 35mm slides with viewcamera correction. The KI was a magnificently machined camera made from between about 1955 and 1960. Hard to find today, but well worth the looking.)

Individual processing advantages
The last technical point in favor of large-format photography is that the film is loaded and processed separately. In 35mm and rollfilm photography, anywhere from one to three dozen (and sometimes even more) exposures are strung together on the same long strip of film. Thus, all of the pictures on the roll get the same development, exactly the same developing time and temperature, and so on. In effect, this means that everything done in 35mm and rollfilm has to be a compromise. (Some zoneal zealots who doubt this are actually about 37% right: it is possible to give exactly the same exposure to every shot on a roll, and to restrict all of the shots to the same sort of original subject contrast. What these Adamsites don't realize is that by doing this they're really throwing away all of the advantages of the 35mm and rollfilm formats.)

What at first appears to be an inconvenience in large-format film—the separate sheets which need separate development (usually in hangers that hold a single sheet)—in fact means that large-format photography offers a custom-tailoring of both exposure and development that 35mm and rollfilm formats cannot. As a matter of fact, most of the deserved ridicule of the Ansel Adams/Minor White zone system is based on the fact that the "True Believers" are trying to cram the flexibility of 35mm/rollfilm into the large-

A Short Course in Black-and-White Exposure and Development
In large-format black and white exposure and development remember that:

1. The golden rule is to expose for the shadows, and develop for the highlights. This means enough camera exposure to get the shadow detail that you want, and not too much developing time in order to prevent highlight build-up that you don't want.

2. Increasing or decreasing exposure produces big changes in shadow densities, little difference in the highlights.

3. Increasing or decreasing development time changes the highlights much more rapidly than the shadows.

4. When you want to reduce subject contrast, give a bit more exposure and less development.

5. When you need more contrast, because of very flat subject lighting conditions, give a bit less exposure and a touch more developing time.

format mold. When you string a lot of small-format exposures together on the same strip of film you have no choice—all exposures have to be at close to the same basic level, as established by a preselected effective ASA index, and they all have to go into the same developer together, and come out at the same time. No such compromise is necessary for large-format

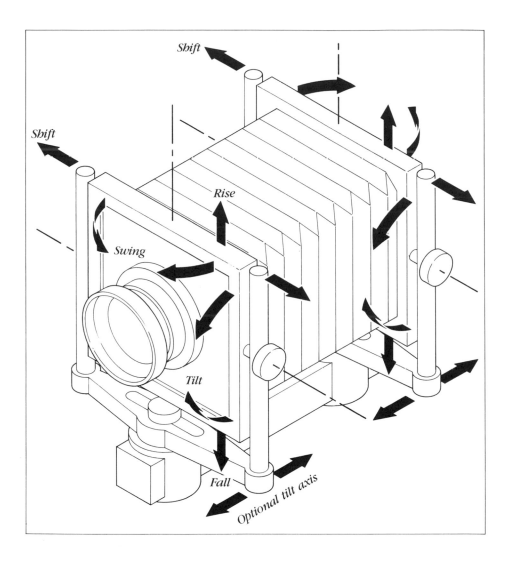

Shift

Shift

Rise

Swing

Tilt

Fall

Optional tilt axis

work (although often preferred in commercial studio operations in order to simplify and speed-up processing procedures). Devotees of the "fine print" can develop each shot individually, and all of the formal and informal systems of tonally-biased exposure— the "Zone System" and its variants— are not only possible, but they actually make sense.

Swings, tilts, and shifts

Large-format camera movements always sound a lot more complicated than they are. Fear not, most photographers learn the movements slowly, by trial-and-error, as they're needed (or as the interest is aroused), and this method is undoubtedly best. However, just to get you started, here is a brief introduction.

There are three movements: angular swings, angular tilts, and lateral shifts. Swings are right/left, in a horizontal plane around the optical axis. Tilts are up/down, in a vertical plane, most often around the optical axis, but sometimes not. Shifts are straight-line movements, up/down, left/right, at right angles to the optical axis of the lens. Geometrically, the angular swings and tilts are really two versions of the same idea. In the most elegantly expensive monorail cameras, like the Sinar p, Linhof Master L, and Horseman 450, the front and back movements are identical. But the great majority of past and present large-format and view-camera designs have different front (lensboard) and back (film holder) movements. In almost all cases of such inequality you'll find more flexibility at the front, often with almost no back movements at all, save a bit of tilt.

One purpose of all of these camera movements is to allow you to bring all of the important areas of your subject into razor-sharp focus. Their capabilities far exceed the extension of the zone of focus obtainable through a reduction in lens aperture (increase in depth of field). When these movements are combined with the use of smaller lens apertures, the viewcamera has formidable focusing abilities.

Manipulating areas of focus

This is the so-called Scheimpflug principle diagramed on page 152. When lines through the subject, lensboard, and film-holder planes intersect at a common point, the image will be sharp right across the groundglass even with the lens at full aperture. This is especially important in close-up work when depth of field is limited, even at small apertures.

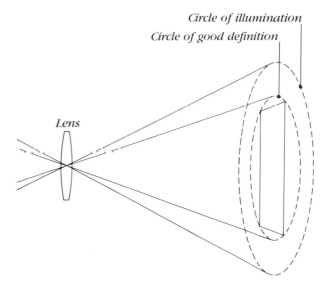

Circle of illumination
Circle of good definition

Lens

Viewcamera lenses must cover an area larger than the film format for which they are intended; otherwise, the image will be vignetted when tilts or swings move the lens off axis. Normally, this area of coverage is slightly less than the maximum circle of coverage given by a lens and will increase as a lens is stopped down or focused at close distances. (Lens manufacturers give the covering power of a lens when it is focused at infinity.)

The Scheimpflug principle states that the image will achieve optimum sharpness when the planes of the lensboard, film holder, and subject intersect at a common point. (This can occur when these planes are parallel, as in a copystand or enlarger; then they intersect at infinity.) This principle is the basis of many of the special applications of large-format cameras, particularly in close-up work. In the illustration, above left, the three planes do not intersect at a common point and only part of the subject will be in focus. Tilting the camera back (center) or the front (right), or a combination of both movements will bring the subject in focus across the complete image plane.

Note that if it's sharpness you want, it won't matter whether you do the trick by bending the front or the back of the camera. But there is an important reason for using the front. This is because tall buildings, or architectural lines in general, will always tend to converge or diverge if the camera back is not perfectly vertical, or parallel to the subject.

Tilts are the controversial part of viewcamera design. Swings are always central, and straight shifts are simple lateral movements. But the up/down tilting can occur at the center of the lensboard or camera back, or it can be hinged at the base, or the tilt may be the anything-goes style in which loosening some locking nuts lets you simply move as you wish. This is the way the front of the famous Chicago-built Deardorff viewcameras are made. One advantage of this construction is that you can fold the camera up more compactly than is possible with any other large-format camera design. It's a bit

harder to learn to use, but a lot easier to lift and carry.

Not so the modern monorail view-camera, which in the vast majority of past and present models provides central front and back tilts. The practical working difference between the two sorts of tilts is this: a central tilt throws the groundglass image out of focus, and it must be refocused; a base tilt shifts the focus and throws the center of the picture far away from its original position, so that both of these unwanted effects must be corrected.

As far as picture perspective is concerned, there would be little need for the viewcamera if we could always position the camera back parallel to all subject verticals and horizontals, and always place the lens at whatever height is needed to capture the subject's undistorted perspective. This is, of course, impossible, and for this reason viewcameras have additional swings (to keep the film parallel to subject horizontals) and shifts (to keep

the film parallel to subject verticals, and avoid harmful upward or downward tilting).

Additional equipment

Interchangeable bellows, a feature of some of the more expensive viewcameras, are necessary to focus lenses of different focal lengths. This is because the longer the focal length of the lens, the longer the bellows extension that will be needed to bring a subject into focus on the groundglass, and vice versa. However, problems can occur when bellows and lens are mismatched. For example, when you are focusing a short focal length lens with a long bellows, the bellows may physically not be able to accordion-fold down to the short length required. Or, the long bellows may wiggle like a snake rather than fold like an accordion when drastically shortened, especially when the front and rear standards have been shifted, tilted and dropped, or raised. Conversely, it may well be impossible to bring a long lens into focus without using a long bellows. The moral of this is to always have the right bellows for the lens and to make sure, on fixed-bellows models, that the bellows is suited for the kind of work you intend to do and the lenses you will be using.

Like most medium-format machines, large-format cameras can usually take different backs, from either their manufacturers or independent manufacturers. Standard backs are, most often, of the reversible type. That is, they can be removed and turned through 90° to change the format from horizontal to vertical. Revolving backs needn't be removed to change the format from horizontal to vertical or to anything in between; they can simply be rotated, usually through a full 360°, while remaining light-tight. If you opt for a revolving back, though, you'll do well to remember that you can't swing the negative diagonal in the same size camera. That is, you need an 8x10in camera to swing a 5x7in diagonal (8.6in) or a 5x7in camera to swing a 4x5in diagonal (6.4in).

Both reversible and revolving backs which provide for reductions in format

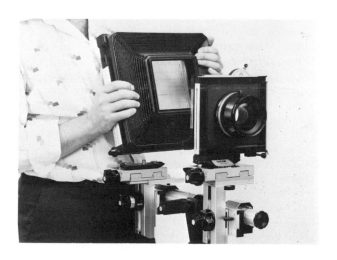

The ability to change camera backs, bellows, and other parts of the camera is one of the benefits of sophisticated monorail cameras like this Sinar. But because this often adds both to the camera weight and its price tag, it is hard to justify for non-commercial photographers.

Lens focal lengths for large-format cameras

Format	Normal lens field of view 45°-60°	Telephoto lens field of view 6°-45°	Wide-angle lens field of view 60°-115°
4" x 5"	5" to 6"	7" to 50"	2" to 5"
5" x 7"	7" to 9"	10" to 70"	2" x 5"
8" x 10"	11" to 14"	14" to 100"	3½" to 10"

size are available for some models. For example, an 8x10in camera can be equipped with a back which provides for a reduction to 5x7in or to 4x5in; a 5x7in camera can be equipped with either type of back, to reduce its format to 4x5in. These backs are usually offered with Graflock fittings. These incorporate a Graflock metal back, with field lens, and a pair of side-clamping levers which permit the quick and easy removal of the groundglass and its replacement with rollfilm or 4x5in or 405 Polaroid film holders (once you have focused the image, of course).

The right lens for the format
There is no real shortage of lenses for large-format cameras, be they normal, telephoto, or wide-angle, but the choice among makes and types is miniscule compared to that offered to the 35mm SLR photographer. In addition, the choice gets smaller yet as you move away from normal focus lengths to telephoto and wide-angle lenses. While you can get nearly any lens in shutter to fit a large-format camera's lens board, you must make sure that its coverage is sufficient for your work. Large-format movements (or any camera lens movements) require a lens

that can cover an area larger than the film format. Whereas some lenses will cover the groundglass from corner to corner with a sharp, crisp image when its optical axis is lined up with, and perpendicular to, the center of the groundglass, the image's corners and edges may well begin to grow soft and fuzzy, or even dark, once the front or back is tilted, shifted, raised, or lowered. It's just another thing to look out for. Lens manufacturers specify covering power with the lens set for infinity. Close-up, the covering power of a lens is greater and the potential for camera movements is increased.

Prices of fast, first-rate, large-format lenses are anything but cheap. Adding one to an 8x10in viewcamera, in any focal length, can easily cost more than double the price of the camera, even if it is a Deardorff. And prices rise dramatically as the speed and covering-power of large-format lenses increase.

One of the main reasons for their high prices is the built-in leaf shutter. Cheaper lenses without shutters are available, but the Speed Graphic notwithstanding, behind-the-lens focal-plane shutters present great problems in larger formats. For sizes of 4x5in and above, it is increasingly difficult to pro-

duce focal plane shutters that will operate at high speeds and give precise, even exposures. Copal does make a separate leaf shutter that fits behind the lens which stays open for viewing and focusing and only closes when the film holder is inserted, but its price offsets much of the savings made in buying shutterless lenses.

Leaf shutters are not without their problems in large format work. For most exposures the lens markings—f stops and shutter speeds—are accurate enough. But at small apertures and high speeds, there is a marked increase in shutter efficiency leading to changes in the actual exposure given to the film. (Shutter efficiency measures the amount of light that actually gets through a lens during a given exposure compared to the amount of light that could theoretically pass if the shutter was fully open for the full exposure time.) If, for example, your meter indicated an exposure of f/22 at 1/500 sec, you might find by making a critical test that the increased efficiency of the shutter at this small stop was giving you as much as a full stop of overexposure. Every lens/shutter combination will vary slightly in this regard, so it is necessary to run tests, with fast transparency film, to determine the corrections needed.

Retouching, one of the main reasons for large-format work among advertising and product photographers, is a lot easier to perform on these large negatives. In commercial work, professional retouchers command fees often way in excess of the cost of the original shot, and they deserve it. They can move something from the bottom to the top of the frame, combine a model's smile in one picture with the hair and flesh tones in the next, or re-create an entirely new image to the customer's specifications. However, beyond simple spotting, retouching is a skill best left to the professionals. You need nerves of steel, supreme self-confidence, an array of special equipment (knives, abrasive powders, dyes, pencils, even an air-brush) and, last but not least, several years experience.

There's no doubt but that large-format cameras can deliver the best photographic image quality. But there are sacrifices, and whether you need such a camera depends on how important this is to you and to your style of photography. If still-lifes and scenics, architecture and artifacts, are your subject areas, consider this big-film route. A large-format camera is unsuitable for almost any sort of action. Smaller cameras, down to 35mm, work remarkably well in very low light, and can capture the spontaneity of mood and feeling. A big camera needs lots of light to work in, seldom performs effectively without rigid tripod support, and concentrates on physical reality.

Large-format cameras are harder to rate and recommend than 35mm and medium-format hand cameras. The big box is really a tool, and far less trendy, less subject to fickle fashion. Almost all viewcamera designs are sensible solutions to that perennial compromise between capability, convenience, quality, and cost.

SPEED AND CROWN GRAPHIC

The best way to test the large-format waters is with an old, used 4x5in press camera of the Speed- or Crown-Graphic type. Incidentally, these are among the few large-format cameras which you can consider using hand-held. Models that can be used in this way are often called "field" cameras. The 4x5in Speed Graphic was the backbone of professional press photography until the dawning of the 35mm era about twenty years ago. Its "Speed" designation refers to its built-in cloth-

curtain focal-plane shutter with speeds of up to 1/1000 sec. Graphics not so blessed with such back shutters were called "Crown." Normally, both models can use lenses in central, leaf-type shutters, so the advantage of a Speed Graphic is minimal.

There is, however, one possible advantage to owning a Speed Graphic. By owning a 4x5in camera with a back shutter you have the beginnings of a second macro-camera system. As 35mm and medium-format macro

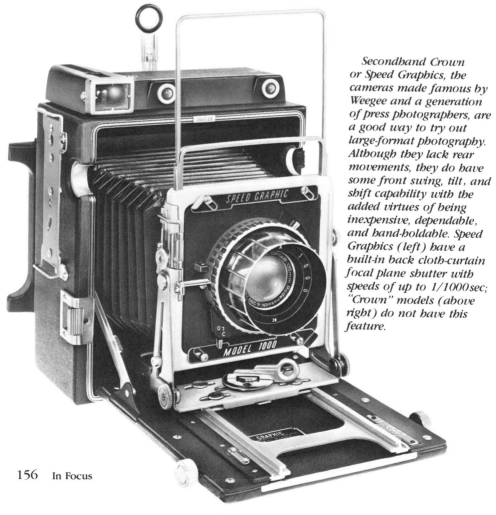

Secondhand Crown or Speed Graphics, the cameras made famous by Weegee and a generation of press photographers, are a good way to try out large-format photography. Although they lack rear movements, they do have some front swing, tilt, and shift capability with the added virtues of being inexpensive, dependable, and hand-holdable. Speed Graphics (left) have a built-in back cloth-curtain focal plane shutter with speeds of up to 1/1000sec; "Crown" models (above right) do not have this feature.

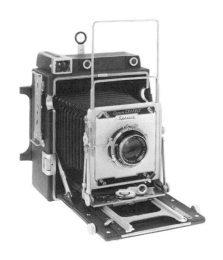

least expensive, and most sensible approaches to large-format work.

One thing that should be noted is the covering power of the lenses that you're likely to find at reasonable prices on the used market. The most popular 4x5in press-camera lenses were 127mm in the USA, and 135mm in Europe. These were prized for their wide-angle or semi-wide-angle vision; a 127mm focal length on 4x5in covers a 64- or 65-degree field that's equivalent to using a 35mm focal length on the 24x36mm image patch. Great, but they hardly cover outside of the 4x5in image circle, limiting what you might be able to accomplish even with the limited front movements of the Speed Graphic. Much better for use on these cameras would be an older (and maybe slower) lens that gives a bigger image circle. A Tessar is a good choice, preferably one not faster than f/4.5, and a longish focal length (like 180mm) if possible. Because of the "Speed" back-shutter, you can often take advantage of bargain-priced lenses in barrel mounts—lenses usually priced far beneath their real value because they're not mounted in Compur or Compund inter-lens shutters. Probably the greatest old-time name of all is Dagor, the first and most famous of the "double anastigmats" noted for their large image circles and crisp definition. Don't worry that they are not coated, Dagors hardly need this modern extra. Actually, *do* worry if they are coated because a lot of fine old lenses have been incompetently coated to increase their sales value, at considerable worsening of their real optical performance. All but one of the genuine, coated Dagor lenses were made in the USA; the exception is the last 14-in Dagor from Schneider (mysteriously made in Switzerland!).

lenses will cover much larger formats, like 4x5in, in the macro and close-up ranges, they can be adapted for use on this camera. All you need is a lensboard adaptor to take your camera's bayonet lensmount. These are easy to make, or to have made for you by a professional camera repairman. On 35mm film, a half life-sized image means that you're covering a subject field measuring 2x3 in. Make a 1:2 image with the same lens on your improvised Speed Graphic, and you've got the same image magnification but on a subject field of 8x10in.

Speed and Crown Graphic cameras have no back movements at all, but the front standard offers limited but useful doses of swing, tilt, and shift; and if you look closely you'll see that there is an extra set of notches on the right- and left-hand bed supports, giving a second "drop-bed" position to clear the way for short-focus wide-angle lenses.

Graphics are rugged, dependable, always-repairable cameras with a lot more on- and off-tripod picture potential than a lot of 35mm users might imagine. They also provide one of the

CALUMET AND OMEGA

When cost comes first, but you want a new camera that is small with good strength and versatility, look to the Calumet and Omega lines. These are monorailed gymnasts with central tilts, lots of leverage, strong locks, and horizontal/vertical reversing backs. There are lots of good standard-spec monorails out today, including models by Linhof, Cambo, Plaubel, and Arca-Swiss. But Calumet or Omega can put you on the starting line with a lot less cost.

Calumet C-1 is a lightweight 8x10in with reducing backs for 5x7 and 4x5. With 8x10 Polacolor added to your list of large-format options, it might make a lot of sense to think bigger, with a box that can shoot 4x5 and 8x10. The

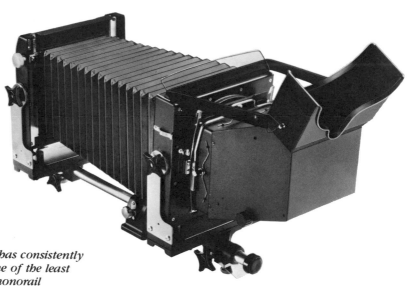

Calumet has consistently offered some of the least expensive monorail viewcameras, which makes them good first models for the beginner. Reliably made of die-cast aluminum, they lack interchangeable bellows but are versatile enough for most work and will accept viewing accessories, as shown here, rollfilm and Polaroid holders.

famous 4x5in Calumets are a fixed-bellows threesome called CC-404 with a long 22 in accordion, CC-403 with 16 in of draw, and CC-402 in the shortened wide-angle version with about six ins of stretch. These are good professional bodies, widely used but only sometimes sold outside the USA.

Omega View models 45E and 45F are the same camera, the E with a reversing, and the F a revolving, 4x5in back. The camera gives a very high rise, with generous angles for the swings and tilts. Despite its less than jewel-like finish, low price plus good quality have made friends for this newcomer.

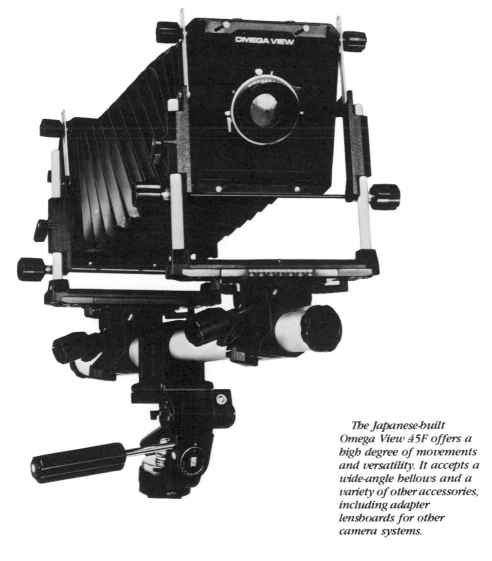

The Japanese-built Omega View 45F offers a high degree of movements and versatility. It accepts a wide-angle bellows and a variety of other accessories, including adapter lensboards for other camera systems.

SINAR

For sheer perfection with no thought of price think of the Sinar-p, that monorail with the patented difference (as arch-rivals Linhof recently discovered in law courts!). Swiss Sinar owner-inventor-photographer-photowriter Carl Koch started up after the Second World War with the most slenderly elegant single-tracked viewcamera the world had ever seen. But those svelte lines and that light carry-on weight were built around base tilts—the sort that nobody really likes as it is difficult to get the picture sharp again after tilt-

ing. As a result, this base-tilt model, now called the Sinar Standard, no longer made.

In its place is the Sinar-p. By borrowing the principle of forward and backward leanings from rocking chairs Koch was able to make the back tilt in the image plane, and the identically fashioned front tilt in the lens' nodal plane. This produces tilts without trouble; in most cases the image stands still and stays in focus. And Herr Koch even managed to improve on this improvement by making his tilting and swing-

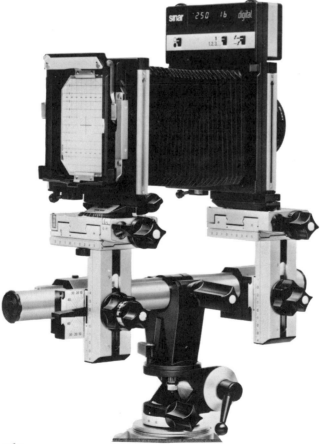

The Sinar-p is the ultimate in viewcamera design and the most versatile model on the market. It features a unique tilt and swing around a stationary axis (that is marked on the groundglass) that greatly simplifies the use of the Scheimpflug principle. The Sinar's fully modular construction allows the basic camera unit to adapt to a variety of configurations without sacrificing any part.

ing axis off to the sides, "asymetrical," to demystify viewcamera technique further.

But everything is not perfect in paradise. Few ordinary professionals are ever rich enough to afford the simplicity of a Sinar-p and the most extensive (and expensive) line of large-format camera accessories imaginable.

To keep the price down, Sinar offers the Sinar-c with a Sinar-p back and a simplified front standard, and even the Sinar-f which uses this simplified standard front and back. It's like a set of Sin-

arblocks: everything fits everything else, and you can custom-assemble almost anything you want. But the camera that counts is the Sinar-p, a design years ahead of any other viewcameras.

There are many more high-cost monorail marvels, although they do leave much of the viewcamera's mystery unsolved. Look especially at the neat little Horseman 450, or the awesome Linhof Kardan Master L. Both feature opensided "L" frames for front and back standards, making for better accessibility, with style and stability.

The Sinarsix , below, is one of the unique accessories available in the Sinar system. The "six" is a specially designed exposure meter that eliminates many of the problems of exposure compensation and enables you to take spot-reflected light measurements at the film plane. Although the meter is expensive, it is a convenience that has to be experienced to be fully appreciated, and Sinar is even talking of producing a semi-automatic TTL meter in the near future.

Sinar offers two behind-the-lens shutters for their cameras: a mechanical auto-aperture shutter and a digital shutter, above. The cost of these shutters can be more than made up by the saving in buying shutterless lenses, and they have the added advantages of giving you constant shutter speeds, no matter what lens you are using, and enabling you to set all the exposure controls from behind the camera.

DEARDORFF

Finally, there is dear old Deardorff, those hand-made wooden beauties from Chicago. Old-fashioned, with limited back movements and irrational frontal gymnastics that take a lifetime to learn, this grand old lady remains the toast of American professionals. Opened and extended she's a living reminder of the beauty that once was photography's hardware. Folded up box-like for transport she's just about the most portable 8x10 or even 11x14in viewcamera.

Competing, or trying to compete, in this wooden viewcamera race are a number of Japanese-made models that look something like a viewcamera, maybe even a Deardorff, but avoid them. Inspired by a desire to capture the US market, they're only for looking at, not for working with. Use them hard and you soon have a shambles.

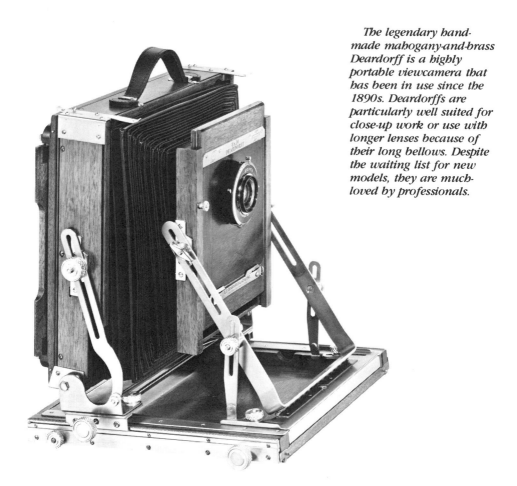

The legendary hand-made mahogany-and-brass Deardorff is a highly portable viewcamera that has been in use since the 1890s. Deardorffs are particularly well suited for close-up work or use with longer lenses because of their long bellows. Despite the waiting list for new models, they are much-loved by professionals.

Black-and-White Film

Black-and-white films are judged by four basic criteria: grain, gradation, sharpness, and speed. None of these terms are as simple as they sound or as complicated as many photochemists pretend, but they all need some explaining.

The fundamentals of black-and-white

Black-and-white films are made up of extraordinarily high numbers of tiny light-sensitive particles called silver halides—silver bromide, silver chloride, and silver iodide. Within a 35mm film's normal 24x36mm picture area there may be something like three to four billion of these light receivers.

Exposure to light rays from the camera lens produces microscopically small specks of silver—the latent image—which are called "development centers." In processing, the film developer can distinguish between silver halides that have been light-struck, and those that were not exposed. Theoretically, a perfect developer is able to turn the light-struck crystals of silver halide (the latent image) into pure metallic silver (the photographic image), and to leave the unexposed halides alone. Finally, a fixer, or "hypo," is used to dissolve away the unexposed silver halides, leaving an image consisting of pure silver.

Photographic image graininess, or granularity, depends primarily upon the size of the silver halides used. It would seem to follow, then, that to obtain the finest results, the emulsion layer should be packed with the smallest possible crystals. ("Emulsion" is the accepted misnomer for the colloidal suspension of silver halide crystals in a gelatine layer. The organic animal gelatine reacts mysteriously with inorganic silver halides to enhance light sensitivity.) This would be a mistake, however, since bigger crystals are faster (meaning more light-sensitive), produce higher film-speed index numbers, and require shorter camera exposures. Not enough big crystals, not enough speed. Film could not be composed entirely of big crystals, either. Unless there is a mixture of crystal sizes, the film won't be able to record a continuous scale of tones from black to white, through many shades of gray.

Recording a range of tones

Suppose you are photographing a black-and-white zebra standing in front of a gray wall. If all the crystals in the emulsion are the same size, and therefore the same speed, each tone will either be recorded or not. In other words, the image of the zebra will be right, but the gray wall will be recorded as equal either to the white or to the black stripes. With a film containing a mixture of big, medium-sized, and small crystals you have fast grains, medium-speed grains, and slow grains. In the picture, the black stripes will be recorded thinly on the negative by exposure of some of the biggest grains only. The middle-tone gray wall will be recorded by all of the fast grains, and by some of the medium-sized, medium-speed grains. Finally, the white stripes will record by exposure of all grain sizes, big, medium-sized, and small; fast, medium-speed, and slow. This variation of grain size and sensitivity within the emulsion layer is essential for the realistic recording of a long scale of subject tonal values. A one-size emulsion (usually composed of fairly small grains) such as the high-contrast Kodalith films, is good for document copying, and similar technical subjects containing only two values: black black and white white.

A normal black-and-white photographic print is composed of several tones, ranging from black through to white. Its extent and which part of the range is most dominant, is determined by the subject, the actual exposure, and the developing and printing. The graduation of the tones is the contrast— a contrasty print, for example, would have very few intermediate tones between black and white. The highest contrast would therefore exist in an image which was composed only of solid blacks and white whites, such as the lith film image of the bridge, above. Without this tonal range, the image of the subject loses a sense of form, volume, and depth.

Ilford Pan F *Kodak 2475 Recording Film*

The fastest 35mm film currently available is Kodak's 2475 Recording Film, rated at ASA 1000. Its speed gives it fairly low contrast, which makes it a good choice for surveillance photography

even when pushed. At the opposite end of the scale, Ilford's Pan F is rated at ASA 50 and is much snappier in terms of contrast. Because Pan F lacks a grainy appearance,

it appears to have a much smoother tonal range than 2475 does. Pan F is one of the few longer scale, slow emulsions and doesn't tend to block up when it is improperly exposed.

Speed and grain

The irregular granularity of the developed image is only partly due to the inherent grain structure of the film. Very strong developers, or prolonged overdevelopment, cause some migration of developing halide crystals. What happens is that weakly exposed grains tend to cluster around grains that received stronger exposures. This accounts for the fact that in black-and-white photography, "grain" is always evident as darker specks against a lighter background. The "grain" is really a pattern of empty spaces in the emulsion.

Faster films are grainier than slower ones, but today's state of the art has eliminated a lot of the once-legitimate fear of high-speed films. Photographers and photowriters are basically conservative people, and like generals and admirals, they're always preparing for the last war. The fact is, that unless you make really huge enlargements, say in the 16x20in range for 35mm or 20x20in for 2¼ square, it is almost impossible to see differences between well-exposed and properly-processed results from high-speed ASA 400 materials, and those of the medium-speed films (ratings between 100 and 160).

Increasing rated speeds

The three important 35mm ASA 400 high-speed films are Kodak Tri-X, Ilford HP-5, and Agfapan 400. (Another really excellent ASA 400 film, Neopan 400, is made by Fuji in Japan, but is seldom exported.) Press photographers all over the world swear by Tri-X and/or HP-5, which through uprating and push-processing can give them speed indexes as high as ASA 1000, by extended development in many commercial fine-grain formulas. But don't get carried away by all this: indexes very much higher than 1000 either result in bad print quality (too contrasty, too grainy), or extra work because the light level was so high that they weren't really needed in the first place. The limiting factor to pushing is the latent image left in the emulsion by exposure. No latent image, no developed image: it's really as simple as that. If there is a latent image, normal development will bring it out. Overdevelopment (which is really what pushing and some of the proprietary developers are all about) will not create an image where none was registered on the film. All they will do is increase the high-light and middletone density (providing more highlight and middletone detail), the grain and the contrast. They will not affect shadow density to any perceivable extent. Since it is a good bet that most amateurs push film in an attempt to get more detail in the shadows, the effort is generally wasted.

The overwhelming majority of working professionals today rate ASA 400 films at ASA 400—at least, whenever possible—in order to obtain best possible grain and long-scale gradation. Probably the best advice is to avoid ASA inflation wherever possible and go for pictures and picture quality, not

Push Processing

Push processing pushes everything but the shadow areas in the latent image. Push-processed negatives produce grainy prints with blocked highlights and improved middle-tone detail, but no improvement in underexposed shadow detail.

Kodak's recommended push-processing procedures for maximum film speed call for processing at 68°F (20°C) with continuous agitation as follows:

Film	Developer	Time
Tri-X Pan *1250ASA*	D-76	11 min
REcording *2475 3200ASA*	DK-50	8 min
Royal-X Pan *4000 ASA*	DK-50	7 min

speed-index numbers. Kodak does produce one very high speed film in 35mm format. Called Recording 2475 (Estar-AH Base) and normally rated at ASA 1000, it is very grainy and therefore offers relatively low resolution and poor tonal qualities. Under extreme circumstances, it can be pushed to EI 4000, but only with a considerable loss in image quality.

Slow, "thin-emulsion" films produce noticeably better sharpness in the image. Lens and camera are obviously important in defining image sharpness, but so are the film and the developer. Two things, light irradiation inside the emulsion layer and silver solvent in the film developer, alter sharpness after exposure. Irradiation is greater with a fast

film that has a thick emulsion layer (see diagram). With a thin emulsion film, the same lens brings the same cone of rays to the same focus, but the irradiated image disc is much smaller. This is the basis for thin-emulsion films like Kodak Panatomic-X, Ilford Pan-F, and Agfapan 25.

Thin-emulsion films

These types have a distribution of small-to-very-small grains, and are capable of very good tonal gradation if properly exposed and developed. This means using them at their normal ASA ratings and avoiding underexposure and overdevelopment. But these films are a lot harder to live with than the comfortably soft ASA 400 materials. Their grain structure is so amazingly fine that you'll need one of the really high-magnification grain focusers to get your print sharp. Thin films are something to experiment with against the day when you're called upon to produce huge, mural-sized blowups. But they're just too slow to go for normal shooting. Moreover, man does not live by grain alone, and when Costa Manos produced his famous "Where's Boston?" show he used Tri-X negatives for all of his big 40x60in pictures. Good technique—holding grain to inherent emulsion levels—is the secret.

Silver-solvent action

The other common cause of loss of sharpness after exposure occurs because of the silver-solvent action of the developer itself. At one time, when films were really grainy, actual silver solvents were added to the developers; even small doses of hypo were sometimes included for this cannibalistic purpose. Today, it's doubtful that any genuine solvents are actually included in commercial finegrain developer formulas. But dissolve some silver they do, because of their high concentration of the preservative sodium sulfite. This means that when you develop a black and white film, three things are happening at the same time: 1) the developing agents reduce the light-exposed halide crystals to pure metallic silver; 2) the high concentration of sulfite acts to dissolve away some of this silver; 3) dissolved silver plates out randomly throughout the image.

A recently-introduced developer, Ilford ID-11 Plus, has been specially formulated with a silver-trapping additive to eliminate the random plating of dissolved silver. From its inception, about forty years ago, Ilford ID-11 was identical to the famous Kodak D-76 formula. The new ID-11 Plus shows the real effect of replating dissolved silver by giving sharper, more brilliant images.

Medium-speed films

As far as 35mm and 120 are concerned, medium-speed films have been falling in popularity. The trouble isn't that there is anything wrong with them, but that the faster ASA 400 films are so very good. Small- and medium-format photographers tend to think first of grain, and second of sharpness. In these formats steady improvements have narrowed the gap far beyond what anyone considered possible ten and twenty years ago. But the large-format photographers prefer medium-speed film. The reason is partly that grain and sharpness are rarely in question in this work, while gradation is critical. Also, despite the fact that big-camera lenses are very slow, most large-format pictures either are adequately lit by studio illumination, or they are of static subjects in which long shutter times don't matter

Ilford's Pan F

*Kodak's 2475
Recording Film*

Comparing Pan F and
2475 for sharpness
illustrates the difference
between fast and slow
films. Slow, Pan F is far
sharper and less grainy
because its emulsion is
much thinner and its
grains of silver smaller.
Films like 2475 sometimes
use a dual emulsion
which, along with the
large grain, reduces
definition still further by
diffusing the image.

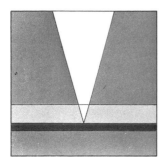 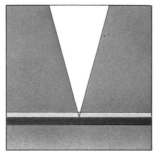

For large blow-ups, a thin emulsion film is an ideal choice because the finer grain and higher sharpness contribute to a more realistic rendition. However, careful use of a thicker emulsion, with added exposure latitude and greater speed, can achieve good results.

Thick emulsion　　　*Thin emulsion*

and a medium-speed film is viable. In this way, large-format photographers obtain good gradation and generally work with one or other of the popular medium-speed films—particularly Kodak Plus-X and Ilford Pan-F. And there are some 35mm and 120 people, particularly in the fashion and commercial fields, who share the same preferences.

In addition, there are things that can safely be done to medium-speed materials that should not be done with high-speed films. They can, for example, be processed in Rodinal, a non-finegrain developer that is used at high dilutions to produce very sharp, very brilliant negatives. With fast films like Tri-X or HP-5 (but not Agfapan 400) Rodinal is usually considered far too grainy. But use this ancient soup (it's been made and bottled by Agfa, now Agfa-Gevaert, since about 1891) at a dilution of 50 parts water to one part Rodinal concentrate, with a basic starting time of about nine minutes at 68° F/20° C, and medium-speed films start to sing with a quality that's hard to believe until you've tried it. The films to consider are Agfapan 100 (ASA 100) Ilford FP-4 (ASA 160), and Kodak Plus-X (ASA 125), but keep your meter set at ASA 100 for the whole group. These films also do nicely in D-76, and ID-11 Plus, using the developers at one-to-one water dilution, for something like eight to ten minutes, according to personal taste.

High-speed films

There are quite a lot of fast large-format films. Kodak leads in this respect with Royal-X Pan, which has an official ASA of 1250, giving a lot of slow old-time lenses another lease on life. Push-processed beyond Kodak's conservative recommended development, this film can work safely at "forced" ratings like ASA 2000 or even 3000. It all depends on the kind of subject contrast you have, and the kind of negative contrast that you want. And, as in all formats, more pushing means more contrast. The one difference is, with a large-format negative you can rest your fears of increased grain for a very long while. There are two sorts of Tri-X supplied in big-sheets, both with an ASA 320 rating (this is also the rating for "TXP," or Tri-X Professional 120 and 220 rolls, which have a roughened retouching surface on the emulsion-side of the film). One is Tri-X Pan, the other Tri-X Ortho.

Ortho versus pan

Panchromatic films are sensitized for the complete visible spectrum, from violet all the way to red. Orthochro-

matic films don't go so far, usually stopping just short of the orange region. Thus, the big difference between ortho and pan is the red: pan has it, ortho doesn't. Considered dangerous for women's portraits, as the lips will go jet black on the final print, ortho emulsions are often preferred for male portraiture, because the lack of red sensitivity gives more "character" by effectively darkening the smaller shadow areas within the portrait. Some people claim similar results using pan films with a blue filter, but this is an old and doubtful argument. Incidental-

ly, both of these large-format Tri-X types are coated on a plastic polyester filmbase which doesn't expand after processing and is practically untearable. But beware of plastic film bases in 35mm (such as the new Ilford 72 exposure HP-5 film, mentioned on page 88)—their spiral curling after drying makes contact-printing with them a nightmare.

Tri-X, HP-5, and Agfapan 400
Returning to ASA 400, and talking primarily in terms of 35mm and rollfilms, how do Tri-X, HP-5, and Agfapan 400

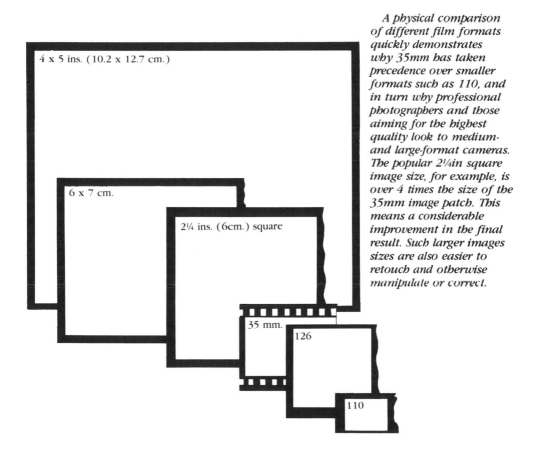

A physical comparison of different film formats quickly demonstrates why 35mm has taken precedence over smaller formats such as 110, and in turn why professional photographers and those aiming for the highest quality look to medium- and large-format cameras. The popular 2¼in square image size, for example, is over 4 times the size of the 35mm image patch. This means a considerable improvement in the final result. Such larger images sizes are also easier to retouch and otherwise manipulate or correct.

4 x 5 ins. (10.2 x 12.7 cm.)

6 x 7 cm.

2¼ ins. (6cm.) square

35 mm.

126

110

compare with one another? These are all great films, and almost any photographer could live quite happily with any one of the three. Most choose Tri-X, largely because it is the senior member of the group, having been marketed, albeit with many periodic improvements, since 1954. Tri-X introduces a kind of "snap" that most people like today. This means a combination of low-to-normal overall negative contrast, but with extra contrast in the middletone and shadow areas. Today, this film is at its peak in grain, gradation, and sharpness, and leaves little to be desired.

Between Agfapan 400 and Ilford HP-5, HP-5 is the more similar competitor to Tri-X, giving the same kind of internal shadow and middletone contrast, maybe even more than Tri-X. Sometimes, this extra HP-5 dark-area contrast lets a photographer get printable shadows with less density than Tri-X. This has given the newer Ilford contender (introduced in 1976) a reputation for better pushability. The theory is that if you can print with a bit less shadow density you can develop for a lot less highlight density, so you can keep the extended developing time short enough to keep the bright highlights in check, and maybe take a slight grain advantage as well.

The other side of the coin is that in many situations you're forced to overexpose (because light is light, and shutter speeds have hardly changed much in the last 40 years of photography, but films are now up to ASA 400 and faster). And, in many cases of high subject contrast you may want to overexpose and underdevelop in order to lower final negative contrast. Here, Tri-X seems to have the edge, being able to deal with heavier densities somewhat better than HP-5. But all of this is really a matter of two very fine wines having a very slight difference in bouquet. They're both excellent films for all-around photography, and both work well at ASA 400, all the way to about

Black-and-White Film Retouching

Many, but not all, black and white films, ranging from 35mm through 11×14in or larger, have surfaces which the manufacturers describe as suitable for retouching (Kodak uses the expression: "matte both sides for retouching"). Such Kodak black and white films usually include the word "professional" somewhere in their designations (for example, Plus-X Professional Film 2147 Estar Base). "Matte" surfaces make it easier to do pencil retouching by providing a tooth to grab and hold the graphite. It is theoretically possible to retouch 35mm negatives under a strong glass and with a very steady hand, but for all practical purposes retouching is only possible on larger images.

Pencil retouching is only one of the ways negatives can be mechanically manipulated. Others include dyes (to increase density) and mechanical abrasion with abrasive powders or with a knife (to reduce density). Negatives can also be chemically manipulated by intensification (to increase density) and reduction (to reduce density). Generally, retouching is a skill best left to experts.

ASA 1000. Do consider the advice of David Vestal and others who advise re-rating to numbers as low as ASA 50; but if this makes sense to you, consider switching to a medium-speed material to begin with. One of the most obvious reasons for underrating film is to obtain more detail in the shadow areas of your pictures, and indeed many photographers believe (with some justification) that manufacturer's ratings are too high. Tri-X, for example, is rated by Kodak at ASA 400 but is given an EI (exposure index) by many critical workers that is as low as 200. This seems a bit too low, and EI 320 seems to produce the best results.

Now we come to Agfapan 400. This is a very different sort of material that has been designed to give a gently rising contrast from shadow to highlight areas. None of that "Tri-X snap" for Agfapan 400, which turns out the kind of old-style silvery gradation that was once most admired. More than this, Agfapan 400 is a remarkably finegrained film that in this department puts Tri-X and HP-5 to shame. In the Ilford ID-11 Plus developer, for invidious example, an eight-minute timing for Tri-X and HP-5 produces just a touch more grain than 13 minutes on Agfapan 400.

This is all to Agfapan 400's credit, the drawbacks come with its speed and pushability. If you measure speed scientifically, using a densitometer, you'll find that Agfapan 400 is a jot slower than Tri-X or HP-5. So that if these two films really are ASA 400 materials, Agfapan 400 should have a tag of about ASA 320. Or better still, looked at from the other side, if Agfapan 400 really clocks in at ASA 400, Tri-X and HP-5 are doing ASA 500 in a walk. Second, Agfapan 400 just can-not be pushed. Get in trouble with Kodak or Ilford and you can hike up to something like ASA 1000 with very decent quality, and only a small loss of shadow density and detail.

So, Agfapan 400 won't push, and shoulder-to-shoulder with Tri-X and HP-5 it's almost a third of an f-stop slower. But what you get are the most desirable normal-rating negatives in the ASA 400 range today, with best grain, best sharpness, and longest, smoothest, silveriest gradation. Incidentally, because of these inherent characteristics Agfapan 400 works remarkably well in non-finegrain Rodinal, where Tri-X and HP-5 do not belong. The fact that both film and developer come from the same Agfa-Gevaert stable might be one reason for this.

The developer/film combination

Most professionals today use a small circle of film developers, leading off with Kodak D-76 (at the one-to-one dilution). Other favored soups are Acufine Inc's Acufine and Diafine, Ethol UFG, and Ilford Microphen. All of these last foursome are famous pushers, giving printable shadows without blocked highlights, and with very decent grain.

If you have just started to do your own developing, start off with one film (or film type) and only one developer. Tri-X and D-76 (at 1:1 dilution) is a good basic recipe, although you can use HP-5 or Agfapan 400 to break the monotony occasionally. Don't experiment with developers until you've used D-76 for at least a full year. D-76 is the international yardstick by which all small-format film developers are measured, and by knowing this famous formula you'll really know what you might want in the way of a different developer. If you develop film like a

Black-and-White Polaroid Film

Result	Product Name	Format	Print Size (inches)	Speed (ASA)
High Speed Print	Type 47	Roll	$3\frac{1}{4} \times 4\frac{1}{4}$	3000
	Type 107	Pack	$3\frac{1}{4} \times 4\frac{1}{4}$	3000
	Type 084	Pack	$3\frac{1}{4} \cdot x\ 4\frac{1}{4}$	3000
	Type 667	Pack	$3\frac{1}{4} \times 4\frac{1}{4}$	3000
	Type 87	Pack	$3\frac{1}{4} \times 3\frac{3}{8}$	3000
	Type 57	Sheet	4×5	3000
Negative and Positive	Type 665	Pack	$3\frac{1}{4} \times 4\frac{1}{4}$	75
	Type 55	Sheet	4×5	50
Fine Grain Print	Type 42 Polapan	Roll	$3\frac{1}{4} \times 4\frac{1}{4}$	200
	Type 52 Polapan	Sheet	4×5	400
High Contrast Print	Type 51	Sheet	4×5	125 320
Continuous Tone Transparency	Type 46L	Roll	$3\frac{1}{4} \times 4$	800
High Contrast Transparency	Type 146L	Roll	$3\frac{1}{4} \times 4$	100 200
Ultra High Speed Print	Type 410	Roll	$3\frac{1}{4} \times 4\frac{1}{4}$	10,000

travelling alchemist in whatever happens to be handy or hyped at the moment, you'll never really learn what part of the result was due to what input. Keep to an ASA 400 film of your choice, or at least to this category, and be loyal to one good soup until you have come to know it intimately.

Large-format workers might like to standardize on Rodinal or one of the more active Kodak tank developers like DK-50, for cleaner, more brilliant gradation on medium-speed films. Regardless of format, for the softest long-scale gradation try mix-it-yourself D-23, which consists of 7.5 grams of metol (or Kodak Elon) and 100 grams of sodium sulfite in a liter of solution.

The fastest film developers for push-processing are probably either Acufine or Diafine, or the older Ilford Microphen formula. Best sharpness means Rodinal, Ethol Tec, Tetenal Emofin, or Kodak HC-110. (But please note that because of the viscosity of its liquid concentrate HC-110 results can't be guaranteed unless the whole $3\frac{1}{2}$-gallon unit is mixed at one time, and you

Normal Development Time at 75°F(24°C)	Special Characteristics
15 seconds	General purpose, high speed film.
15 seconds	General purpose, high speed film.
15 seconds	For cathode ray tube recording.
30 seconds	General purpose, high speed film.
30 seconds	General purpose, high speed film.
15 seconds	General purpose, high speed film.
30 seconds	Medium contrast.
20 seconds	Medium contrast.
15 seconds	Wide tonal range, superb detail.
15 seconds	Wide tonal range, superb detail.
15 seconds	Sensitive to blue light only.
2 minutes	Continuous tone image.
30 seconds	High contrast image.
15 seconds 60°F(15°C)-90°F(32°C)	High contrast print.

Polaroid makes a lot of different films to satisfy professionals, amateurs, and industrial photographers. In black-and-white work, medium-format users should have a back that takes the Type 665 film, which can deliver instant prints and negatives of an extremely high quality—is ideal for the photographer on location. (It is also available for 4×5 in cameras.) Polaroid's high-contrast films can snap up a dull shot for darkroom manipulation later.

will have the problem of storing 3½ gallons.) The best developer really comes down to being the one that gives the best overall compromise between those four goals of grain, gradation, sharpness, and speed. There are many candidates for this crown, but the leading four are: Kodak D-76, Ilford ID-11 Plus, Acufine, and Ethol UFG.

The new commercial garden-variety finegrain developers like Kodak's Microdol-X, Ilford's Perceptol, Agfa-Gevaert's Atomal have been left out so far with reason. These are really good developers, and they work wonders at one-to-three dilution ratios, but they don't have the pushing flexibility needed by working professionals and by most serious personal photograhers. Today, when you find an expert using one or more of these developers, it's almost never as a one-and-only developer, but as the preferred soup for strong lighting and hard contrast. This is fine, and you can do the same thing too—once you have really learned the ins and outs of a truly basic soup like old D-76.

Bulk loading

As film prices increase, bulk loading of 35mm film becomes an economically viable alternative for even the weekend photographer. With a small initial outlay and a little time and patience, you can load your own cartridges for about one-third of their retail price. Most black and white films and several color print and reversal films are available in bulk rolls. (100ft rolls give the greatest savings.) A loader and empty cartridges (about two dozen are needed for a 100ft roll at 36 exposures each) are available at most camera stores.

Once the film is in the loader, you can work in normal light. To load, put the cartridge in a light-tight chamber, after first attaching the leading edge of the film to its spool with masking tape. Then, turn the crank on the loader to transfer the film on to the cartridge. The loader's frame counter will show you how much film has been loaded.

Your greatest enemy while bulk-loading is dust, and if you want to avoid scratching all your negatives, you must keep your equipment scrupulously clean.

Bulk 35mm film availability

Black-and-white	Speed	Length
Ilford Pan F	E.I.50	55', 97'
FP4	E.I.125	55', 97'
HP5	E.I.400	55', 97'
Kodak Panatomic-X	ASA 32	27 ½', 50', 100'
Plus-X	ASA 125	27 ½', 50', 100'
Tri-X	ASA 400	27 ½', 50', 100'
2475 Recording	ASA 1250	125'
Direct Positive Pan 5246	ASA 80D, 64T	100'
High Contrast Copy 5069	ASA 64	50'

Color Film

Before discussing the nature of individual color films it is important to describe the color relationships that form the basis for all color photographic materials. For photographic purposes white light (daylight) is considered to consist of three equal components—red, green, and blue light. Red, green, and blue are the three additive primaries; using these primaries in different combinations, you can form any visible color in the spectrum.

This can be demonstrated very simply with three spotlights giving red, green, and blue light respectively. When they are focused on the same point, the color of the light will be white. When the red light is turned off, the green and blue together form cyan; cyan, then is "minus-red." When only the green spot is turned off, the color is magenta; thus, magenta is "minus-green." With the blue spot off, the red and green light together produce yellow; yellow is "minus-blue." Cyan, magenta, and yellow, the opposites to the additive primaries, are the subtractive primaries. By selectively subtracting red, blue or green from white light, they also can reproduce any color in the spectrum.

Color films
Color films are either negative-to-positive (print), or reversal (slide) types. Like black-and–white films, color films are judged by their grain, gradation, sharpness, and speed. But unlike their monochromatic brethren, color films must also be carefully selected for their color balance (because the color of the light used to illuminate a scene varies greatly) and more importantly, their color rendition.

The structure of color film is considerably more complex than black-and-white film. Modern color films contain three emulsion layers stacked one atop the other, on a plastic film base. Each layer consists of the same basic components that go into black-and-white film—silver-halide particles of several sizes suspended in an organic gelatin layer—but each layer is quite different and serves a different purpose in reproducing the image.

Color negative film
The least complex, and therefore the easiest to understand, route to forming a color image occurs with negative (print) film. The uppermost emulsion layer in color negative film contains silver-halide particles that have been treated with dyes or other organic substances, so that they register only light from the blue part of the visible spectrum. In addition to these particles, this layer contains an organic-chemical substance called a coupler. When the film is processed the coupler reacts with the processing chemicals to form yellow dye wherever the silver-halide particles were struck with blue light (remember, this will be a color negative and yellow is blue's complementary, yellow is minus-blue).

Below the blue-sensitive layer is a yellow-dyed layer of gelatin that serves two purposes. First, its yellow dye will absorb any blue light that might pass through the blue-sensitive emulsion layer. Second, the layer separates the top from the middle emulsion layer. The yellow dye in this layer washes out of the film completely during processing and performs no image-forming function whatsoever.

The middle emulsion layer contains silver-halide crystals which are sensitive (largely) to green light. Largely, not solely: this emulsion will also respond to blue light and this is the rea-

The structure of color film

Blue - light-sensitive emulsion layer
Silver halides plus color coupler

Yellow filter
Water-soluble dye in gelatin

Green - light-sensitive emulsion layer
Silver halides plus color coupler

Separator
Clear gelatin

Red - light-sensitive emulsion layer
Silver halides plus color coupler

Plastic film base
Water-soluble black dye
for anti-halation properties

The miracle of color film is not only that each emulsion layer is consistent in terms of speed and color balance from batch to batch, but also that the color sensitizers and couplers remain within their layers. Kodak keeps wayward couplers where they belong by using a water-insoluble resin-like substance that absorbs the couplers in micro-globules while still permitting the developer to reach them in processing. All Kodak color films, and many other brands, use this technique.

son for the yellow filter layer. During processing the coupler in the middle layer reacts with the chemicals to form magenta dye wherever a latent image is formed of the green portion of the subject. The magenta dye so formed is not as spectrally pure as it ought to be, since it also absorbs a little blue light. To compensate for this the coupler incorporated in this layer is colored pale-yellow. After processing the coupler retains its pale-yellow color wherever no magenta dye is formed. That way the blue light captured by the magenta dye is compensated for over the entire emulsion layer, because wherever the magenta dye does not absorb blue light the pale yellow couplers will.

A layer of clear gelatin separates the center and bottom emulsion layers. The lowest emulsion layer, like those above it, contains mixed sizes of silver-halide crystals and a coupler. The silver-halide crystals respond to red light. The coupler reacts with the processing chemicals to form cyan dye wherever a latent image was formed of the red-content of the subject. The cyan dye also isn't as pure as it ought to be: it tends to absorb a little blue and a little green along with red. For that reason, the coupler in this layer is colored pale-red to compensate for the unwanted losses that occur where cyan dye is formed. (Red is formed when magenta [green's complementary] dye

The colors of light

Color is not only a very subjective thing—no two people would describe "red" the same way, if they could describe it at all—but it also physically varies from place to place, from season to season, from hour to hour, and is dependent upon the direction of the light. Further, the colors you see around you are a function of the color of the light illuminating what you see. If you are outdoors, in direct sunlight, the color of that sunlight will be much redder in early morning and late evening hours, when the sun's rays have to pass tangentially through the thick layer of dust, pollutant gasses, water vapor and air we call our atmosphere, than it is at midday when the rays come in at a much more nearly perpendicular angle for a shorter passage through the atmosphere.

The color of sunlight also varies, with latitude. The sun is never more than about 23° from overhead at the equator at noon, but at that same hour it hardly moves above the horizon near the polar regions. And for the same reasons, the color of sunlight will vary from season to season, as the sun's position at zenith varies. If, in the northern hemisphere, at any time during the day you happen to be in a room which has windows only on its north wall, the color of the illumination coming through that window will be blue (if it's a clear day and the sky is blue) or white (if it's a cloudy day).

About the only place you can rely on the color of the light being what you think it is, or you want it to be, is in a studio with no windows and very carefully controlled artificial illumination. If, therefore, you decide to do your own color testing of color film, you had better make sure it is under such controlled circumstances. Otherwise you will just be fooling yourself.

Filters For Fluorescent Light

Fluorescent Lamp	Daylight Film	Tungsten Film
Daylight	40M + 30Y	85B + 30M + 10Y
White	20C + 30M	40M + 40Y
Warm White	40C + 40M	30M + 20Y
Warm White Deluxe	60C + 30M	10Y
Cool White	30M	50M + 60Y
Cool White Deluxe	30C + 20M	10M + 30Y

Color temperature and correcting filters

Light source	Temperature	Daylight film (5500K)	Tungsten light film (3200K)
Candlelight	1800K		
Household light	2800K	80A	82C
Photolamps	3400K	82B	81B
Sunlight	5400K		85B
Flash	6000K		
Blue Sky Light	7200K	85	86

The Kelvin Scale is a continuous measurement of the color temperatures of light. Each light source is given a value in degrees Kelvin such as shown left; for example, candlelight is a lower and warmer color than sunlight. Our eyes adjust automatically to such differences in the color of light, but color film can only be balanced for a specific temperature, and lighting of any other temperature will create a color cast in the image. Most color films are balanced for daylight. Candlelight, for example, will leave a distinctive orange cast on daylight-balanced film. A few films are balanced for tungsten light (3200°K) and for photolamps (3400°K). In order to compensate for unmatched lighting, you can put color filters over the lens. Some filtration recommendations for various common light sources are shown in the chart, but you can never be really certain of your results unless you use a color temperature meter

Fluorescent lighting probably presents the greatest problem for the critical photographer because it emits combinations of line and continuous spectra and so does not have a fixed point on the Kelvin scale. Kodak recommends using daylight film under fluorescent lighting and the filter combinations shown in the table opposite.

The structure of color paper

Red - light-sensitive emulsion layer
Silver halides plus color coupler

Separator
Clear gelatin

Green - light-sensitive emulsion layer
Silver halides plus color coupler

Separator
Clear gelatin

Blue - light-sensitive emulsion layer
Silver halides plus color coupler

Base
*Plastic-coated, optically brightened,
highly reflective paper*

Fading is not the only reason for reversing the order of emulsions in color paper. When light travels through an emulsion, it is diffused somewhat and at the bottom layer it is more visible. For the sake of a sharper appearance, it is preferable to have the bottom layer yellow in place of the visually dominating and image-enhancing cyan. Reversing also allows the elimination of a yellow filter below the top layer.

and yellow [blue's complementary] dye are mixed.)

The mixture of residual dyes in the couplers in the center and the bottom emulsion layers give color negatives their characteristic pale-to-strong orange color.

To make a print from a color negative, the negative should be placed in an enlarger emulsion-side down, and the enlarger lamp's white light should pass through it and project the image on to the printing paper. As the beam passes through, the dyes within the negative (which are subtractive primary colors) remove the appropriate portions of the color spectrum from the white light. The topmost, red-sensitive emulsion layer records any red light that has passed through the cyan-dye screening of the negative; the middle, green-sensitive layer records any green light that passes through the magenta-dye screening; and the bottom, blue-sensitive layer picks up whatever blue light filters through the negative's yellow-dye screening.

During chemical processing, the action of the coupler and the processing chemicals converts the latent image in the paper's red-sensitive emulsion layer back into a cyan-dye image, that of the green is converted into magenta, and that of the blue into yellow. In effect, there have been two complete reversals of the image's coloring. Finally, after the chemical process is completed, and all traces of silver from the

printing paper have been removed, the image is rendered in the print with those colors originally perceived by the photographer's eye.

The order of the color sensitivities of the emulsion layers is reversed between film and paper because, although all dyes will fade if exposed to ultraviolet light, and chemical fumes (in the air) and even water vapor (humidity), yellow dye is most susceptible to ultraviolet fading. Printing paper manufacturers therefore arrange the emulsion layers so that the yellow-dye layer in a finished print is beneath the magenta and cyan layer. These dyes, less susceptible to ultraviolet light, protect the easily faded yellow dyes under normal viewing circumstances.

It's impossible to predict how any particular photographic image—whether a print, negative or transparency (slide)—will fade with time. Everything depends on the conditions to which the image is normally exposed. Slides that are frequently projected will fade faster than those that are stored in the dark and only occasionally viewed on a light box, since the ultraviolet in the projection light causes the dyes to deteriorate. Prints that are exposed to sunlight are equally prone to fading (much to the consternation of some collectors of photographs). The most stable dyes used in photography are those found in Cibachrome materials, but all dyes fade in time. Kodak recommends that to prevent fading, you should store color photographic images by wrapping them in a vapor-tight material and placing them in a dark freezer!

Color reversal slide film

The construction of color-slide film is essentially the same as that of color negative film, except that the colored dyes are omitted from the green-and red-sensitive layer's couplers, and the absorption characteristics of the dyes formed in processing are adjusted for this omission.

The real difference between the way the image is formed on a slide and on

Color		
Kodak Ektachrome Slide Duplicating 5071	ASA 8	100'
Vericolor II Professional 5025 Type S	ASA 100	100'
Ektacolor Internegative 6011	ASA 12	80', 100'
Ektachrome 50 Professional	ASA 50T	100'
Ektachrome 64 Professional	ASA 64D	100'
Ektachrome 160 Professional	ASA 160T	100'
Ektachrome 200 Professional	ASA 200D	100'

D denotes daylight, T denotes tungsten

Bulk loading color films can save you money if you shoot a fair amount of film. Some exotic films are only available in bulk, those offered by Kodak are shown left. However, there are several factors that you should consider: it is easy to scratch the film, loading takes time, and Ektachromes and Kodachromes are not available in bulk loads.

a negative lies in the film processing. In reversal processing, there are two development stages. First, the latent image recorded in each of the emulsion layers is reduced to a metallic-silver negative image in a black-and-white developer. Then the film is deliberately re-exposed (with a strong chemical-fogging agent) so that the negative-silver image is "contact-printed" to form a positive latent image in the remaining, unreduced silver-halide in each emulsion layer. It is this positive latent image which is then developed in a color developer. The developer reacts with the coupler in each emulsion layer to form the appropriate subtractive-primary-colored dyes, producing a positive color image.

In a transparency, white is formed by the white viewing light passing through the clear film base and silver-less and dye-less emulsion layers in areas where no dyes whatever have formed. Black appears wherever the maximum dye density of all three subtractive primaries has formed. (Black isn't a color at all but the absence of white light. If all three subtractive primaries are present, they will absorb all three of the additive primaries and allow no viewing light at all to pass through the film.)

Similarly, in a color print the whites are those of the viewing light bouncing off the white, reflective paper base wherever no dyes are present in the overlaying emulsion layers. Black appears where no light is able to penetrate the maximum dye density in each of the three dye layers overlaying the paper base.

Among the color reversal films, the Kodachromes really are different. None of them contains built-in color couplers. Instead, the couplers are added during the rather complicated and

Color film latitude

Color films, especially reversal film, do not have the generous exposure latitude of black-and-white film and contrast is almost always a problem in color work. In color work, your exposures should be more carefully selected. As a good working rule of thumb, you can count on 2½-stops of exposure latitude with color print film—from ½-stop of underexposure to 2-stops of overexposure. But if you are not very critical of the results you can get away with as much as a full-stop of underexposure and three stops of overexposure.

With reversal film, deviation from normal (nominal ASA, or your own EI) of more than ½-stop will be detrimental. Uncritical photographers may get away with as much as a stop of under- or overexposure.

Adjustment to the first-developer processing time can be made to compensate (to some extent) for one-stop of overexposure and up to two-stops underexposure, with any of the Ektachrome films. But the results so obtained won't satisfy critical workers.

tricky processing that involves, among other things, re-exposure of each of the emulsion layers separately, by means of colored lights. This is why the Kodachromes can't be home-processed. This coupler-less construction and critical processing allows the Kodachrome films to be manufactured to provide the least grain, the highest resolution, the best dye saturation, and

the most generally pleasing color rendition of any color-reversal material. However, it must always be borne in mind that these characteristics are not obtained without some sacrifice. The two Kodachrome films are very slow materials, rated at ASA 25 and ASA 64. But aside from this obvious drawback they are the best color-reversal material available, bar none. The fact that Kodachrome film is available only in 35mm and smaller sizes has probably done as much to promote the growth of this format as any other single factor.

Color film processing

There are many home color film processing kits available, from Kodak and other firms. They are designed to allow you to process print films compatible with Kodak's process C-41, or the reversal films compatible with Kodak process E-6. Aside from the Kodachromes and Agfa's CT-18, the films that aren't compatible with those processes don't really bear mentioning, since virtually all film manufacturers have had to conform with Kodak's E-6 and C-41. Not only does this compatibility insure a potential market-share by guaranteeing their customers an available network of processing facilities that can handle their films as well as others, but it also insures that the processing labs handling their films can meet today's more stringent environmental-protection regulations.

Home color-film processing is unproductive, uneconomical, unpredictable, and generally unnecessary. Color films are specifically designed to be processed in huge quantities, continuously, under carefully controlled circumstances. Home-processing kits take advantage of none of these characteristics, but rely instead on substituting very inexact time-extension methods for the careful chemical monitoring and control really needed. The small, one-pint kits do, in theory, have a total processing capacity of six or eight 35mm film cartridges. But in practice their use means that you have to have a fairly substantial number of these

The accompanying table lists Kodak's recommendations for adjusting the first developer to compensate for deviation from the standard ASA of certain films.

KODAK'S RECOMMENDATIONS FOR ADJUSTING DEVELOPMENT TIME

Film	Alter time of first developer by:		
	+5¹/₂ min.	+2 min.	-2 min.
Ektachrome 400 (*Daylight*)	1600	800	200
Ektachrome 200 (*Daylight*)	800	400	100
Ektachrome 160 (*Tungsten*)	640	320	80
Ektachrome 64 (*Daylight*)	250	125	32

rolls of film on hand, ready and waiting to be processed, within a relatively short period of time, since the shelf life of the processing solutions is rather short, especially after they have been diluted to working strength and partially used. In addition, there is almost no way that you can predict your results when processing the sixth roll of film. Besides, these kits are designed to process only two rolls at a time, so just getting to the sixth roll can be quite a chore. In the end, you can come out slightly ahead on cost if you manage to process all the film possible with the entire contents of a kit.

Some home processors argue that they can push their films when processing at home. True enough: if you don't mind the results obtained in this way. But almost any lab will provide the same services, and under much more controlled conditions.

There are, however, some good reasons for processing your own color films at home. You might, for example, need to have a take processed by early Monday morning from film you shot late Sunday night. But, except for such extreme circumstances, it is better to avoid home processing, unless you simply want to experience the whole chain of events between the time you press the shutter button and the finished processed image.

Don't, however, allow anyone but a custom-color printer to make important color prints for you, and do that only if you can't do the printing yourself. Unlike color processing, color printing is easy to do at home with complete control and relative economy. Something else to consider: you can always remake a color print if you foul up its exposure or processing, but you have no second chance with color film processing. If you make a mistake, it cannot be rectified.

Color print films

Several foreign brands of color print film are available, but unfortunately, they do not match up to Kodak films. Kodak makes a number of color-print film loads, the primary differences among them being contrast. Ranked in order of increasing contrast they are: Vericolor II Professional, Type S; Kodacolor II; Kodacolor 400; Vericolor II Professional, Type L; and Vericolor Commercial Type S. All but the Kodacolor 400 are medium-speed films (ASA 64 to 100). They are all somewhat grainy, but naturally Kodacolor 400 is the grainiest, and provides the lowest resolution among them. Type L calls for long exposure (1/10 of a second or more) and is balanced for 3200°K illumination, while Type S calls for exposure shorter than 1/10 of a second and is balanced for daylight.

Color print film is generally still lagging behind reversal and black-and-white films in terms of resolution, so the larger the negative the better. If you shoot color-negative film, medium or large-format negatives can provide you with very high quality prints. However, even 35mm negatives will provide quality images at magnifications below about 9X.

Color reversal films

There is nothing available in any size film load that can produce results equal to Kodachrome 25; it is the best film on the market and the best choice, if its very low speed can be tolerated. For higher speeds there are the other Kodachromes (Type A and 64), although they go only to ASA 64. Beyond that speed, Agfa and Fuji both have

"Professional" films

Some Kodak and Agfa films are called "professional", or "commercial"—several Ektachrome films are labled "professional", and there is even a "professional" Kodachrome—Kodachrome II Professional A.

Probably the most significant feature of these films is that they are difficult to use properly. They have to be refrigerated (frozen is better) until they are needed, when they must be thawed. Then they have to be frozen again until they can be processed.

The reason for this sort of elaborate handling is simply that all color materials (and all black-and-white materials) change their properties as they age, and high temperatures accelerate this process. The principal change in a color film is its color balance—the way it will render the colors in the subject you are photographing. Such characteristic changes are the reason that film manufacturers end-date their film. If film is left long enough at high enough temperatures, it will be rendered useless not only by the color balance shifting, but also through fogging.

Kodak's "professional" films are allowed to age to an exact color-balance prior to shipment. Photographers who use "professional" loads usually buy the films in very large quantities, to make sure that all the material bought comes from the same emulsion batch (an emulsion batch number is on every box of Kodak film). Then they carefully shoot test exposures and process the film to establish its exact color balance characteristics. Since the film stock is kept frozen they will then be able to deal with known color characteristics, thereby avoiding nasty color surprises.

Kodak's amateur films, on the other hand, are usually shipped before they have aged to an ideal color balance and allowed to "ripen" on the dealer's shelves or in the camera. Unless you are an absolute perfectionist, or are working for one, you can ignore the "professional" loads in favor of the more stable, if less predictable "amateur" films.

films worthy of consideration. Agfa CT-18 is a good choice if pastels and browns and blacks predominate in the subject. Otherwise, any of Kodak's numerous Ektachromes should be considered. Be aware that as the speed of the films increases the quality of image they will produce decreases, and the Ektachromes, particularly the 400 speed, are too grainy for many critical workers. If quality is paramount and you can't use one of the Kodachromes, it is better to use medium- or large-format and capitalize on the significantly larger images they give you.

Color printing materials
If you choose to make your own color prints at home, you will find that the process is not difficult, and can be extremely rewarding. These days it is quite possible to make color prints of

Color Polaroid Film

Result	Product Name	Format	Print Size (inches)
Color print	Polacolor 2, Type 108	Pack	$3\frac{1}{4}$ x $4\frac{1}{4}$
	Polacolor 2, Type 668	Pack	$3\frac{1}{4}$ x $4\frac{1}{4}$
	Polacolor 2, Type 88	Pack	$3\frac{1}{4}$ x $3\frac{3}{8}$
	SX-70	Pack	$3\frac{1}{2}$ x $4\frac{1}{4}$
	Polacolor 2, Type 58	Sheet	4 x 5
	Polacolor 2, Type 808	Sheet	$8\frac{1}{2}$ x $10\frac{3}{4}$

very good quality directly from color slides, at reasonable cost, and in reasonable periods of time. Things are easier, and faster too, for the printer who works with color negatives, now that two- or three-solution processing chemicals and contrast-graded paper of exceptional speed are available.

For making prints directly from slides Kodak's suggested combination of Ektaprint R-1000 chemicals and Ektachrome 2203 is very good. Cibachrome Type-A print material and their P-12 chemicals is a simpler process, with only three steps and two fewer chemicals. But Cibachrome is expensive and although good for strong graphic images, it should be avoided where excessive contrast will be detrimental to the image.

For printing from negatives, Kodak's Ektaprint-2 chemicals and their Ektacolor 74 RC (low-to-normal contrast) and Ektacolor 78 RC (normal-to-high contrast) printing paper are probably the best general papers available. Comparable materials from independent makers can serve either for beginners or where budget is a large factor.

Color printing papers today all use plastic-coated (RC), middle-weight (MW) stock, except Cibachrome, which is on an all-plastic base. A wide variety of surfaces are available including glossy, semi-matte, luster, and silk.

Speed (A.S.A.)	Normal Development Time at 75°F (24°C)	Special Characteristics
75	60 seconds	Balanced for Daylight.
75	60 seconds	Balanced for Daylight and Electronic Flash.
75	60 seconds	Balanced for Daylight.
	Self timing 45°F(7°C)-95°F(35°C)	Balanced for Daylight.
75	60 seconds	Balanced for Daylight and Electronic Flash.
80	60 seconds	Balanced for Daylight and Electronic Flash.

Among the Polaroid instant color films, the most notable is the Type 808 8×10in Polacolor, which produces a finished 8×10in image almost immediately. You can't sling it over your shoulder, but an 8×10in camera with Polaroid 808 is a very special tool. Perhaps the greatest obstacle to general acceptance is the resistance to Polaroid among some professionals. This stems from two factors: its amateur connotations and the fact that studio tests on Polaroid often result in the art director becoming the photographer while the photographer is relegated to looking after the camera setting like an assistant.

Enlargers

I t is an old truth, but one which cannot be denied, that there is no point in having even the very best cameras and lenses, if you are going to make your prints on a cheap enlarger. An enlarger should be as basic an investment to your photography as your camera, and choosing a particular model should be done with great care and consideration for the type of work you want to do.

In many respects, buying an enlarger is much easier than buying a camera. Although steady progress in cameras, lenses, and some leading accessory items (like flash units) brings a kind of perpetually planned obsolescence, this does not apply to enlargers. Enlargers in use for twenty and even thirty years can perform as well, and often actually outperform any contemporary cheapened models.

Initially, there are two things to look for in any enlarger—format (film size) and versatility. Obviously, the enlarger you choose should take the film format you normally use but, if you can afford it, an enlarger one format larger is preferable. This gives you the option to work in larger film formats when the occasion demands, without losing control over the printing. Thus, if you normally work in 35mm, you may do better getting a medium-format enlarger that will take a rollfilm carrier. Probably the only reasons beyond your budget for ignoring this advice are the now discontinued Leitz/Valoy (manual focusing) and Focomat (auto-focus) enlargers with their distinctive round heads and single-condenser illumination systems. These 35mm format machines provide a kind of silvery long-scale black and white print gradation that other sources can't match. Neither

the bigger Leitz Focomat II-series machines (that go to $2\frac{1}{4}$x$3\frac{1}{4}$in/6x9cm) or the stylish, but almost useless Focomat V35 (35mm only) can produce prints as good. Even so, the Valoy and Focomat I-Ic machines were, and still are expensive.

Illumination systems

Versatility in an enlarger starts with the lamphouse system, which can range from diffusion to point-source illumination. Diffusion enlargers scatter light rays in every direction, so that the negative is illuminated from almost every angle. Light rays from a point-source lamphouse strike the negative head-on, or only at a very small angle.

Completely diffusing enlargers are the traditional choice for large-format black and white negatives, and have recently become the preferred system for color enlarging. Genuine point-source enlargers are almost never used for pictorial purposes, but are used to produce enlarged copies of material stored on micro-film, whether in a library, or in the morgue of a newspaper. Most black-and-white enlargers use a condenser system in which the light is focused by a lens on the negative.

Enlarger-lamphouse design affects picture quality in several ways. Diffusion enlargers and those similar to them share a reputation for soft, long-scale print gradation, while ignoring defects like grain, scratches, and dust. Condenser enlargers are closer to the point-source type, and so they are regarded as "harder," giving more contrast and better sharpness with clearer grain and all the consequent blemishes. This difference between the two systems goes back to something called the Callier effect.

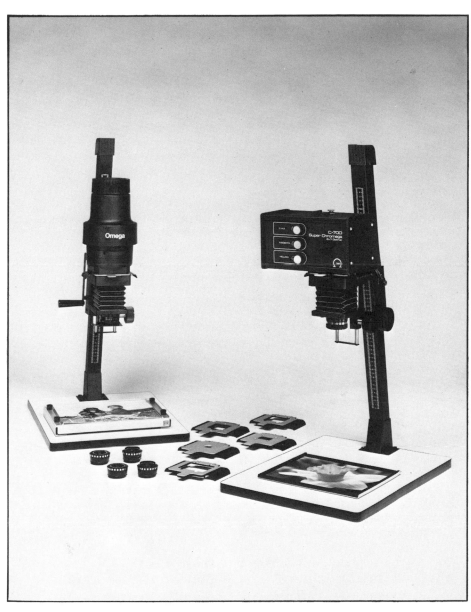

The Omega enlarger system, above, is typical of today's enlarger designs that allow different lenses, negative carriers, and light sources to be interchanged for different tasks. The enlargers also adapt as copy stands.

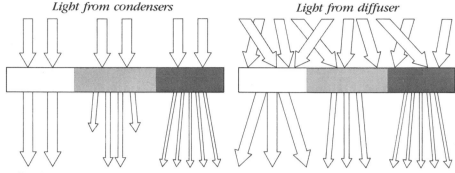

Light from condensers　　　　*Light from diffuser*

Illumination from a condenser-type enlarger (left) is scattered less when passing through the low-silver-partical-density shadow and middle-tone areas of a black-and-white　*negative than is illumination from a diffusion-type enlarger (right). For this reason, black-and-white prints made with a condenser enlarger show more*　*contrast than those made with a diffusion type. The effect is absent in color printing, as neither color negatives nor slides contain any light scattering silver particles.*

The Callier effect

In 1909, Andre Callier discovered that the same negative could yield different degrees of contrast if the enlarger or projector lamphouse was changed. Callier wasn't the first to notice these differences, but he was the first to explain why they occur.When highly directional light rays strike specks of colloidal silver (the stuff that B&W images are made of), they act like tiny lenses and prisms, bending some light out of the ray path that reaches the enlarger lens. The denser the silver particles, the greater light losses due to refraction. Therefore, dense parts of the image print much lighter than if illuminated by diffused light, while the thin parts of the image—the "shadow areas"—print about the same. This increases the contrast between highlights and shadows in prints from a condenser enlarger, and, because the border lines between brighter and darker image areas are somewhat exaggerated, there is a greater impression of sharpness. At the same time, the refracted light rays which never reach the enlarger lens

emphasize the granular structure of the image, and consequently reveal defects like dust and scratches.

All of these effects depend upon the presence of silver specks in the image, but color materials, including color negatives, contain no silver after processing. No silver, no Callier effect; and if there is no Callier effect, there is no need to use anything except a diffusion enlarger, since defects like grain, scratches, and dust, which are emphasized by straight–line light sources, will be hidden by diffusion. Thus, a color enlarger is really only a diffusion lamphouse to which some method of color filtration has been attached. This is great for making color prints, but not so great for high-quality black and white results.

Before color enlarging became popular, enlargers were designed to produce different sorts of image quality. Then, as the grainy films of the early days of 35mm photography were replaced by modern fine grain materials, some compromise systems were accepted as preferable. Today these prin-

Diffusion enlarger illumination systems

A diffusion light source employs a single lamp. This relatively inefficient type of light source is often found in older black-and-white enlargers.

Early diffusion color heads used two matched bulbs with an integrating or mixing light chamber that allowed increased light output and even illumination.

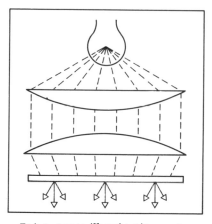

Point-source illumination system

A point-light source gives high intensity, very collimated light that can reveal dust, scratches, or any other defects on the negative very readily.

Opal bulb with condensers

Condenser-illumination systems use a soft, opal bulb to help diffuse the light beam. This compromise light source is used in most enlargers for black-and-white printing.

ciples are increasingly being ignored by manufacturers who want to cut costs by producing cheap diffusion lamphouses.

Illumination adjustments

For the vast majority of enlargers, there is virtually no adjustment you can make to your illumination system, except to optimize it for the format you wish to use. A few enlargers do allow you to position the lamp within the lamphouse (a feature of many Durst models, for example) to achieve even illumination across the entire area of the negative-carrier aperture. In addition, this allows you to rotate the bulb to eliminate imaging of its filament, or to minimize the effect of shadows cast by information printed on the bulb itself, as well as allowing you to position the bulb at its ideal location within the lamphouse, a position which may vary from lamp to lamp.

Lamp output should be optimized every time you change formats. It should be obvious that printing speed will be enhanced when you use a 4x5in enlarger to print 35mm frames, if the full lamp output can be concentrated evenly across an area not much larger than the aperture in the 35mm negative carrier. In any kind of enlarger, this is fairly easy to accomplish. Condenser enlargers can be adjusted for format optimization by three different means: 1) through the addition or removal of special (supplementary) condenser elements; 2) through repositioning of one or more of the normal condenser elements; and 3) through repositioning of the negative stage relative to the condenser elements. All these methods are effective, though the last is by far the most convenient, since it is usually accomplished by turning a knob, rather than by physically moving the condensers themselves. Several of the Beseler enlargers use this third method.

Diffusion enlargers use concentrator boxes to funnel optically the full lamp output down to the size of the smaller film formats. These boxes are literally

funnel-shaped and are much less efficient at concentrating light than the several condenser methods are. However, they do help; and diffuser enlargers, with their generally lower lamp-utilization efficiency need all the help they can get to achieve the high printing speeds often needed for the color work these machines are principally designed to do.

Distortion controls
You can make limited corrections of distortion at the printing stage. The sort of convergence of lines that occurs when the camera is tilted upward for architectural shots, for example, can be corrected by tilting the image during printing (employing the Scheimpflug principle, see page 152). Many enlargers, Beseler and Durst for example, feature tilting lens boards for this sort of correction. But you can do it equally well by tilting the easel, and Omega (under Saunders brand) offers a vacuum base magnetic device to do this. Using any of these methods, however, will throw a part of your image out-of-focus, and you should use the smallest aperture possible to minimize this problem through increased depth of focus.

Enlarger uprights
When you raise the enlarger head to make bigger prints, if the column is vertical the image will cut into the base of the column. A canted column that leans forward (like those made famous by Simmon Omega) avoids this by keeping out of the light path. A canted design, however, reduces rigidity, and professional labs with lines of Omegas use extra bracing to secure the heads. Omega offers wall-brackets as accessories, or you can make your own using guy wires pulled tight by turnbuckles obtainable from any hardware store.

Choosing a negative carrier
There is no doubt that glass-negative carriers offer both the best possible image sharpness and the maximum imaginable annoyance. Although glass carriers hold negatives perfectly flat, giving corner-to-corner sharpness, they introduce dust and dirt problems. (Best of all is an enlarger that takes both glassed and glassless carriers interchangeably.) In addition, unless glass carriers introduce a small layer of air (either by mechanical or optical design), there is danger of wavy lines known as Newton's rings, forming between the two glass surfaces.

Despite their theoretical disadvantages, many critical photographers use glassless open-frame carriers, and work with small lens apertures, like f/11, and some sort of condenser lamphouse. The greater accuracy given by glass-negative carriers is more advantageous for diffusion enlargers. The reason is complicated, but basically the more concentrated the enlarger light source, the more the light is packed into a small aperture, giving increased depth of field. Very diffuse lamphouses fill the whole lens with light, thereby reducing this depth.

Many sensible arguments support the use of plastics in camera design, particularly for the SLR's top plate. But in enlargers, which tend to heat up when used for long periods of time and which are generally located in darkrooms where there are various chemicals, plastic components can spell disaster. Worst of all are plastic negative carriers, which themselves almost guarantee problems.

Negative carriers

A simple sandwich frame carrier with two metal frames to hold the negative is the most commonly used today.

A single-glass plate with a metal frame lessens the chance of dust collecting.

A double-glass sandwich carrier offers the best possible negative flatness but causes dust spot problems in smaller format work.

The condenser and metal frame is typical of 35mm enlargers such as the Leitz Focomat.

Manual and automatic focusing

Auto-focusing enlargers, which have been produced for more than 60 years, work on a much simpler principle than auto-focusing cameras. This is because there is a fixed relationship between the elements: the negative carrier (the subject), the baseboard (the image), and the lens. After this, it is only necessary to know the focal length of the lens and have some mechanical means of changing the lens-to-negative distance as the enlarger head goes up and down in order to make the enlarger auto-focusing.

The best auto-focusing enlargers are the Leitz machines which use a parallelogram for the up-and-down movement, with a small eccentric cam made out of specially hardened tool steel. Less reliable is the Omega system using long blade-type eccentrics made of aluminum strips that run almost the full height of their canted columns. Nevertheless, many photographers feel that even this less-than-perfect auto-focusing mechanism is a big help because it saves time by keeping the image close to focus. If for some reason you use many different lenses or change paper easels frequently, you could probably work quicker without an auto-focusing mechanism. If you do opt for one, however, use a glass negative carrier so that the mechanism "knows" exactly where the negative is at all times.

Auto-focusing can be a time-saving convenience, but it can also be a costly one, and can introduce some unexpected difficulties. Make certain that you understand how it can be adjusted, particularly if you later decide to change lenses. The focal lengths of lenses are seldom exactly as engraved: 50mm lenses, for example, can, and often do, vary in actual focus from around 48 to 52mm, and this is more than enough to throw an auto-focusing mechanism out. Good systems, however, like that of the Leitz Focomat enlargers, are fairly easily adjustable.

Calibrated magnification scales

Magnification scales are one of the most dispensable features on an enlarger. If you know the size of your negative and can read the calibrations on your enlarging easel or an ordinary ruler, you can find the degree of enlargement much more accurately and at much less expense.

One argument frequently used in favor of scales is that in color work photographers often make small-scale test prints, then raise the enlarger head to make the final print at higher magnification. The scales are supposed to tell the amount of added exposure necessary, which they sometimes do. But in fact most photographers in this situation use color analyzers or other baseboard metering aids, and have little need for these scales. Some recent enlarger models, particularly those of Vivitar and Rollei, look like glorified slide rules, and are about as useful.

Positioning filtration

Lamphouse light needs color filtering if you're printing black and white on a variable-contrast paper, or doing any sort of color work. Beware of any filtering below the lens, as was once (and is still sometimes) offered for variable-contrast papers like Kodak's Polycontrast or Ilford's Ilfospeed-Multigrade. If the optical quality of your image is important, you should do your filtering at or near the light source. This means inside the enlarger-lamphouse head, above the negative stage.

The Rodenstock Apo-Rodagon represents a state-of-the-art enlarging lens whose symmetrical six-element construction permits a high degree of correction. The image given by such a lens is extremely sharp, and for high magnifications in color (over 10x) its performance is matched by few lenses.

Dichroic filtration systems, introduced originally for color printing using the subtractive method of cyan, magenta, and yellow, are equipped with dial-controls for altering filtration. Such luxury isn't necessary, and you can easily use individual filters; the black and white Omega D-series heads for example, let you drop 5x5in filter squares above the condenser pack. Almost every current enlarger provides some sort of acceptable topside filtering system. The problem of adapting older models without so-called "color heads" usually requires some ingenuity, so consult a camera repair service.

Choosing an enlarger lens

The most important part of any enlarger is its lens. Lenses accepted as "standard" focal lengths for a film format are about the same as those used for normal enlarging. Acceptable enlarger lenses are built along the same lines as quality standard-focus camera optics, and are either 4-glass/3-group cemented triplets of the Tessar type, or more complicated Gauss-type designs. About half of all the enlarger lenses on the market today are uncemented 3-glass triplets of a type discredited for camera use and thus to be avoided.

Tessar-type triplets have always made good enlarging lenses, although today there's no comparison with the more expensive Gauss-types, for two basic reasons. First, the 4-glass cemented-triplet design gives the designer some freedom, but not nearly as much as a 5- or 6-glass Gauss design. As a result, Tessar-type enlarging lenses generally produce an undesirable "zonal aberration," an area of inferior imagery between the center of the picture and its edges.

The second basic weakness of the Tessar-type enlarging lens is that because their design is highly unsymmetrical they won't perform equally well at all image magnifications. Tessar-type lenses are really just standard-focus camera optics coverted to enlarging and are almost always corrected to give their best image quality at, or near infinity when used with a camera which would give very large blow-ups on an enlarger. In normal enlargements (meaning only 5 to 10x for 35mm negatives, and a lot less for the bigger formats) various defects show up. One of these is distortion, the lens aberration in which the straightness of parallel lines is altered without affecting image sharpness. But the main difficulty is zonal aberration, which deprives the whole image of even sharpness.

About 25 years ago, Schneider Kreuznach, the well-known German producers of Symmar and Super-Angulon lenses for large-format photography, began to make enlarging lenses similar to the symmetrical double-anastigmat lenses for large-format cameras which appeared under the now-legendary Componon (recently revised as Componon-S) trademark. These were the first 6-glass Gauss-type lenses specifically designed for the enlarger. Today, top-grade Gauss designs are also produced by Rodenstock (Rodagon), Nikon (El Nikkor), Fuji (Fujinon), and Leitz (Focotar-2). In addition to the more even sharpness over the whole image field afforded by their complicated optical designs, these lenses have all followed the original Schneider Componon line in optimizing performance for relatively high-print magnifications of about 10– to 12x. In a few cases, like that of the original Componon 80mm f/4 for 6x6cm negatives, some negative (or barrel-shaped) line-distortion will result if the same lens is used for making very small enlargements or prints at close to 1:1 (but after all, these enlarge ments aren't commonly made).

Good as they are, very few of these elegant enlarging lenses (or any others) work really well at their full apertures, and most should be closed down at least two f-stops for critically sharp work. This means working a 50mm f/2.8 at printing apertures no greater than f/5.6. But, incredibly, in most of these lenses the spherical aberration has been so well corrected that you can trust the central focus at maximum aperture. Most enlargements are made at smaller stops, like f/8 or f/11. One reason for this is to compensate for the lack of perfect negative flatness when using a glassless carrier, or even to compensate for some small degree of error in the alignment of the enlarger.

For absolute print perfection within the capabilities of the enlarging lens, three planes must be perfectly parallel. These are the planes of the enlarger baseboard and the negative-stage, as well as a theoretical 90-degree line running through the enlarger lens.

Another very practical reason for preferring smaller f-stops is quite simply that they allow longer print exposures. These make any needed burning-in or holding-back ("dodging") operations easier, and it's axiomatic that exposures not measured by photo-electrical enlarging meters are generally more accurate when they're longer. It is also best to focus with a bright f/2.8 baseboard image, and then stop down for exposure, but to be able to change to f/11 without a shift of focus is a small miracle.

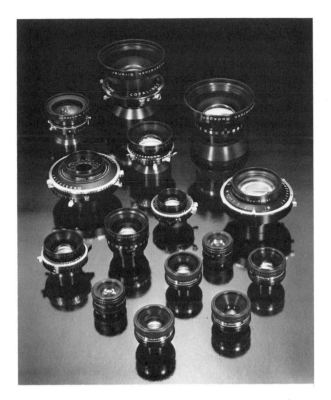

Rodenstock produces a variety of enlarging (and camera) lenses that vary in performance as well as type. Economically priced lenses from such a range tend to have fewer and slower optimum working apertures and give a more limited range of high quality magnifications.

Optical corrections in lenses

It is sometimes thought that optical color correction is relevant only or primarily to color photography. This is utter nonsense because no kind of sharp imagery is possible without some degree of color correction. In its principal, and simplest, form, chromatic aberration causes a longer focal length for red than blue-violet light rays, with green falling in between. The case could be argued that ordinary black-and-white enlarging is the hardest case for color correction because you focus the enlarger by eye, using yellow-green light rays mainly, while ordinary black-and-white papers are sensitive almost exclusively to blue-violet wavelengths. In general, modern enlarging lenses are very adequately color-corrected, espe-

cially in the shorter focal lengths that are commonly used for rollfilm and 35mm negatives. One of the best chromatically corrected lenses currently available is the Rodenstock Apo-Rodagon 50mm f/2.8, but such a costly correction may not be necessary.

Exchanging lenses between camera and enlarger

One justification for investing in high-priced enlarging optics is their possible use as macro lenses on bellows-focusing units for 35mm and rollfilm reflex cameras. But this can cause problems. All of the modern Rodenstock Rodagon lenses, as well as a number of others, have trans-illuminated aperture scales that reveal bright white f-stop markings in the darkroom. But

that same light that can get out from the enlarger lamphouse can get back into a camera by ambient subject illumination. Thus, before using these lenses for camera work, place a snip or two of black masking tape to block any chance of fogging the film.

Since the early days of 35mm photography, a perennial question concerns the use of interchangeable camera lenses for enlarging, using the adaptor rings currently on the market. In most cases this isn't really advisable for two basically different reasons. First, very few high-grade camera lenses have the special field characteristics and other correctional features needed to make high-quality enlargements. Second, camera lenses, especially those of high quality, contain at least some cemented surfaces, which means at least one optical component consists of two pieces of glass cemented together. And herein lies the rub, because not all optical cements are able to withstand the heat of an enlarger lamphouse. Modern high-quality enlarger lenses are cemented with specially heat-resistant resins that are sometimes used for camera lenses as well, but don't count on it—the experiment could cost you separated lens elements and a lens that's either permanently ruined or very costly to have repaired.

Short and zoom lenses

Some recent design trends in enlarging lenses are worth noting and probably worth rejecting. One of these is the use of shorter-than-normal focal lengths for certain film formats. An example is the new availability of 40mm enlarging lenses for the 24x36mm usually covered by an optic of 50mm focus. The shorter optics give higher image magnifications for the same negative-to-baseboard distances. While a 40mm lens will provide an image that's roughly 20% bigger from exactly the same negative-to-image distance, it is actually a semi-wide-angle that needs to cover a diagonal field of 57 degrees, instead of the 47-degree field required of a 50mm lens. The 50mm optic has to be better, assuming other factors (like aperture) are equal. These slight gains in magnification are not worth the loss of potential image quality, and for normal-sized prints their shorter throws make it more difficult to get in between lens and image for hand-dodging operations.

Also to be ignored are zoom lenses for enlarging. Actually, they were originally designed (by Schneider, in their Betavaron 51 to 125mm f/5.6 zoom) for commercial photofinishers with non-adjustable, or hard-to-adjust automatic printers that cause difficulties when slight print-size changes are required. With these commercial printing machines, a zoom system suddenly makes sense. In any other application and for nearly all amateurs using versatile equipment, they're superfluous.

SIMMON OMEGA

Many photographers and darkroom workers swear by one machine new or used, the Simmon Omega model D. Omega designates its different models with a capital letter followed by an arabic numeral. The letter gives the maximum film format: A for 35mm, B for 2¼x3¼in, C for the once popular

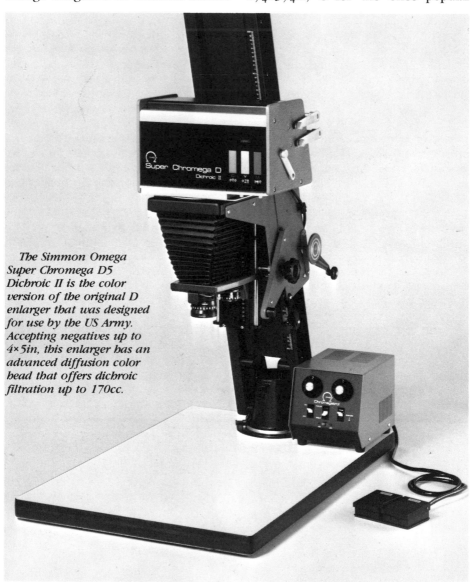

The Simmon Omega Super Chromega D5 Dichroic II is the color version of the original D enlarger that was designed for use by the US Army. Accepting negatives up to 4×5in, this enlarger has an advanced diffusion color head that offers dichroic filtration up to 170cc.

$3\frac{1}{4}$x$4\frac{1}{4}$in sheet-film size, D for films to 4x5in, and E to 5x7 in. Even numbers indicate manual focusing, odd numbers auto-focusing mechanisms. The top of the line is the Omega D-6 (formerly D-2). D-5 is the auto-focus version of D-6—probably the most controversial item in Omega history.

The D-series Omega enlargers are part of a system of equipment that makes them as adaptable as any 35mm SLR camera. They are the only enlarg- ers that take interchangeable lamp- houses, and you can get a grid style cold-light diffusion head, a hot-cathode ring style diffusion lamphouse, a totally diffusing dichroic "Chromega" color lamphouse, or fully collimated point-source "DM" lamphouse. Carriers for the Omegas are available for everything from 8x11mm Minox sub-mini nega- tives up to 4x5in, and there are other accessories for printing scratched neg- atives, and eliminating distortion.

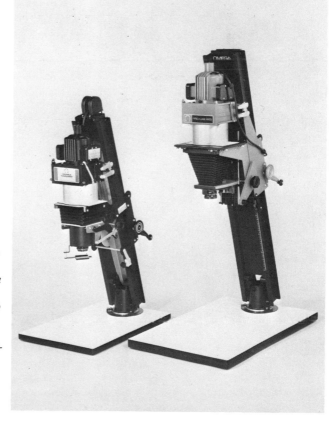

The Omega System is one based upon versatility for professional use. The smaller enlarger features a variable condenser system that eliminates the need to store separate condenser sets for format changes. The extra-length girder Pro-Lab model offers special options designed to speed operation, such as a lens turret that will hold three different lenses, a filter holder that adjusts for different size lenses, and a coarse/fine dual focusing system.

DURST

Another excellent enlarger is made by Durst, the world's biggest enlarger manufacturer, located in Bolzano, Italy. Durst uses a very reliable condenser-diffusion lamphouse design with a 45-degree mirror reflecting an image of the lamp down to the double-condenser pack. Many professional photographers believe that this lamphouse has much of the sharpness of double-condensers and something of the long-scale silvery gradation that you get from large-source diffusion lamphouses. Most importantly, of all basic color enlarger designs that have built-in filtration, Durst's lamphouse is one of the best for quality black and white printing.

Durst's enlargers range from small 35mm only models, suitable for a beginner in black-and-white work, to luxurious and expensive 8x10in machines. For serious darkroom work, you should examine the M-series enlargers which includes three models: M305 (24x36mm); M605 ($2\frac{1}{4}$x $2\frac{1}{4}$in); and the M805 ($2\frac{1}{4}$x$3\frac{1}{4}$in). The basic M305 is a black-and-white enlarger with a condenser illumination system. For color work this is replaceable with a tungsten-halogen mixing head. Perhaps the best and most versatile of the M-series, however, is the 605, a color enlarger that does excellent work in black-and-white printing too. Negative carriers for the M-series take some getting used to, but are among the best on the market.

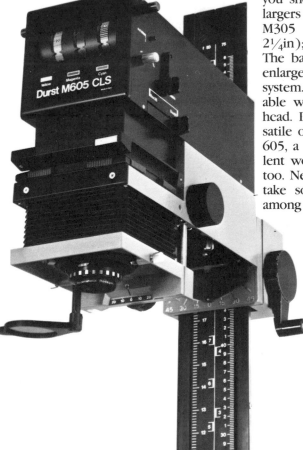

The Durst M605 is a high quality machine that is ruggedly and precisely built. It features a tilting lens stage for perspective correction and interchangeable lamphouses, including the CLS diffusion color head with dichroic filters shown here.

TIMERS

If you can possibly afford to, buy an electromechanical (big, black, clock face) enlarger timer that counts all the way to one hour, backwards in one-second increments, and offers sockets for your enlarger and your safelight. The excellent GreyLab Model 300 will serve developing and enlarging needs very well.

Avoid all electronic timers. They are an unnecessary expense, provide unnecessary accuracy, and can be affected by the heat and humidity in your darkroom and electrical transients generated by other darkroom equipment.

SAFELIGHTS

The only safelight filters you'll need are a Kodak OC for black-and-white work, and a #13 for color work. These can be purchased as 5in diameter glass units which fit the front of most Kodak or competitive brand safelights. Use a 15 watt frosted bulb inside the safelight for black-and-white work, and a 7½ watt frosted bulb in the safelight when printing color negatives. Use no safelight whatever when printing color slides, or when handling film.

TRAYS

Buy at least three, or four trays for processing, in 8x10in or 11x14in sizes. Good quality plastic trays which are rigid enough to remain steady when filled with chemicals are probably best. Choose them in a pale color or white because it will show any dirt or stains quickly.

A feature of hundreds of professional and amateur darkrooms, the GreyLab 300 timer has a timing range from one second to one hour and is well-suited to both enlarging and processing. It can run an enlarger, printer, or processing machine that draws up to 750 watts of power.

THERMOMETERS

Your first thermometer probably ought to be a glass-rod type, with a range of from about $50°-120°$ F and should be accurate to between $1°$ and $\frac{1}{2}°$ F. Be sure to buy one which is easy to read and responds to temperature changes very quickly. The Kodak Color Thermometer is reliable and easy to use. Dial-type thermometers are very popular, but many do not have a zero adjust and they can easily go out of calibration.

Stainless steel tanks are universally recommended for their easy cleaning, thermal conductivity, and chemical resistance. Plastic (usually PVC) tops minimize any leaks and are easy to remove.

FILM TANKS AND REELS

Your first film-processing tank ought to be a one-pint, stainless-steel type with a plastic top and cap. Don't buy any tank that has a stainless steel top and cap, because the metal top and cap will leak and freeze in place making it difficult to remove. Choose a tank which will take two 35mm wire reels or a single 120 wire reel. (If you use 220 you will have to buy a special tank and reel combination.) Wire reels are difficult to learn how to load, but give better circulation of the solution and are easier to clean than plastic reels.

CHEMICAL STORAGE BOTTLES

Avoid plastic bottles if you can and use glass bottles instead. Although plastic concertina bottles are frequently recommended to minimize oxidation of chemicals, this is a weak claim (some color chemicals actually like oxygen) and they are very difficult to clean properly. Perhaps the best containers are those one-quart resealable cap glass bottles used by your pharmacist.

GRAIN FOCUSERS

It is possible to focus your enlarger by sight alone, but a grain focuser will give you sharper and more consistent results. All grain focusers magnify the image, or rather the grain structure of the negative, so that you can make fine adjustments to the focus to get your print as sharp as possible. Always focus at maximum aperture, when the image is brightest, before stopping down for exposure. (Although each f-stop of the enlarging lens has a slightly different focus, stopping down will compensate for this by increasing depth of field.) In addition, always focus on a sheet of paper about the same thickness as your printing paper so that you are focusing on the exact image plane.

Magnifications given by grain focusers range from 2.5 to 30x, but power is not necessarily an indication of quality. True image sharpness means corner-to-corner focus of the grain, and the best focusers can work as well at the edges of the image as at the center. The best, most elegant, and most expensive magnifiers on the market today are the French-made Scoponet and Omega's "Micromega." Also very good, but at a fraction of these prices are the Paterson models from England. The small Paterson "Micro Focus finder" is preferred by those who want to be able to see the enlarged image—of about 8x—rather than abstract grain patterns.

The Omega Grain focuser is an extremely advanced device that allows you to focus precisely anywhere on the image, even at the very edges of the easel. This is done by mounting the objective on a pivot and a long silvered mirror. This focuser makes it possible to check enlarger alignment and lens resolution, and make very sharply focused prints.

Index

south essex college

FURTHER & HIGHER EDUCATION
SOUTHEND CAMPUS